Grant Wood

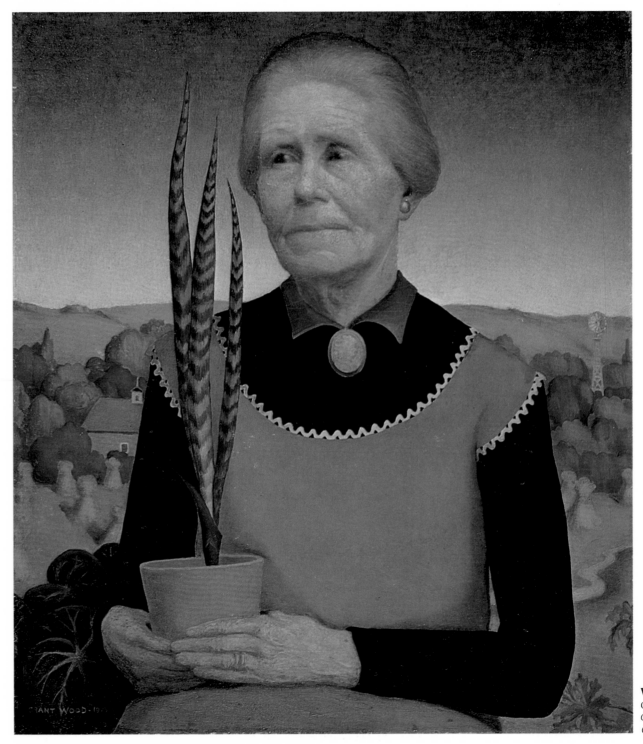

WOMAN WITH PLANTS 1929
Oil on upsom board, 20 1/2 × 17 7/8 in.
Cedar Rapids Museum of Art,
Cedar Rapids Art Association Purchase

Grant Wood
THE REGIONALIST VISION

Wanda M. Corn

Published for The Minneapolis Institute of Arts by
YALE UNIVERSITY PRESS
New Haven and London

This book was produced in conjunction with the exhibition
Grant Wood: The Regionalist Vision

Whitney Museum of American Art, New York
June 16–September 4, 1983

The Minneapolis Institute of Arts
September 25, 1983–January 1, 1984

The Art Institute of Chicago
January 21–April 15, 1984

M. H. De Young Memorial Museum, San Francisco
May 12–August 12, 1984

This exhibition has been made possible by generous grants
from Burlington Northern Inc., the National Endowment for
the Humanities, and the National Endowment for the Arts.

Designed by Christopher Harris with James J. Johnson
and set in Aster Roman type by The Saybrook Press,
Old Saybrook, Conn. Printed in the United States
of America by The Murray Printing Company,
Westford, Mass.

Library of Congress Cataloging in Publication Data

Corn, Wanda M.
 Grant Wood, the regionalist vision.

 Catalogue of a traveling exhibition held at the
Whitney Museum of American Art, New York, and other
galleries.
 Bibliography: p.
 Includes index.
 1. Wood, Grant, 1892–1942—Exhibitions. 2. Regionalism
in art—United States. I. Minneapolis Institute of
Arts. II. Whitney Museum of American Art. III. Title.
N6537.W66A4 1983 760′.092′4 83–3514
ISBN 0–300–03103–3
ISBN 0–300–03104–1 (pbk.)

10 9 8 7 6 5 4 3 2 1

This book is dedicated to my midwestern roots—
Emeral and Maud,
Edward and Ella,
Keith and Lydia,

and to Mildred, for whom Emeral
became a New Englander.

Contents

Foreword

Were the "man in the street" asked to name three paintings of any period, Grant Wood's *American Gothic* would likely be one of those named. Along with perhaps the *Mona Lisa* and Whistler's Mother, this work has, for a multiplicity of reasons, imbedded itself in the national consciousness, and it appears to be there to stay. This, of course, is not sufficient reason to mount a major retrospective of the artist's work, but it is a clear indication of the power of one man's vision and his ability to capture the essence of a nation's sensibilities in a single canvas.

There are other reasons to reassess the work of Grant Wood—not the least of them being that there has been no comprehensive exhibition of his work in a major museum since his memorial show in 1942. Furthermore, *American Gothic* has not been shown outside Chicago since 1959. In recent years, there has been a growing interest in the movement known as Regionalism, in which Wood was a seminal figure. Given these factors, it seemed both desirable and feasible—conditions that had not coincided in over forty years—for The Minneapolis Institute of Arts to organize this exhibition of the artist's major works.

The exhibition, most generously sponsored by Burlington Northern Inc. and supported by grants from the National Endowment for the Arts and the National Endowment for the Humanities, focuses primarily on Wood's mature years—between 1929 and 1942. This concentration yields a wealth of powerful imagery not properly seen in context for far too long.

We are grateful to Wanda M. Corn of Stanford University for her devoted labors both as author of the text and as guest curator of the exhibition. Invaluable assistance was rendered by James Maroney and James Dennis, consultants to the exhibition, in locating important loans. Indebtedness is equally due to the many lenders whose cooperation made this exhibition possible. Special conditions have been created to allow the loan of normally "unlendable" works, which are traveling for perhaps the last time.

The largest single lenders are The Cedar Rapids Museum of Art and The Davenport Art Gallery, which due to their unique collections of Wood's work have suffered by dint of their generosity. The central loan from The Art Institute of Chicago and major works in the possession of The Amon Carter Museum, The Cincinnati Art Museum, The Joslyn Art Museum, The Metropolitan Museum of Art, and numerous private collectors form the core of the exhibition; we are moved by the cooperative spirit of all the lenders.

Special acknowledgment is made to Nan Wood Graham, the artist's sister and sitter to her brother on more than one occasion. May her hopes as well as ours be realized in this venture.

Samuel Sachs II, *Director*
The Minneapolis Institute of Arts

Tom Armstrong, *Director*
Whitney Museum of American Art

James N. Wood, *Director*
The Art Institute of Chicago

Ian McKibbin White, *Director*
Fine Arts Museums of San Francisco

Acknowledgments

I have been researching, writing, and lecturing about Grant Wood for almost a decade now and have received help from many quarters. I thank all of you, named and unnamed below, who have talked or corresponded with me about the artist, sent me Grant Wood parodies, answered my questionnaires about *American Gothic*, and remained patient this past year during the all-consuming preparation of this catalogue and exhibition. It is my hope that everyone who has contributed to the project will share my rewards by coming, as I have, to a new appreciation for Wood's place in the history of the 1930s: for his artistic vision; his gentle, often witty art; and his short-lived attempt to stake out a cultural position opposed to that of the New York art establishment.

Although she sometimes disagrees with my interpretation of her brother's work and with my historical reading of the rise and fall of the regionalist vision, Nan Wood Graham, the artist's sister, has given generously to this project. Her good humor and careful attention to detail—so much like her brother's—has lightened my way. I also extend my heartfelt thanks to the many others who shared their memories or knowledge of Wood: John B. Turner, Park Rinard, Paul Engle, Winnifred Cone, Mrs. Herbert Stamats, Virginia and Jim Sigmund, Reeves Lewenthal, Jeanne Kline, the late Dr. George D. Stoddard, Helen Hinrichsen, John and Isabel Bloom, Byron Burford, Robert Kocher, Wallace Tomasini, Bruce Kelley, John Zug, Ellen Williamson, and Mark Emmons. For gracious tours of the homes Wood designed, decorated, or lived in, I am indebted to John B. Turner, James B. Hayes, Mrs. James Pickens, the late Van Vechten Shaffer, and especially Esther Armstrong, who shared not only her home but also her recollections of Wood as an artisan, artist, and friend. My thanks also to Dr. Milton D. Heifetz for showing me the Wood murals he salvaged from the Hotel Chieftain in Council Bluffs.

The exhibition has been a model of cooperation among museums and private lenders, all of whom have agreed to part with their paintings, prints, and drawings for over a year so that they may be seen in major museums across the country. I am indebted to them and to Samuel Sachs II, director of the Minneapolis Institute of Arts, who has shepherded the exhibition into being and graced it with his enthusiasm and wholehearted support. It has been my pleasure to work with him and his staff.

Rosamond Hurrell, the museum's coordinator for the exhibition, has tended to the countless details of the project graciously and efficiently. My special thanks to her and to Gary Mortensen, the museum photographer whose work appears throughout these pages, as well as to Timothy Fiske, Kathryn Johnson, Liz Sela, Marilyn Bjorklund, and Karen Duncan, each of whom has been responsible for preparing the exhibition to travel across the country. Thanks also to those in other museums who have joined in this common effort: to Tom Armstrong and Jennifer Russell at the Whitney Museum of American Art; James N. Wood and James Speyer at the Art Institute of Chicago; Ian McKibbin White and Margaretta Lovell at the Fine Arts Museums of San Francisco; L. G. Hoffman, Ann Madonia, and Joseph Fury at the Davenport Art Gallery; and Joseph S. Czestochowski at the Cedar Rapids Museum of Art. I am also grateful for help given by Stan Wiederspan, the former director of the Cedar Rapids Museum of Art, and by Kyra Curtis at the Detroit Institute of Art.

At Yale University Press, it has been my good fortune to work closely with Judy Metro, a patient and exemplary editor, with Kate Schmit, copyeditor and picture coordinator, and with Christopher Harris and Jim Johnson, the book's designers. For prompt response to requests for photographs, my thanks go to John Barry of Cedar Rapids, Joan Liffring-Zug of Iowa City, and Elizabeth Gibb at Stanford University.

My collection of *American Gothic* parodies grows weekly thanks to donations from friends, students, and people who have heard me lecture on the painting, too many to name here. Let me single out, however, Carol Nockold, Mary Boehm, Susan Ciriclio, and Susan Kendall for their perseverance and numerous contributions over the years. I am also happy to list here other collectors of *American Gothic* ephemera who have shared their collections with me: Price Slate in Anamosa, Iowa, Edwin B. Green in Iowa City (who donated his caricature collection to the Davenport Art Gallery), Linda Good of Gowrie, Iowa, and Nan Wood Graham.

For other kinds of assistance I thank the staffs of the Special Collections Department of the University of Iowa Libraries, The State Historical Society of Iowa, The Herbert Hoover Presidential Library, the Archives of American Art, and the Art Library at Stanford University. Students to whom I am indebted for

their help include Vicki Irons and Katy Plumb, graduates of Mills College, and Ellen Todd, Jim Herbert, and my research assistant, Cécile Whiting, at Stanford University. A number of regionalist scholars—Karal Ann Marling, Anedith Nash, Susan Kendall, Lea Rosson DeLong, and Gregg R. Narber—shared their research with me; James Dennis kindly answered queries and reviewed parts of the manuscript. James Maroney, a Grant Wood enthusiast of many years, has been involved in this endeavor from the very beginning and is more responsible than he knows for its realization. Lorenz Eitner, chairman of the Department of Art at Stanford University, and Ian Watt, director of the Stanford Humanities Center, each helped me find time to write this catalogue; a fellowship at the Stanford Humanities Center for the year 1982–83 made it possible for me to write the last draft of this book. I also want to thank Curt Philips, who conquered the mysteries of the personal computer to give me a letter-perfect manuscript; my father, Keith M. Jones, for being my most steadfast critic; and my friends, Susan Ciriclio, Elizabeth Johns, and Eunice Lipton, for their support and criticisms. And finally, my thanks to Joe, the man with the pitchfork in my life.

Introduction

It has been Grant Wood's fate to be widely known but narrowly understood. His reputation has been one of extremes. Midwesterners lionize him as one of their premier painters; those in art circles dismiss him for his illustrative style and antimodernist views; and the public at large enjoys his famous painting, *American Gothic*, but hardly recognizes the artist's name.

All three of these views of Grant Wood share a similar thinness. In Iowa, where the artist lived all his life, Wood is often presented one-dimensionally, as a figure bigger than life, a Horatio Alger–type local boy who began life as an ordinary farm child and grew up to earn national fame. Iowans proudly register the numerous landmarks of his life, the places where he lived, painted, and worked as a decorator. There is a Grant Wood School in Cedar Rapids; a Grant Wood Art Festival in Anamosa, his birthplace; and in Eldon a Grant Wood Trail, which passes by the white frame house Wood placed behind the couple in *American Gothic*. In Cedar Rapids and Davenport there are permanent museum collections of Wood's work and of memorabilia chronicling his rise to fame and celebrating his success.

To members of today's art establishment, however, Grant Wood was not a success, let alone a great artist. If critics or historians notice Wood at all, they are likely to think of him as a kind of traitor who repudiated modern art in the 1930s to champion an old-fashioned, sentimental, even reactionary, art of country folks and pastoral landscapes. The disinterest in or hostility toward Wood's life and career among intellectuals is as profound as is his adulation among midwesterners. In 1974, the senior art critic of the *New York Times* referred to Wood and his work as a "corpse" that he saw "no need to disinter."[1] Historians have tended to agree, viewing the regionalist movement as an unfortunate, ill-considered attack on modernism that is best forgotten. Until very recently, only two scholars, most notably James Dennis, have written seriously of Wood.[2]

Believing that no artist should be stricken from history—particularly one whose name was as much a household word in his day as, say, Andy Warhol's is today—yet not one to be moved by unquestioned adulation, I have tried to learn from both views. I have visited the landmarks of Wood's life—the cities and towns in which he lived, the sites he painted, and the houses he decorated—and spoken with people who knew the artist well. I have also studied the Grant Wood files in Iowa's museums and libraries and read the two chatty and anecdotal books, one by Darrell Garwood and one by Hazel Brown, that weave together local memories of the artist's life and activities.[3] From all these sources it is easy to construct a picture of the artist that explains the affection his state, and particularly the city of Cedar Rapids, has for him. Wood was a likable person, a bachelor artist whose gentle humor and dedication to the artistic life enlivened Cedar Rapids in the 1920s. He left behind a string of witty works and anecdotes which people never tire talking about. Cherubic in stature, he was shy and had a slow manner of speaking and a habit of rocking back and forth on his feet whenever he spoke, but he also had an infectious wit. To most people he seemed infinitely gentle and perpetually boyish. Even his naiveté about such worldly matters as paying taxes and keeping financial records and his reliance on others to manage his everyday affairs had a certain charm.

While drawing upon people's reminiscences and the great store of Wood memorabilia to re-create the artist's life and personality, I have also kept in mind the charges art critics and historians make against Wood and his fellow regionalists, Thomas Hart Benton and John Steuart Curry—that their art was narrow in focus, descriptive and story-telling, conservative and nationalistic. Even granting that the descriptions are accurate, one still wants to know why such an art developed in the late 1920s and 1930s, why it flourished in the Midwest, and why it attracted such an immense popular audience. These are questions we will never be able to answer until we overcome the art establishment's prejudices against such art and reconstruct, as we would do for Stuart Davis or Edward Hopper, the intellectual and artistic development of the major regionalist painters. The real problem in discussing Regionalism is that we know so very little about the movement or, for that matter, about any twentieth-century movement that ran counter to modernism or that developed far away from cosmopolitan East Coast art centers, in places like Cedar Rapids. It is my intention here to present Wood's story as a case study in 1930s American Regionalism. Much like the regionalist painter, I am exploring the particular to uncover the universal; in this case a close study of one individual illuminates the broader phenomenon of the regionalist movement in Depression-era America. When this study is put together with work now under way or recently

published on other regionalist painters, we may finally be able to see the complexities of this short-lived but highly publicized movement in history, to judge its influence, and to integrate it into our texts in a more dispassionate way than has been possible thus far.

My study is divided into three parts, each intended to be complete in itself. There is first a biographical essay, then a section interpreting Wood's major works, followed by a discussion of *American Gothic* tracing the origins of the painting and examining its recent reinterpretation through parodies and takeoffs. In order to make this book a comprehensive study of the artist, I have on occasion discussed and reproduced works of art that will not be in the exhibition. Throughout the text I maintain several convictions about Wood and his regionalism that determine the way I present his art and life. First, I see his move at the age of ten from a rural family farm to the city of Cedar Rapids as a classic example of modern dislocation, an experience that profoundly influenced the themes and subjects of his regionalist art. The move was not only from the country to the city but, in a manner of speaking, from nineteenth-century agrarian America to twentieth-century urbanism. Millions of Americans experienced this same transition in the early twentieth century. In painting country folk and farm rituals and contrasting them with small-town and city types, Wood was commenting on one of the major social changes of his time. He could be humorous about modern living and its effects on established patterns of thought, but he was also elegiac about a way of life he knew was passing.

My second conviction stems from the first. It is impossible to understand Wood's art and his regionalism unless one places it in the context of midwestern history, most particularly the history of Cedar Rapids in the early part of this century. For Wood's regionalism was molded by the civic pride and booster spirit exhibited by his mentors and patrons, by their pride in the frontier origins of Cedar Rapids and its quick rise as a modern, prosperous city. Wood's regionalism was nurtured in a boomtown ambience.

Furthermore, once Wood became convinced that art could be made out of local materials, he played a more important role in publicizing and disseminating the principles of Regionalism than is commonly acknowledged. Of the three midwestern regionalists in the 1930s—Wood, Curry, and Benton—Wood was the *compleat* regionalist, the one who defined and promoted the movement in every aspect of his life. Wood not only painted the people and places around him, but he also lectured nationwide on Regionalism and held important teaching posts through which he primed others to take their subjects and themes from their native surroundings. His favorite painting outfit was a pair of farmer's overalls, and he developed a deep appreciation for Iowa's antiques and architecture, going so far as to buy and restore a Civil War–era house in Iowa City. Unlike Curry and Benton, who lived for long periods in the East, Wood took pride in the fact that he lived his entire life in one region. It was he who helped convince Curry and Benton to return to the Midwest in the mid-1930s to serve as role models for the younger generation.

Finally, it seems clear that Regionalism, as Wood practiced it, developed in the 1920s but won its mass audience in the 1930s. It was preeminently a phenomenon of the Depression. The movement's brief flowering had much to do with the insular mood of the nation during the 1930s and with America's psychological need for reassurance and a sense of continuity with the past. Once the economy began to right itself and the country turned away from domestic concerns to deal with the rise of Fascism and the threat of war abroad, Regionalism foundered and came under critical fire. We can see this clearly in the events and controversies of Wood's life. From 1930 to 1935, his art had a wide base of support and was endorsed by a range of critics. During those years he blossomed as an artist and painted most of his best works. Beginning in 1935, however, critics began to object vehemently to the artist's narrow aims and parochial thinking. Increasingly they attacked Wood for his antimodernism, his midwestern chauvinism, his illustrative techniques, and his nationalism—qualities which earlier had held him in good stead. Wood responded by trying to tie his art to national concerns rather than regional ones. By the late 1930s he claimed his art reflected American democracy, not midwesternness, and he sought to make his work more abstract in design. But he did not change either his style or his approach to art enough to survive the turn toward international concerns and the rise of a new school of American abstract art. Instead, he became more dogmatic and defensive, and at the time of his death in 1942, his kind of art—an art founded on grass-roots imagery and local history—was decidedly in eclipse.

Grant Wood

The Regionalist Vision

I. ROOTS 1891–1901

Though Grant Wood spent most of his life in small, modern cities, his beginnings were rural and Victorian. He was born and lived for ten years on a farm near Anamosa, Iowa, a town of 2,000 people twenty-five miles north of Cedar Rapids. His father, Francis Maryville Wood, a strict, industrious man of Quaker origins, met Hattie Weaver, the artist's mother, at the local Presbyterian church: she played the organ and he was superintendent of the Sunday school. Miss Weaver taught school in Anamosa and Maryville (who was always called by his middle name) was a local farmer. Both were the firstborn children of moderately prosperous families that had come from the East to Iowa during its first decades of settlement. They married in 1886, he at thirty years of age and she at twenty-six, and soon set up housekeeping in a new, two-story farmhouse that Maryville had built on property adjacent to his family's farm three miles outside town. Hattie, whose family had run small-town businesses, became a farmer's wife. She bore four children in thirteen years: Frank in 1886, Grant in 1891, John in 1893, and Nan in 1899.[1]

Grant spent his first ten years as a typical farmer's child. He

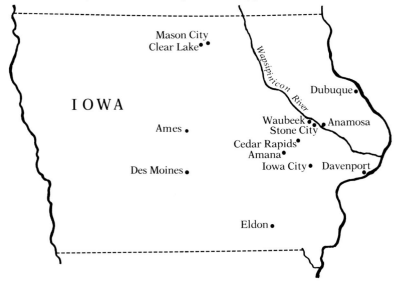

1 Map of Iowa, showing those places where Grant Wood lived and worked.

developed a particular fondness for farm pets, raised chickens, ducks, and turkeys, and avidly learned the names of birds, vegetables, and wildflowers. He received a rudimentary education in a one-room schoolhouse and at the feet of his parents, who read aloud to their children. Like most farm children's lives at the turn of the century, Grant's life in Anamosa was insular and highly circumscribed. There were no telephones, radios, or cars to link the farm to the outside world, and the family's circle of company was no wider than the live-in hired man, nearby neighbors, and relatives. Special occasions were horse-and-buggy excursions, threshing days, country fairs, church socials, and the exchange of a few handmade gifts at Christmas. Wood was too young, really, to do hard labor in the fields or to share the family's worries—money shortages, illnesses, droughts, and storms—and it was only when his father died unexpectedly in 1901, at the age of forty-six, that he began to feel the weight of hardship and responsibility. His daily life changed radically when his mother sold the farm and moved her young family to Cedar Rapids, where her parents lived in retirement. The move put Wood, a chubby farm boy, into city clothes and much bigger public schools; he and his mother gardened rather than farmed, and he had to take odd jobs to help support the family. It was the end of Wood's childhood.

Nearly thirty years were to elapse before Wood realized that his memories of the 1890s were his richest resource as an artist. He changed his style and began to paint the types of people and landscapes he recalled from his youth. It would be his peculiar mark as a regionalist, in fact, to paint very little of the 1930s life taking place outside his Cedar Rapids window. He chose instead to return to his late-nineteenth-century roots as a midwesterner and to scenes that were becoming extinct even within his lifetime.

Wood's artistic reliance upon his childhood is made clear in his unfinished biography, "Return from Bohemia, A Painter's Story," written in the late 1930s *after* Wood had painted his best work and become nationally known. The book was to be a full-scale narration of the artist's life, but only the first part, the chapters about his farm years in eastern Iowa, was ever completed. These chapters were in the first person, as if Wood had written them, but were actually drafted by Park Rinard, Wood's young collaborator.[2] Wood recounted his life for Rinard, emphasizing those scenes from his boyhood that he had already distilled into major paintings: he described the annual midday meal for the threshing crews that became *Dinner for Threshers* and recalled his student days in a rural schoolhouse *(Arbor Day)*, his pet chickens *(Adolescence)*, and his "tall gaunt" domineering

aunts *(Victorian Survival)*. These events were always narrated from a young boy's perspective, with never an indication that this same boy would one day turn into an artist and paint scenes based on his youthful experiences. But as informed readers, we know that when young Grant hears his mother tell the story of Paul Revere's ride, this is the origin of the artist's famous painting.[3] Furthermore, we come to sense from the biography's repeated references to handcrafted country furniture, patterned fabrics, and Victorian engravings that these things were important to the boy and would some day be influential in his art. The heavy dinner plates that the young Wood peeked at through his fingers during grace, with their trademarks of lions and unicorns, the Haviland set and brown willowware that came out on threshing days, "the tintypes in the plush album and the colored engravings in the big family Bible" that so pleased the hired man on Christmas day—these are the objects, recalled from childhood, that the artist turned to in creating his major paintings.[4]

Wood's biography, despite being ghostwritten and incomplete, is full of useful information, not only about the facts of the artist's life and the sources for his paintings, but also about the peculiar nature of 1930s midwestern Regionalism. Written well after Wood had become a confirmed painter of the Midwest, it is contrived as much as a piece of 1930s regionalist literature as an account of Wood's youth. Like his regionalist paintings, the memoir renders a very rosy, mythical account of boyhood on a midwestern farm. Although there is mention of hardships, farming is viewed as a life in tune with the changing seasons and replete with the simple pleasures to be found in a close family and a small community. There are only a few of the brutally realistic passages about the toil and drudgery of farming that we associate with the novelist Hamlin Garland, who was writing of midwestern farmers in the 1890s, when Wood was a child. Writing in the 1930s as a city artist, not a farmer, Wood looked back at his childhood through a veil of fond memories and sentimentalized the adventures of rural boyhood. The Saturday horse-and-buggy shopping trip to nearby Anamosa, for example, or the occasional excursion to Stone City to sit by the pretty Wapsipinicon River were as adventurous as ocean crossings. "In my own private world," the boy in the memoir says, "Anamosa was as important as Europe was to Columbus, and the Wapsie Valley, a half-dozen miles from our farm, had all the glamour that the Orient had for Magellan and Vespucci."[5] At another point, he elevates a hayride into a monumental event. "Alexander, Caesar, Napoleon, you all had your great moments, but you never tasted the supreme triumph; you were never a farm boy riding in from the fields on a bulging rack of a new-mown hay."[6]

This kind of evocation—equating the experiences of the humble with those of the great—was common in American letters of the time, particularly in literature about provincial life. Sinclair Lewis used the device often. In *Main Street*, for example, a young man asks the energetic and ambitious heroine why she doesn't want to settle down and raise children. The question, Lewis reminds us, is "the immemorial male reply to the restless woman. Thus to the young Sappho spake the melon-vendors; thus the captains to Zenobia and in the damp cave over graved bones the hairy suitor thus protested to the woman advocate of matriarchy."[7] Lewis used such historical analogies to universalize provincial manners, as did Wood to amplify farm life. For reasons we will explore later, Wood felt called upon to create a colorful, legendary history of the rural Midwest, to redeem it, in effect, from the grim portrayals circulated by turn-of-the-century realists like Hamlin Garland and from the bumpkin-rube associations that in the 1920s had become part of national humor. By the 1930s Wood had come to view farmers as a distinctive midwestern folk type endowed with a unique, but unsung, folklore. Indeed, he saw his youth on an Iowa farm as an archetypal rural American experience which, if probed, would reveal a strain of the national culture that was as rich and colorful as that of any other region or period in history. It was the predominance of farm culture, Wood believed, that gave the Midwest its unique character.[8]

Wood's biography was based on the facts and personages of his life but was conceived as an archetypal midwestern folktale—the adventures and rise to fame of an ordinary farm boy. Like Sinclair Lewis's novels, in which people and events represent universal small-town types and activities, Wood's biography treated the people of Anamosa as representative country types: his father symbolized every farmer; his unmarried aunts, all Victorian old maids. Certain occasions—the dinner for threshers, the trip to town—were treated as momentous and significant as sacraments.

The two most dominant images in the memoir, however, are the Earth and the Midwesterner. The biography is set against the inevitable and universal drama of the changing seasons and the "pageantry of growing things."[9] In the opening chapter the narrator tells us that "the naked earth in rounded, massive contours, asserts itself through everything laid upon it."[10] By working this earth and living close to it, the midwestern charac-

ter was formed. Wood saw this character in both his parents, who blended, he believed, the reserve and uprightness of their East Coast ancestry—Mrs. Wood's was Puritan New England; Mr. Wood's, Pennsylvania Quaker—with the hardiness and resilience that came from living in constant contact with the earth. Theirs was a distinctive American folk type, Wood believed, one formed in the nineteenth century when hard-working and religiously devout Easterners were lured to the Midwest by the promise of land.

Finding no woodlands or deep valleys to shelter them, they had to learn a special intimacy with the soil. They had to adapt themselves to the vast openness of the prairie and the ubiquitous light of an unbroken sky. And they and their children developed a character . . . akin to that of the land itself. One could see it in their eyes. I saw it in the eyes of my father and mother—a quality bleak, far-away, timeless—the severe but generous vision of the midwest pioneer.[11]

These two complementary images, the stern Midwesterner and the rounded Earth, dominate the artist's paintings as well as the biography. Wood painted midwestern people as hard and stiff, while he depicted the regional landscape as round and soft, often verging on the erotic. The one, we might say, is masculine, the other feminine. His paintings of people are generally ambivalent in statement, whereas the billowing landscapes are filled with the artist's unquestioning affection. Indeed, there is in this dichotomy an analogy to the very different feelings Wood had for his two parents, a subject he explored with some frankness in the biography. His relations with his father were tense, unresolved; for his mother he had a tender, adoring love. Both parents were reserved, but his mother's "restraint," he said, "was earthbound; it was penetrable." It was she who encouraged Grant to draw at an early age, she who gave him the cardboard from crackerboxes and bits of charred sticks as his first materials. She was generous and gentle, a "small and willowy" lady. As a child the artist thought "she must be the most beautiful lady in all the world."[12] The bond between them was so strong ("excessive," a friend once said) that Wood lived with his mother for most of his life.

The artist's relationship with his father, on the other hand, was tense and lacking in the approval and affection Grant sought as a child. Wood remembered Maryville as "more a god than a father," a man whose words were "law" in the home.[13] Maryville appeared to the young boy as solitary and mysterious, "a stranger in his own house."[14] Better educated than most farmers, Maryville, at the time of his marriage, was described by the

Anamosa *Eureka* as a man who kept himself "informed of the progress of events." He would, the paper predicted, "take his place among the most thoughtful, intelligent and progressive men of our times."[15] Maryville had attended a local college for two years, and as a farmer subscribed to *Harper's Magazine* and *Wallace's Farmer* and read biographies of figures such as Abraham Lincoln and William Penn. But even when reading at home in the evening, he impressed his young son as having a "stern aloofness," as being a man of intelligence and industry but not of human warmth and empathy.[16] Furthermore, because he was a Quaker and believed only in "true things," he had a genuine distrust of the imagination and worried about Grant's artistic leanings. He once made Grant return a book of Grimm's Fairy Tales to a neighbor because it was not about real life, a story the artist often told in his later years.[17] Wood was deeply affected by his father's prejudice against "graven and pictorial representation and fiction,"[18] more deeply, perhaps, than he ever acknowledged. Although he became a maker of "graven" images, he never could appreciate art that was not based on observation and research; for his entire life Wood was hostile to abstract painting.

Wood's stern and rigid father lurks behind some of the artist's most memorable images, all of which are, in some way, tenuous in their affections. The gaunt, humorless man in *American Gothic*, the overbearing authority of the *Daughters of Revolution*, and even the humorous but tense parent-child relationships in *Adolescence* and *Parson Weems' Fable* reflect Wood's memories of his authoritarian father. Until the end of his life, in fact, Wood wrestled with his father's psychological presence. In his final illness, the artist talked to several bedside callers about wanting to paint his father's portrait as a companion piece to *Woman with Plants*, for which his mother had posed. He had never before talked about painting his father; only when he sensed that his illness was fatal could he approach this painful topic. He would use, he said, his memories and family photographs to make his portrait.[19] Though Wood died before he could execute the work, his final thoughts were to capture the archetypal midwesterner one more time and to put a difficult personal matter to rest.

Wood's unfinished biography ends with the premature death of his father in 1901, the auction of the farm goods, and the family's departure from Anamosa. The young boy is excited by the move to Cedar Rapids, a city so large that its "little finger," his older brother tells him, "is bigger than Anamosa."[20] Yet as he looks around the empty farmhouse for the last time, Grant

has "a vague, calamitous feeling that the world would never be the same again."[21] The moment, we are made to feel, is a profound one; an era is over in the boy's life and another is about to begin. At just this dramatic juncture, as the boy and his family move from the country to the city, the manuscript stops.

It is possible, however, to make an informed guess as to how the artist expected the biography to proceed. In the 1930s, Wood gave journalists and critics a number of short accounts of his life, all of which have a similar pattern. He divided his life into three parts. First there was his youth on the farm and the move to Cedar Rapids. The 1910s and 1920s he recalled as his "bohemian" years; he went to art school, traveled and painted abroad, grew a beard, tried to create a Latin Quarter in Cedar Rapids, and worked in an "impressionistic" style. Then in the late 1920s, after visiting Munich, he entered the final phase of his career—his regionalist years. Inspired by the fifteenth-century Flemish painters, whose works he had seen in the Alte Pinakothek, he determined to do as they did and to paint meticulously "decorative" works of the people and landscapes around him. This, he realized, was how he had painted as a boy; and it seemed natural to give up the thick brush of the impressionist painter and work in craftsmanlike detail. Furthermore, he now wanted to create paintings out of personal experience, paintings everybody could understand. This new resolve marked the artist's emergence as a regional midwestern painter and, as he titled his biography, his "Return from Bohemia."

From boyhood on the farm to the romantic life of the artist-bohemian and back again to his midwestern roots—such was the life path Wood wove into legend, into a down-home, midwestern version of the return of the prodigal son. He told it so often that it annoyed his detractors, who saw it as picturesque self-aggrandizement. But the artist's mythic view of his life was completely consistent with the tenor of his 1930s paintings. Both biography and paintings elevated and mythologized life in the Midwest. Both were conscious attempts to instill pride and confidence in midwestern culture. Legends, Wood had come to feel, were crucial; they brought people together, gave them a sense of a shared past. They made people proud and secure in who they were.

But it took Wood many years to develop pride in "midwesternness" and the desire to paint his roots. After leaving the farm, almost three decades and twenty years of painting would pass before he explored his rural upbringing in his art. During his "bohemian" period in Cedar Rapids, he accepted the conventional idea of the Midwest as artistically impoverished and took little interest in regional culture—or so he would have one believe. But if examined closely and objectively, not through the rosy lens of legend, those years prove to have been critical to Wood's decision to become the painter-advocate of the Midwest. Living in Cedar Rapids—a boom city proud of its prosperity and its frontier beginnings, and supportive of local culture—profoundly affected the course of Wood's career.

2 **DOOR TO 5 TURNER ALLEY** **c. 1924**
Painted wood, glass, and wrought-iron hardware, 78 × 29 7/8 × 1 1/4 in.
Cedar Rapids Museum of Art, Gift of Happy Young and John B. Turner II

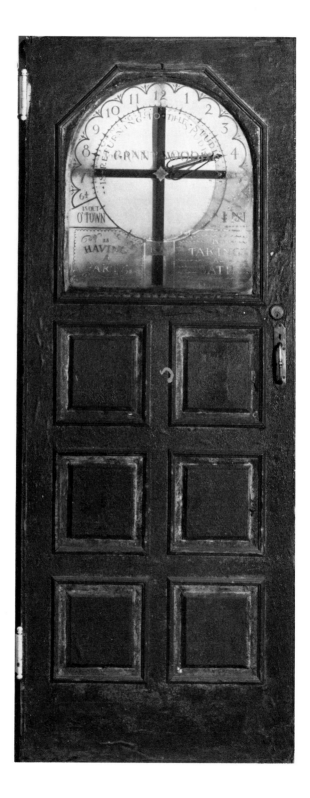

II. HOMETOWN ARTIST 1901–1930

At some point in his teenage years, Wood sat for a photographer. Wearing a turn-of-the-century painter's smock and seated in front of his easel, the young Wood posed like the serious artist he wanted to grow up to be. Ever since moving to Cedar Rapids he had been a promising student in art. With guidance and encouragement from Emma Gratten, the art teacher in his grammar school, he progressed rapidly and at fourteen won his first art prize for a chalk drawing of oak leaves submitted to a New York contest. In high school he contributed drawings to the yearbook and with Marvin Cone, a fellow artist, he designed theater sets and assisted with chores at the Cedar Rapids Art Association. The day he graduated from high school, in June of 1910, he took a night train north to follow a summer course at the Minneapolis School of Design and Handicraft. Despite having little money in his pocket, he had determined to study for the summer with Ernest Batchelder, a nationally known architect and designer in the Arts and Crafts style. He wanted to be able to earn a living as an artist.

Off and on for the next six years, Wood took sundry art courses. Not having money for foreign travel or a steady education, he pursued his training at an irregular pace, taking courses at night or in the summer. The courses he followed were predominantly late nineteenth century in character, ranging from a correspondence course and two summer courses in fin-de-siècle decorative design to academic courses in drawing from the model. While still in high school he had subscribed to a correspondence course from the *Craftsman*, an influential Arts and Crafts magazine that promoted handiwork in woods and metals and simple, stripped-down, modern designs. This was adventuresome for an early-twentieth-century student, far away from the artistic centers of Philadelphia, Boston, or New York. It led to his desire to study with Batchelder, undoubtedly the most progressive art teacher Wood ever had. He took courses from him in jewelry making and copper working and absorbed his teacher's commitment to modern abstract design. Wood surely studied Batchelder's 1904 textbook, *The Principles of Design*, which laid out the grammar of modern design as it was understood by Art Nouveau and Arts and Crafts masters.[22] The text emphasized the abstract beauty of Japanese art and taught the modern designer how to build his work upon principles of decoration rather than imitation. Throughout his life Wood's work reflected Batchelder's insistence on simplicity, repetition of form, beauty of contour, and use of pattern. Indeed, these same principles, hardened and stylized, eventually became the

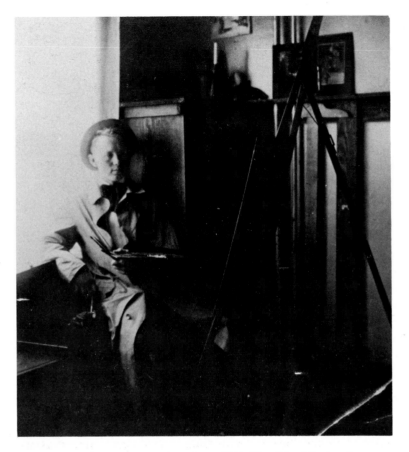

3 Grant Wood as a young artist, winter 1910. (Nan Wood Graham)

basis of Grant Wood's regional style. Wood, in fact, called his late style "decorative," a testimony to his grounding in the fin-de-siècle aesthetic.

Wood's scanty training, however, was not exclusively in design. After studying for two summers in Minneapolis (although Batchelder was there for only the first), Wood sporadically attended a life-drawing class for one year at the University of Iowa under Charles Cummings, a French-trained academic artist. Then, from 1913 to 1916, Wood lived in Chicago, where he took occasional night classes to draw from the model at the Art Institute. Together with a few months' work at the Académie Julian in Paris in the early 1920s, these classes constituted Wood's formal training. He had learned how to craft decorative pieces out of metal and wood, to design Art Nouveau paintings, and to paint straight academic figure studies. And somewhere in the late 1910s he was introduced to a timid sort of modern

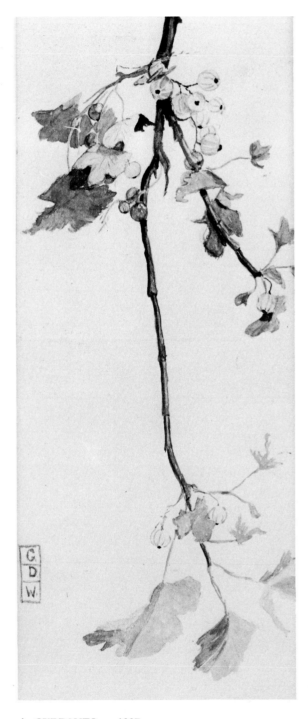

4 **CURRANTS 1907**
Watercolor, 11 1/2 × 4 9/16 in.
Davenport Art Gallery, Davenport, Iowa

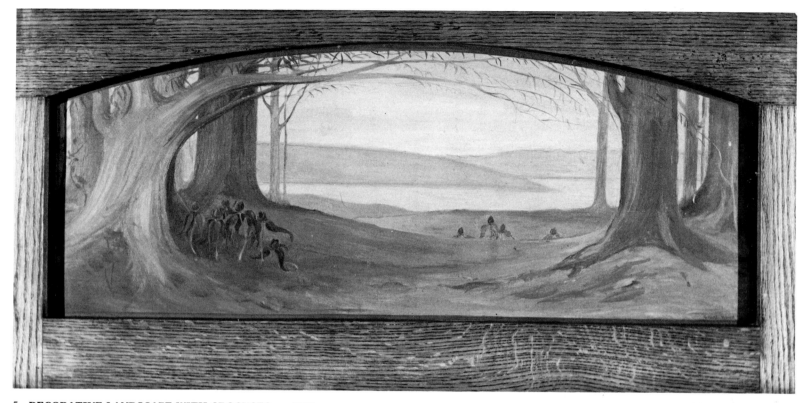

5 **DECORATIVE LANDSCAPE WITH CROCUSES** 1912
Oil on canvas mounted on wood, 15 × 34 1/2 in.
Mrs. James T. Holmes

painting, a brushy late Impressionism, which he used to paint landscapes and still lifes.

In the early years of his career Wood had trouble earning a living. He had no interest in a "regular" job; he wanted to work in the arts, with his hands. Not yet an accomplished painter in the 1910s, he tried to make a living by teaching for a year in a country school and by putting his arts-and-crafts training to use by making jewelry and lamps in a Cedar Rapids metal shop. When he went to Chicago in 1913, he found a job with the Kalo Silversmith's Shop and then left it to enter into a short-lived partnership making fine handwrought jewelry. In 1916, when his mother fell on hard times and had to sell their home, Wood returned to Cedar Rapids in order to support her and his sister. Both his brothers had married and moved away and it fell to him to keep the family. He built the three of them a modest little cottage to shelter them for the difficult, cold winter. Then, with a friend, Wood set about constructing two small bunga-lows, one for each of them, in Kenwood Park, on the northern

edge of Cedar Rapids. With their overhanging hipped roofs, latticed windows, and abstract facades—a simple, dark hori-zontal band of windows wrapped around each building—these houses looked like designs straight off the pages of the *Crafts-man*. Wood continued to make an artisan's living however he could: crafting jewelry or building house models for a local realtor. When he joined the army for a brief stint near the end of World War I, he was assigned to Washington, D.C., to make camouflage. Always looking for a way to earn extra income, he made pencil sketches of his fellow soldiers in his spare time.

After the war, when Wood took a permanent job as an art teacher, his fortunes substantially improved. From 1919 to 1925 he taught in the Cedar Rapids public school system under Frances Prescott, a most sympathetic and understanding prin-cipal. Miss Prescott was a no-nonsense administrator with an eye for talent and a tolerance for unorthodoxy. She was appre-hensive of Wood at first but came to be one of his closest associ-ates and admirers. Underneath his shyness and the soldier's uniform he wore during his first year at the school, she discov-ered an idiosyncratic but natural teacher. With his winning

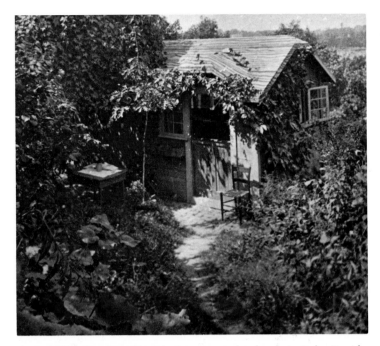

6 In 1916, when Mrs. Wood had to give up her house in Cedar Rapids, Wood built this rustic cottage as an interim home for the family. (Cedar Rapids Museum of Art Archives, Gift of John B. Turner II in memory of Happy Young Turner)

7 One of the two bungalows Wood built with his friend Paul Hanson. The artist lived with his mother and sister in this house at 3178 Grove Court, S.E., Kenwood Park, Cedar Rapids, from 1917 until 1924, when they moved to 5 Turner Alley. (Cedar Rapids Museum of Art Archives, Gift of John B. Turner II in memory of Happy Young Turner)

8 Wood in his army uniform, 1918. (Courtesy of Joan Liffring-Zug)

humor and easy-going ways, Wood had a knack for getting children to open up and create imaginative designs. He was a "Pied Piper," Prescott recalled, "teeming with ideas." Although Wood never remembered students' names and occasionally was late to class, Miss Prescott found him more valuable arriving at "half-past ten than many teachers were at seven o'clock in the morning."[23]

Wood's teaching in the 1920s demonstrated how grounded he was in progressive, turn-of-the-century, artistic thinking. He ran his classroom like an arts-and-crafts workshop, emphasizing handicrafts and natural materials. Students made "parchment" lampshades by ironing paraffin wax onto hand-decorated butcher paper, and they made tin tiles by straightening out metal cans and punching them with decorative designs. At Christmas they carved linoleum-block cards; at graduation, silhouettes of one another for the yearbook. Often they worked cooperatively on projects. Forty-five ninth-grade boys worked on "Imagination Isles," one of Wood's most ambitious classroom projects. Painting on eighteen-inch-wide paper, each boy decorated a few feet with an imaginary landscape. Destined for the school's bare-walled cafeteria, the 150-foot-long mural was premiered as a multimedia theatrical event. The frieze, wound around nail kegs, was slowly cranked across a small stage, much in the manner of early-nineteenth-century panoramas that took the viewer on journeys to exotic places. The lights were dimmed, music played, and a student read a short script, prepared by

Wood, inviting the audience to accompany the artists on a ten-minute trip into the land of dreams and imagination. "No human body can visit these islands. Only the spirit can come," the narrator told the audience, to the land of imagination where artists are "trained to dwell." Ordinary people who "deal only with material things" need the artist to lead them on spiritual tours; for they are so busy and their imaginations so withered that they have become "mental shut-ins."[24]

The idea of the artist as a seer or spiritual guide who leads the public away from the materialist, commercial world and into one of imagination and dreams is a late-nineteenth-century Symbolist idea that, by the early twentieth century, had become an established part of American modernist thought. That Wood voiced such ideas, even in a casual document, tells us that he aligned himself with some of the basic tenets of early modernist thinking and did not espouse, as would a traditionalist, the image of the artist as moral leader striving to create ideal beauty. Though Wood never experimented with twentieth-century modernism (Cubism or Expressionism), there is no doubt that he thought of himself in the 1920s as a participant in the modern movement. He did not paint nudes, as did the traditional or academic artists whose ideas still dominated the art schools in the Midwest, but everyday life. Furthermore, he "designed" his freely brushed paintings in the modern fashion, not according to the laws of perspective and academic practices. For his entire career, even when he became a regionalist, the people of Cedar Rapids thought of him as a modern painter, but not as an "ultra modern," to use a term of the time. While Picasso's or Matisse's works were far too radical for the culture-makers of Cedar Rapids, Wood's paintings were most agreeable.

9 Wood with his ninth-grade students at McKinley Junior High School making the frieze "Imagination Isles," c. 1922. (Cedar Rapids Museum of Art Archives, Gift of John B. Turner II in memory of Happy Young Turner)

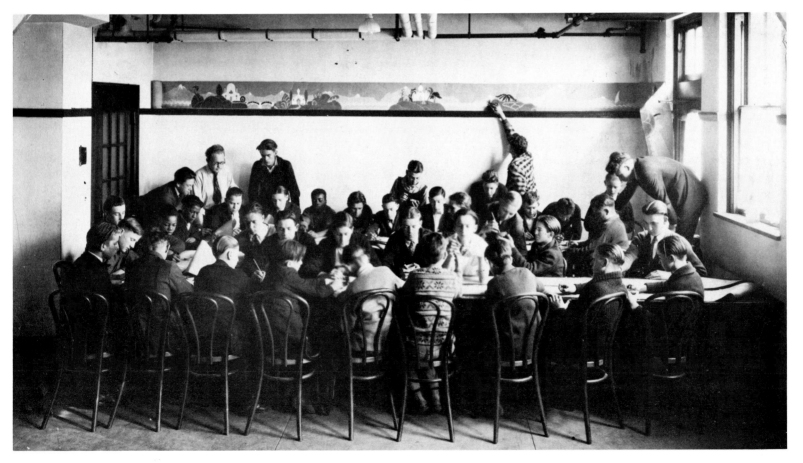

So were Grant Wood's mild eccentricities. Although Wood's life did not conform to the customary patterns of this city of 45,000, where most men worked regular hours as laborers or businessmen, he was never associated with the rebellious Greenwich Village "bohemians" talked about in the newspapers. Wood was too much the small-town boy to flaunt community values and mores, but he had many traits that people stereotypically, though approvingly, thought of as "artistic." He kept strange hours, often painting straight through the night; he was shy and slow-speaking, awkward in getting his thoughts across; and he was absent-minded and ignorant of anything to do with money. Furthermore, he seemed endlessly inventive and witty and had more ideas about making things than anyone else in the community. One Christmas (1917) he cast small, plaster-of-paris portrait reliefs of his own pudgy, smiling face, painting each one in antique gold and attaching a ribbon to the pince-nez glasses resting on the nose. At the Kenwood Park house he built for his mother and sister, he placed gigantic cement footsteps of a swamp monster as stepping stones from a creek below

the house. In his teaching years, he bought a second-hand car and outfitted it with a customized left-hand turn signal: a retractable carved and painted human hand whose index finger pointed left. It was very handy in cold weather and the townspeople loved it, particularly when, one winter day, he painted a glove on the hand. He also made junk sculpture out of odd bits of debris and spent hours getting himself ready for costume parties, a popular form of evening entertainment in the 1920s. Once he dressed up as a fish; on another occasion, round, boyish Wood appeared as Cupid, equipped with mechanical flapping wings.

When Wood looked back at this period in his life, he thought of it as "bohemian," marked for him by the three painting trips he made to Paris and the beard and mustache he grew on the first one. In the summer of 1920, Wood, then twenty-nine years old, went abroad with Marvin Cone and came home looking like a Left Bank artist. People were taken aback not only by the

11 **MOURNER'S BENCH** c. 1921–22
Oak, 37 × 49 × 16 in.
Cedar Rapids Museum of Art, Cedar Rapids Community School District Collection

Wood supervised students in making this medieval-looking mourner's bench to sit outside the high school principal's office.

10 **LILIES OF THE ALLEY** c. 1925

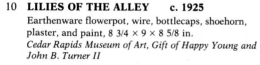

Earthenware flowerpot, wire, bottlecaps, shoehorn, plaster, and paint, 8 3/4 × 9 × 8 5/8 in.
Cedar Rapids Museum of Art, Gift of Happy Young and John B. Turner II

Wood made a number of these flowering pots from odds and ends and gave them away as gifts.

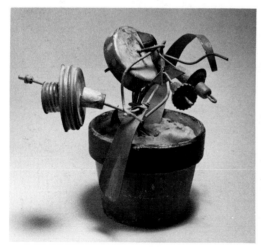

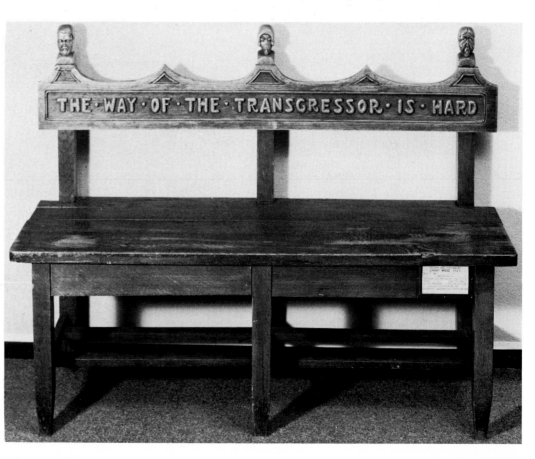

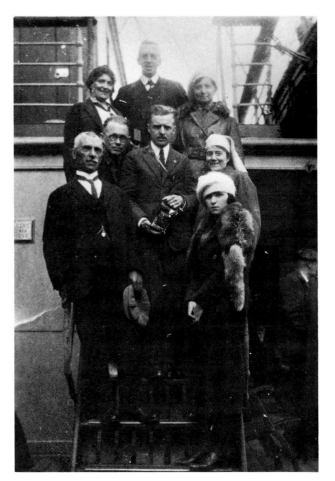

12 Wood and Marvin Cone, the second and third men from the left, sailing for France, 1920. (Davenport Art Gallery, Davenport, Iowa)

14 **THE SPOTTED MAN** **1924**
Oil on canvas, 32 × 20 in.
Davenport Art Gallery, Davenport, Iowa

13 Wood in France, 1920. (Cedar Rapids Museum of Art Archives, Gift of John B. Turner II in memory of Happy Young Turner)

beard but by its color. Wood's hair was dirty blond, but his beard had come in red and had taken a natural part down the middle. In Cedar Rapids, where no one wore a beard of any shape or color, this was seen as Wood's most rebellious gesture. From things Wood said later, he was as uncomfortable with the beard as were his fellow Iowans. Appropriate for Paris, the beard was considered an affectation in Cedar Rapids and the artist shaved it off.

In 1923–24 Wood arranged a sabbatical from teaching and borrowed money from one of his patrons to live fourteen months abroad. He attended a fall class at the Académie Julian in Paris, spent the winter months with artist friends in the warm weather of Sorrento, Italy, and then traveled through the northern provinces of France. On his final trip to Paris, in the summer of 1926, he arranged his first commercial gallery show, an exhibition of forty-seven paintings at the Galerie Carmine. To his disappointment, the show was barely noticed by the press.[25]

From Wood's perspective, he led a romantic, free-spirited artist's life abroad. He lived cheaply, made friends with other artist visitors to the capital city, idled in cafés, and went to the celebrated Four Arts Balls, which art students were famous for

crashing. Having no ear for languages, he learned little French or Italian. Nor did he take interest in what the avant-garde was doing in Paris. In letters and later in lectures and writings, he never mentioned the names of well-known modern movements or artists—Cubism, Fauvism, Picasso or Matisse, for example— or even of such artists as Monet or van Gogh, whose works his own canvases of these years recall. The paintings he made abroad were small, *plein air* landscapes which used the technical innovations of the late nineteenth century, particularly those of the Impressionists and Post-Impressionists, and which were done with a loose, sometimes thick, brush and relatively high-keyed colors. For subjects he chose sites that evoked mood and sentiment: picturesque old buildings, church doorways, cobblestone streets, fountains and squares. During this period Wood painted similar evocative scenes in Iowa: old barns, crumbling sheds, quiet ponds, river views, and on one occasion even a pair of old shoes. It is not clear exactly how many of these small canvases he did in the 1920s, but today they hang in homes all over Iowa. In 1930, when the artist became famous, one estimate had it that over four hundred of his early canvases were hanging in Iowan businesses and residences—so said a proud supporter

15 Wood's Christmas card from abroad, 1923. (Nan Wood Graham)

FROM PARIS 1924

TO ROME

G.D.W. Wishes you a V.M.C. and a H.N.Y.

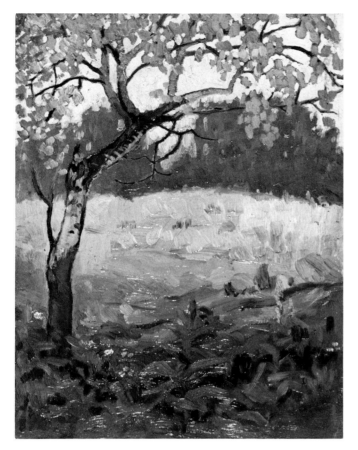

16 QUIVERING ASPEN 1917
Oil on composition board, 14 × 11 in.
Davenport Art Gallery, Davenport, Iowa

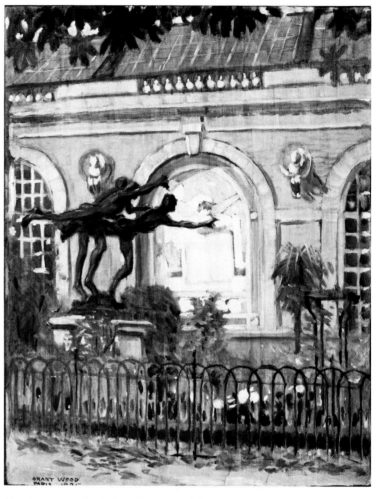

18 THE RUNNERS, LUXEMBOURG GARDENS, PARIS 1924
Oil on composition board, 15 5/8 × 12 1/2 in.
Cedar Rapids Museum of Art, Bequest of Miss Nell Cherry

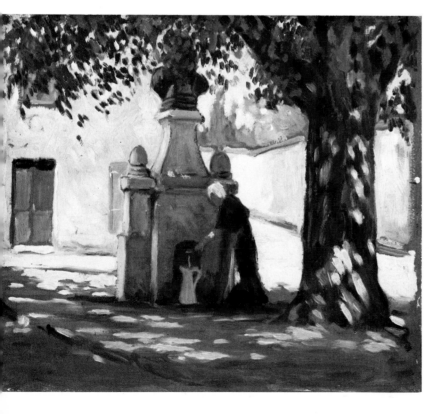

17 FOUNTAIN OF VOLTAIRE, CHATENAY 1920
Oil on composition board, 13 × 15 in.
Cedar Rapids Museum of Art, Gift of Happy Young and John B. Turner II

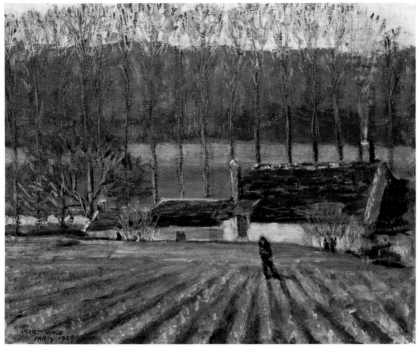

19 TRUCK GARDEN, MORET 1924
Oil on composition board, 12 3/4 × 15 3/4 in.
Davenport Art Gallery, Davenport, Iowa

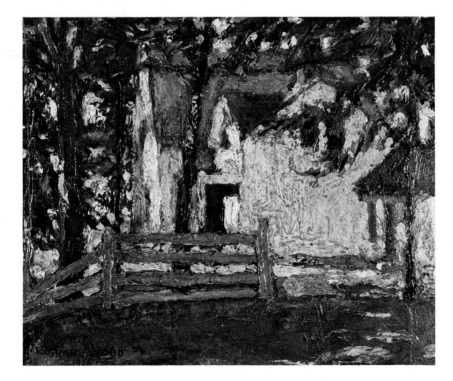

who found such patronage a tribute to the artist and even more to the community's seriousness in supporting culture and home-town talent.[26]

In the 1920s Wood did have a large number of local patrons. They came primarily from the prospering business class in Cedar Rapids, a group eager to beautify the city and improve its cultural life. Once they noticed the artist's cleverness with his hands and his serious commitment to being a painter, they not only bought his "modern" landscapes and still lifes but deter-mined to help him make a living. They offered him patronage of the most varied kinds. In 1919 Killian's Department Store fea-tured Wood's and Marvin Cone's work in an exhibition, and, in the late 1920s, Armstrong's, the other major department store in town, hired Wood to decorate the store and do window de-signs. Henry Ely, an enthusiastic Cedar Rapids booster and home developer, asked Wood to paint a mural to hang outside his office; George L. Schoonover, a Mason, commissioned an allegorical triptych of the *First Three Degrees of Free Mason-ry*; Eugene Eppley hired the artist to paint murals for the res-taurants in his hotel chain; and the J. G. Cherry dairy equip-ment plant commissioned a series of portraits showing different stages of work in the factory. Of all these patrons, David Turner, a funeral director, was the most vocal and generous. He offered Wood free housing, bought large numbers of his *plein air* paint-ings and still lifes, and acted informally as the artist's agent. John B. Reid, president of National Oats Company, bought paintings from Wood and offered him advice in working out his financial difficulties. In the late 1920s other businessmen, or their wives, commissioned portraits, a genre Wood disliked, and many sought his services in building and decorating their houses, a line of work Wood enjoyed.

As this enumeration suggests, Wood came to be the city's all-purpose artist, providing a number of services and working in a variety of styles. He was extremely versatile. He could create complex allegorical triptychs in academic styles; light and airy murals of cornfields for Eppley's hotels; Art Nouveau

20 GRANDMA WOOD'S HOUSE 1926
Oil on composition board, 8 3/8 × 10 3/8 in.
Davenport Art Gallery, Davenport, Iowa

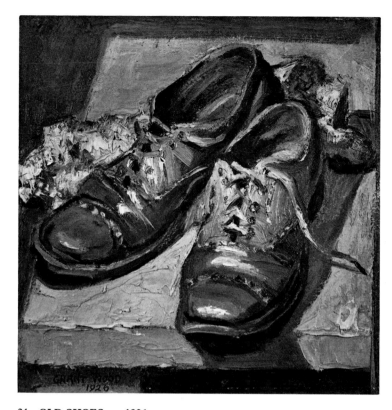

21 OLD SHOES 1926
Oil on composition board, 9 3/4 × 10 in.
Cedar Rapids Museum of Art, Gift of Happy Young and John B. Turner II

lunettes for the high school; or straightforward descriptive portraits. He was equally accommodating in his decorating. He could design and furnish neocolonial houses with the same care he bestowed on rehabilitating a late-nineteenth-century neo-Georgian home. He could paint in oils, design furnishings in metal or wood, and even work in stained glass.

Such eclecticism suggests once again that Wood had absorbed an older mind-set regarding what the artist should be able to offer his public. Like a student of the late-nineteenth-century academy, he accepted the idea that style was relative to the task at hand. For a public commission he used neoclassical allegory; for portraits he painted more literally; and for work done for his own pleasure, he used a freer and more modern style. Wood was, in other words, very much like John La Farge or John Singer Sargent, both of whom called upon a range of vocabularies at different times. His early career stands as a vivid reminder of the grip late-nineteenth-century eclecticism still had on American provincial culture in the 1920s.

Wood's close association with the businessmen of Cedar Rapids helped mold him into a regionalist. These men were proud Iowans and believed in boosting local products. Wood

22 FIRST THREE DEGREES OF FREE MASONRY 1921
Oil on canvas, center panel 25 × 41 in., side panels 25 × 18 in.
Iowa Masonic Library, Cedar Rapids, Iowa

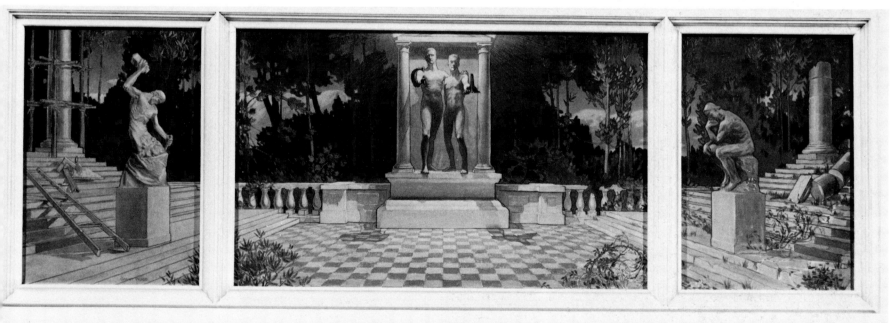

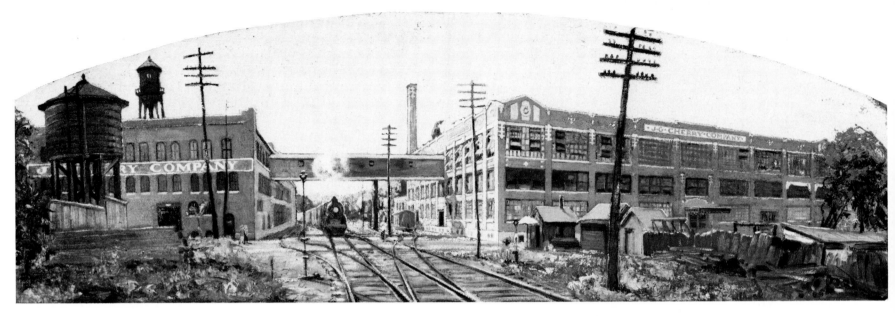

23 **THE OLD J. G. CHERRY PLANT** 1925
Oil on composition board, 13 1/4 × 40 3/4 in.
Cedar Rapids Museum of Art, Cherry-Burrell Charitable Foundation Collection

24 **THE SHOP INSPECTOR** 1925
Oil on canvas, 24 × 18 in.
Cedar Rapids Museum of Art, Cherry-Burrell Charitable Foundation Collection

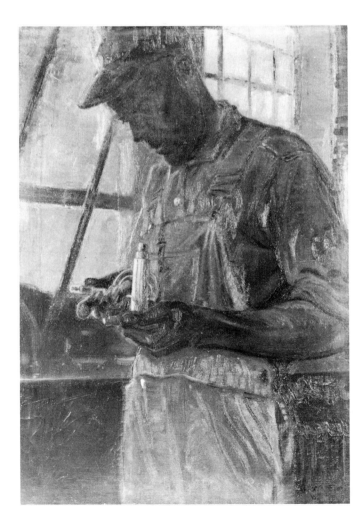

found their spirit contagious and thought their support of him a model of how small cities should develop culture at home. Many who hired Wood to work for them had deep roots in Cedar Rapids. They belonged to families who had pioneered in Iowa and who had founded the city's major industries in the late nineteenth century. Situated on the east bank of the Cedar River, Cedar Rapids had been settled in the 1840s by pioneers attracted to the potential waterpower and transportation lines offered by the rapids and the river. After damming the river in 1844, Alexander Ely established a flour mill, inaugurating an industry that eventually would make the city into one of America's most important agricultural processing centers. By the turn of the century the Sinclair family had opened a pork-packing house (now Wilson Foods Corporation); the Stuarts had begun the North Star Oatmeal Mill (Quaker Oats); J. G. Cherry had opened a dairy equipment plant; and two brothers had begun the Douglas Starch Works to make corn syrup, cornstarch, and other corn products. In 1910 National Oats, which today has its national headquarters in Cedar Rapids, came to town.[27]

25 Lunette of SUMMER c. 1922–25
Oil on canvas, 16 × 39 in.
Cedar Rapids Museum of Art, Cedar Rapids Community School District Collection

26 Lunette of AUTUMN c. 1922–25
Oil on canvas, 16 × 45 1/4 in.
Cedar Rapids Museum of Art, Cedar Rapids Community School District Collection

Summer and *Autumn* are from a set of lunettes called the *Four Seasons*, which Wood made to hang over the doorways of the McKinley Junior High School library.

Most of these businesses had been established by single families in the late nineteenth century, in what in Wood's lifetime was affectionately thought of as the "pioneer days." In the 1910s and 1920s the descendants of these early entrepreneurs still ran the family businesses. These men, second- or third-generation midwesterners, were proud of their frontier past and of the speed with which a mere two or three generations had turned raw countryside into a bustling, modern city. Their civic pride often blossomed into that postwar, small-town boosterism that Sinclair Lewis parodied so riotously in *Babbitt*. They boasted of their city's wealth, literacy, beautification programs, cultural benefits—and of Grant Wood. In 1926, for example, David Turner used the pages of the *Cedar Rapids Gazette* to promote Wood's work and urge people to buy his paintings, then on view at the public library. "In Grant Wood," Turner wrote, "Cedar Rapids has an artist whose work is bringing fame to the city and whose artistic influence is being felt in many

ways which tend to beautify the city." To buy his work would not only encourage a "Cedar Rapids artist," but also be wise economically. "Purchases of these canvases at their present modest prices are making a sound investment. As Grant Wood advances in his profession . . . these pictures will increase in value."[28]

Wood's career benefited enormously from this boosterism, and he was not above exploiting it for his own purposes. In his letter of application to the committee of war veterans responsible for awarding the commission for a large memorial stained-glass window, he carefully reminded them that he was "both a Legion and a local man." He was sure that "no outside man could put into the window the work and devotion"[29] that he would. He received the award without any other bids being sought.

After Wood became famous, he and his patrons congratulated themselves on the way they had worked together (and, indirectly, on their city's contribution to world culture). They had developed, they felt, a formula for nurturing artists, providing, as Henry Ely put it in 1931, the artist had the good sense to stay at home and work within the community. Wood "never bartered his birthright for a one-way ticket to any hot bed of culture," Ely wrote approvingly, "but had the courage, confidence and common sense to stick to his native Iowa and let the wise men of art follow the trail to his own doorway to do him homage."[30] Wood, too, lauded the small city and pleaded for art associations to pay attention to local artists, "so that they are not hindered during their beginning years by a feeling of inferiority."[31] Being an artist in a small community, he said at another time, has advantages, for it arouses local pride, and leads

hard-headed businessmen in the community in general to boost, yes, boost is the word, their local art with the same enthusiasm they would show for a local baseball team or other home enterprise or undertaking.[32]

Nine years before Ely praised Wood for having "never bartered his birthright," he commissioned the artist for a panel painting to use as an advertisement for his realtor's office. Outfitted with a canopy for protection against the weather and lights for nighttime viewing, *Adoration of the Home*, as it was called, stood at a busy downtown corner in front of the "model home" Ely had built to publicize his business and use as his office. A long and narrow panel, the painting looked like an altarpiece of a Madonna and child surrounded by saints, but its plan was completely secular: to encapsulate Ely's aggrandized vision of Cedar Rapids as "the city of homes." The enthroned figure in the center symbolized Cedar Rapids, holding one of

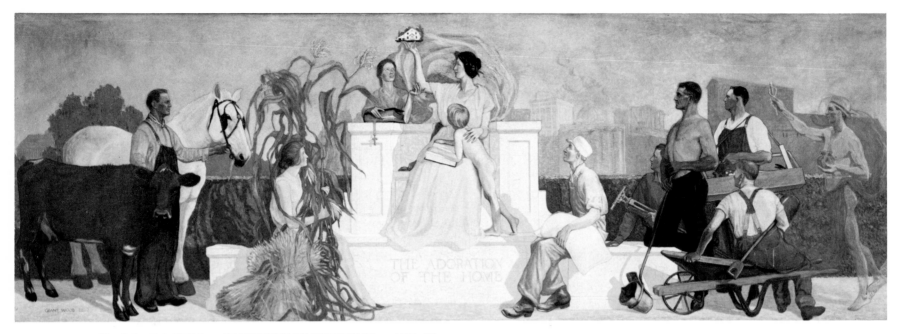

27 **CEDAR RAPIDS, or ADORATION OF THE HOME** 1921–22
Oil on canvas, 22 3/4 × 81 3/8 in.
Cedar Rapids Museum of Art, Mr. and Mrs. Peter F. Bezanson Collection

Ely's modern homes aloft as if it were the light of truth and wisdom.

The program for the mural was carefully worked out to glorify the city's resources and virtues and make the viewer proud of Cedar Rapids' modernity and growth. One of the central figure's arms is supported by the personification of Religion while the other protects and nourishes a young child representing Education. On each side of the throne are heroic figures, that of the country on one side and of the city on the other. On the left, set against the prairie "from which they and the city have risen," are Animal Husbandry and Agriculture.[33] On the right, builders, factory workers, tradesmen, and agricultural middlemen stand poised for action against the city's jagged skyline. From the far right enters the specter of Mercury, the god of commerce (a clear reminder that business is what has made progress possible), who raises his staff with one hand and cradles a bag of money with the other.

Although he never painted another work so unabashedly boosterlike in spirit, Wood's emergence as a regionalist cannot be fully appreciated without understanding the heightened feelings he and other citizens of Cedar Rapids shared regarding their city's growth and prosperity in the 1920s. Proud of their roots—the vast prairies and the persevering pioneers who

tamed them—while simultaneously promoting their city as progressive and up to date, the people of Cedar Rapids supported Wood because they wanted to build an enlightened city; his every success was interpreted as a sure sign of the city's budding cultural life.

There were, in fact, many signs of cultural development in Cedar Rapids, which gave reason to believe that the city was steadily progressing from a frontier town into a metropolitan center. Paul Engle, the well-known poet who grew up in Cedar Rapids in the 1920s and who had had Wood as an art teacher, remembers the city as "tremendously active" in the arts, much more so than other Iowan cities.[34] As early as 1905, the Cedar Rapids Art Association was formed to operate a public gallery on the second floor of the new Carnegie-funded library. The Association used the space for exhibitions and raised money through the Club of 40, a group of patrons, to buy works for a permanent collection. This gave Wood and others like him their first exposure to professional paintings and sculpture. While in high school, Wood did odd jobs around the gallery, even sleeping there when extra security was needed. A number of young artists besides Wood were active in the Art Association, the most important being Marvin Cone, with whom Wood had graduated from high school and made his first trip to Europe; George

Keeler, Wood's cousin, a fine and much-praised metalsmith who worked in Chicago but spent time with the artists in his hometown; Charles Keeler, a printmaker; Arnold Pyle, a young painter who assisted Wood in the late 1920s; and Bruce McKay, the contractor with whom Wood designed and decorated homes. Coe College, on the edge of town, was also a local cultural force. Marvin Cone taught French, and eventually art, at Coe, beginning in 1919; two years later a member of the music department began the Cedar Rapids Symphony Orchestra.

Cedar Rapids could boast not only of its community of artists but also of its budding writers, all of whom Grant Wood knew. Journalist and historian William Shirer, author of *The Rise and Fall of the Third Reich*, spent his teens and early twenties in Cedar Rapids and knew Wood well.[35] So did MacKinlay Kantor, who served in the late 1920s as a young reporter for the Cedar Rapids *Republican* and who recalled his "intimate friendship" with Wood with admiration and respect. "Wood's standards were exacting," Kantor wrote, and his sense of humor "prodigious."[36] Probably the most influential writer on Wood's career, and also on Paul Engle's, was Jay Sigmund. Sigmund worked as an insurance man in Cedar Rapids, but by interest was a poet and writer, publishing poetry and short stories about rural life in the nearby Wapsipinicon Valley.

Even from an outsider's perspective, Cedar Rapids in the 1920s seemed unusually active in the arts. When, in 1928, the administrators of the American Federation of the Arts in Washington, D.C., searched for a medium-sized community in which to place "an experimental art station" funded by the Carnegie Foundation, they chose Cedar Rapids. The city appeared receptive to the arts but "sufficiently removed from any important

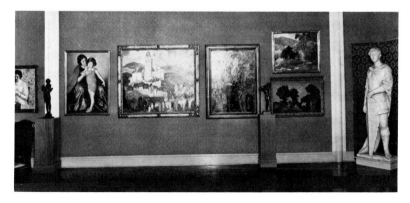

28 Exhibition of modern art in the Little Gallery, Cedar Rapids, c. 1931. (Edwin B. Rowan Papers, Archives of American Art, Smithsonian Institution)

art center which might otherwise be administering to its cultural life."[37] This assessment came from Edward Rowan, a recent graduate of Harvard's M.A. program in Fine Arts and from late 1928 until the end of 1933 the director of the Little Gallery in Cedar Rapids. The Gallery, a populist experiment in seeing how much the contemporary arts could improve the quality of everyday life, began as a tastefully modernized storefront space. In 1931 the Gallery moved into the Palmer house, donated by Mrs. Austin N. Palmer, the widow of the inventor of the Palmer method of writing, who wanted Cedar Rapids to have a proper art facility. Rowan refurbished the Victorian house, making space for classrooms for teaching art; glass cases for displaying contemporary writers' books and manuscripts; and galleries for changing exhibitions. There were rooms for art by local artists, for children's art from the public schools, for photography, for crafts, and for architecture. This latter room, called the "Better Homes Room," housed changing exhibitions of interior design, instructing viewers how to bring tasteful design into their homes using merchandise available locally at moderate prices.[38] A thoroughly professional operation, the Gallery's impact on the artistic community and on Cedar Rapids' image as a cultural center was inestimable. It was "a marvelous thing," Paul Engle recalled, for all the artists, "who could exhibit there, see paintings, read and talk."[39]

The Gallery gave Wood and other artists confidence and encouragement. Rowan urged them to exhibit their work and to send paintings to the Iowa State Fair and the annual juried exhibition held at the Art Institute of Chicago. When Marvin Cone needed money to go abroad, the Little Gallery raised $1,000 by arranging twenty advance sales of works Cone would paint while in France. Rowan's program made everyone more conscious of the breadth of the modern movement, including art, architecture, design, and even dance. On two occasions he helped bring the Denisshaw Dancers to Cedar Rapids and hosted receptions for Ruth St. Denis and Ted Shaw. Rowan's art exhibitions, like Grant Wood's style of painting, were modern, but not avant-garde. You cannot, he maintained, give people Marin and Brancusi and expect them to swoon when they've no experience.[40] So, while the Gallery's library provided books about the "ultra moderns," the exhibition program included predominantly contemporary artists with a realist bent. Rowan showed the American Impressionists, the Ash Can school, Edward Hopper, and Charles Burchfield and gave one-person exhibitions to, among others, Charles Hawthorne, Leon Kroll, Eugene Savage, and Louis Kronberg. His insistence on exhibiting art imported from the bigger art centers sometimes brought him into conflict

with Wood and other locals who felt he should pay more attention to hometown talent. But the controversy was only a question of degree, as Rowan sprinkled his program with activities featuring Iowa's artists and writers.[41] He put manuscripts by Jay Sigmund and Ruth Suckow on exhibit and showed local artists in group exhibitions. He asked artists to help decorate the Palmer house—Wood built wooden display cases and George Keeler created a beautiful wrought-iron staircase as focal point of the new space—and he lectured and wrote about their work (in his twice-weekly column for the *Cedar Rapids Gazette*). After Wood's great success with *American Gothic*, first exhibited in Chicago, Rowan wrote a sensitive and proud review of the painting in the *Gazette* and arranged a reception in the artist's honor. Over six hundred people attended.[42]

The Little Gallery gave credence to the observation that the arts were rooting themselves in the Midwest. Establishing a national reputation, however, was an uphill battle. Most American intellectuals—at least those on the two coasts—believed that cultural life in the Middle Border consisted of little more than literary clubs, overlong, patriotic speeches on Independence Day, and poetry readings in chautauqua tents. Such, of course, was the view promoted by *Main Street* (1920) and *Babbitt* (1922), Sinclair Lewis's well-publicized novels of small-town life. A similar view of midwestern provincialism appeared in the inaugural issue of the *New Yorker*, a magazine for urban sophisticates first published in 1925. Defining the new magazine's purpose, the editor broadcast his distaste for the American hinterland. The *New Yorker*, he wrote, coining a phrase that still serves prejudiced observers, was "not edited for the old lady in Dubuque." He meant that it was not going to be "of the group of publications engaged in tapping the Great Buying Power of the North American steppe region by trading mirrors and colored beads in the form of our best brands of hokum."[43]

Given such sentiments, even midwesterners who loved their area and believed in its culture could not easily escape feeling inferior to northeasterners. Once Wood became a regionalist, he would vigorously combat this inferiority complex, which, he felt, crippled local artists. In the 1920s, however, he understood that "sad and hopeless feeling" Ruth Suckow described as paralyzing Iowans "who strive to keep the lamp of culture burning."[44] An Iowan intellectual keenly interested in defining the special nature of the Midwest and one who had a profound effect on educating Wood, Suckow lamented that her fellow artists and writers "have always felt themselves in the nature of intellectual poor relations to the Eastern States."[45] They felt themselves exiles, colonists who had only an imported culture and who took no pride in their own. While Iowa is proud of its material prosperity, she recognized,

it has copied its best houses from New England and California, disregarding climatic and topographical conditions in its faith that only something from somewhere else can really be artistic. Until the last very few years it has been accepted almost without question that its young intellectuals must go away—preferably to New York, but at least away!—in order to find something "interesting" to write about.[46]

When she wrote these lines in 1926, Suckow knew whereof she spoke, for she was spending summers in Iowa and winters in New York. Like Hamlin Garland before her, she wrote of midwestern rural life while living in the East. Many of her contemporaries, however, left Iowa and unequivocally turned their backs on the home state they felt had not let them develop freely as artists. They took their success on the East Coast as proof of the impoverished spirit in the Midwest. In 1913, for example, George Cram Cook and Susan Glaspell left Davenport for New York, where they helped found the highly experimental and influential Provincetown Players, a theater group that supported young playwrights, including Eugene O'Neill. Another writer, Carl Van Vechten, couldn't "wait to get out" of his hometown and in the 1920s advised William Shirer "to get the hell out of Cedar Rapids as quickly as possible."[47] Born to wealthy parents in 1880, Van Vechten had fled Cedar Rapids in 1899 for the University of Chicago, continuing on to Paris and eventually New York, to become a critic, novelist, and member of avant-garde circles.

Van Vechten's novel, *The Tattooed Countess* (1924), serves as an excellent example of the way a disenchanted Iowa artist felt about his home town in the 1920s. The book revolves around a widowed countess—a real-life Cedar Rapids woman whom many could identify—who has lived in Europe for her entire adult life. She has just ended an affair with a young Frenchman, and in an attempt to cheer herself up visits Maple Valley, the author's pseudonym for Cedar Rapids, where she was born and spent her childhood. Within hours of arrival, she decides that the town is stifling, filled with narrow little minds for whom proprieties and conformity are matters of first importance; she can't even smoke or wear her Parisian fashions without being talked about. The novel is built around confrontation and contrast, and the world of sophistication, free love, and haute couture collides head-on with the world of moral righteousness and bland conformity in Maple Valley. The fifty-year-old countess makes the most of her visit, however, by flaunting small-town ways and falling in love with the brightest and most promising

high school boy in town, whom, at the end of the novel, she takes to Europe to initiate into her worldly ways.[48]

After 1929, when Wood became a regionalist, he drew much from this stereotype of the Midwest as culturally barren, peopled by boosters, Rotarians, Shriners, and gossipy old ladies. He based some of his best regionalist paintings and prints on what people thought was wrong with the Midwest, but he treated the farmer, small-town banker, and ladies'-club member with affection and humor, not with the disgust or disdain typical of artists like Van Vechten. Instead of using clichés to indict his culture, he let them describe the *specialness* of the Midwest. But before he reached such an accommodation with the intellectuals' view of Iowa, he spent a decade or so totally under its influence. He did not flee Cedar Rapids outright, as had Van Vechten, but he did try to combat the routineness of small-city life by initiating cultural activities. He had just enough of the booster in him to believe that it was possible to create something of a Left Bank or Greenwich Village ambiance in Eastern Iowa. Clubs were common in provincial America and Wood found ways to join with local thespians, poets, journalists, artists, and art patrons to generate meaningful alternatives to the activities of the Shriners or Masons. He was the mainstay of the Garlic Club, for instance, a group of journalists and arts people who met regularly to lunch at a particular restaurant for lively conversation and exchange. They named themselves after Wood's French method of making a salad, rubbing the bowl first with a clove of garlic. Wood was also a major force behind the community theater group, making scenery for their performances and finding spaces for them to rehearse and put on plays.

Wood's grandest scheme, however, never came to fruition. Along with David Turner, the savvy and energetic mortician who became Wood's major patron, the artist tried to establish a Latin Quarter in Cedar Rapids. The idea had its origins in the early 1920s, when Turner moved his funeral home to a new downtown location, a late-nineteenth-century mansion. He hired Wood to decorate the building and shortly thereafter offered him the rent-free use of the brick stables behind the house. Ten years older than the artist and a successful businessman, Turner had known Wood since childhood, when their families had lived in the same neighborhood. He had watched Wood's progress as an artist and believed him unusually talented. He figured Wood, who had never had a studio to work in, could handily convert the spacious hayloft on the second floor into a workplace. The artist accepted the offer, redid the interior, and liked working there so much that he decided to make the space into a studio-

29 The Turner mortuary and 5 Turner Alley as they appear today.

apartment and move into town from his home in Kenwood Park, on the outskirts of Cedar Rapids. For the next eleven years, from 1924 until 1935, he lived behind Turner's mortuary with his mother and sometimes his sister.

Wood's ingenious adaptation of 5 Turner Alley, his invented address, enhanced his visibility and his artistic reputation in Cedar Rapids. For he created a design miracle out of a space that had no character to begin with and that was much too small by most standards to accommodate two adults and to work as a studio, let alone convert into a theater, which in fact it did. Using students as assistants, Wood did most of the work himself, making the apartment an open, multifunctional space, not that different from the studios and living quarters artists today carve out of industrial or commercial spaces. Unlike the white walls and geometric spaces of today's lofts, however, Wood's space, with sloping roofs and dormer windows, was cozy and intimate and looked much like the interior of a turn-of-the-century Arts and Crafts bungalow. The walls were covered with an oatmeal-colored plaster, the niches and shelves were recessed to create simple, flat walls, and many of the furnishings—window benches and cabinets—were built in. His large easel always stood majestically in one corner.

Visitors marveled at Wood's inventiveness and economical use of space. Many pieces of furniture were designed to retreat or disappear when not in use, as if the apartment were a yacht or Pullman sleeper. The dining table folded up behind cabinet doors and the beds slid away under cupboards. The long-necked telephone had its own niche; the body of an old clock, its works removed, held the electric meter. The artist lowered the bathtub

into the floor so there would be enough room to stand and shower in the low-ceilinged bathroom; for a fireplace hood he adapted a metal coal scuttle to fit into the chimney. He made cupboard doors look antique by upholstering them in old blue jeans stiffened with plaster and painted to look like well-worn leather; a pocket in the jeans held Wood's liquor utensils. Because the building could not support the weight of the tile floor Wood wanted, he scored the existing wooden floors into squares, which his students painted in different colors to look like tiles. (For this work he designed a special saw, inspired by his mother's half-moon cabbage chopper.) He fashioned wrought-iron lanterns for lighting fixtures, and his mother hand-braided a rag rug for the center of the space. At one end of the room he hung heavy drapes, tied back with tassels, which could be pulled across the room to create a shallow stage where the community theater group could perform. Even the front door of 5 Turner Alley was a conversation piece: it held a glass panel painted like a clock with a hand that Wood could set to whatever hour he would return or to parts of the face that stated he was "In," "Out of Town," "Having a Party," or "Taking a Bath" (see fig. 2).

30 and 31 No. 5 Turner Alley. (Cedar Rapids Museum of Art Archives, Gift of John B. Turner II in memory of Happy Young Turner)

Wood's new residence was such a success—and so clearly an artist's space—that it inspired Wood and Turner to try to establish an artists' colony, "a Greenwich Village of the Cornbelt." Their plan called for a number of studios like Wood's to be created out of the barns along the two-block-long Turner Alley. In 1926 they formed a Fine Arts Studio Group of local artists, musicians, and patrons and announced their hope of creating "the only true Bohemian atmosphere west of Hoboken."[49] Because the other buildings were dilapidated and too costly to renovate, the colony never materialized. As a consequence of these discussions, however, Turner turned his former mortuary, the three-story Mansfield house, into a building for the arts called "Studio House." Wood did the decorating and found qualified tenants to live and work there: a painter took the top floor; a journalist and a musician worked in rooms on the first and second; an art teacher had a studio large enough for classes on the second; and a gift shop, The Hobby House, operated on the ground level. The "most unique art colony in Iowa" lasted only a few years in the late 1920s and then died during the Depression.[50] In its last years, it housed the community theater and a tearoom, with Wood's paintings on the walls, run by the women who owned the gift shop. Though Wood would later reject the notion of a Latin Quarter in Iowa as simply one more instance of Iowa's borrowing culture from elsewhere, the unrealized Turner Alley project and Studio House reveal a side of Wood that is rarely appreciated. Though not at all an entrepreneur—he was basically a dreamer—Wood was a catalyst for artistic activity. With the help of Dave Turner, he became a quiet but forceful promoter of cultural life in Cedar Rapids. In retrospect we see that this was the same kind of organizing he would do on a much grander scale in the 1930s when he established a midwestern art colony at Stone City and became a nationally known advocate for local and regional arts.

In 1925 Turner convinced Wood to stop teaching and make his living from his painting and from free-lance decorating. Turner offered to act as a kind of agent. He tried to stimulate sales by hanging Wood's paintings on the walls of his mortuary and by persuading other morticians to buy Wood's work; he even convinced the slow-speaking artist to address mortician conventions on the subject of furnishing funeral parlors.[51] Turner also helped Wood get jobs around town—designing the new offices, letterhead, and chinaware for the Chamber of Commerce, for instance. During the late spring of 1928 he arranged work for Wood in Estes Park, Colorado, where the Turner family vacationed. Eventually Turner built up the largest collection of

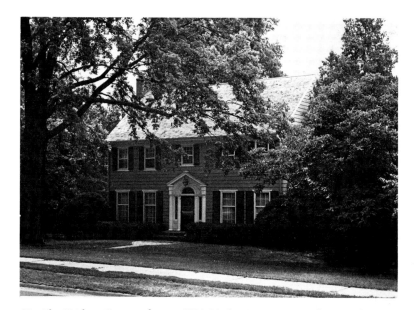

32 The Herbert Stamats house, 2131 Linden Drive S.E., Cedar Rapids, as it appears today. Built by Wood and Bruce McKay, 1929–30. (Mr. and Mrs. A. James Tinker)

the artist's work from this period, which today hangs in the Cedar Rapids Museum of Art.

In the late 1920s, Wood's revenue increasingly came from decorating, which he often pursued in an informal partnership with Bruce McKay, a builder, general contractor, and good friend. Having worked as a craftsman, built a home for his family, and designed his own studio apartment, Wood had earned a reputation in town as a superior home decorator. He was considered meticulous about details and ingenious at solving complicated problems. Everyone involved in a project, from patron to workmen, enjoyed associating with him. He and McKay built neocolonial homes for David and Hilda Turner and for the family of Mr. and Mrs. Herbert Stamats, the major publishers in town; for Hazel Brown, one of the proprietors of the gift shop in Studio House, they built a shake-shingled chalet; and for Robert and Esther Armstrong, owners of a major department store, an "indigenous" home based on late-nineteenth-century Iowan architecture. Wood also took on jobs redecorating older homes, helping with additions, or solving problems people ran into when their own decorating schemes had failed. Many of his decorations can still be seen in Cedar Rapids homes.

As might be expected, Wood did not embrace the most

33 PORTRAIT OF SALLY STAMATS 1927
Oil on composition board, 13 1/4 × 15 1/2 in.
Private Collection

This portrait, done for the Stamatses when he designed their house, was
the first commissioned portrait Wood painted and led to many other
such requests. Although he professed not to like making portraits,
he completed about a dozen others in his lifetime.

progressive building styles of the day, such as the prairie-school
designs of Louis Sullivan and Frank Lloyd Wright, which were
represented by a few homes and several prominent structures in
town, most notably the People's Savings Bank and Saint Paul's
Methodist Episcopal Church. Wood was a historicist, drawn to
revival architecture and decorating, just as he was drawn to
styles from the past in his paintings. In a neocolonial home he
hand-painted flowers on the glass doors of the den to recall
early-American stencil work and hung a hand-tooled, "coloni-
al" lantern in the entry hall.[52] In the Van Vechten Shaffer home,
which featured Elizabethan windows and heavy, wooden, neo-
medieval furniture, he evoked the flavor of a Renaissance villa
by exposing the beams, plastering the dining-room walls with

34 Wood painted these doors for the library of the
Van Vechten Shaffer home in Cedar Rapids, c. 1930.
(Private collection)

unpainted stucco, and painting extremely detailed neoclassical decorations on the wooden doors to the study.

While his business as a decorator flourished, Wood's career as a painter was at a standstill. In his spare time he continued to paint still lifes and landscapes, experimenting in the late 1920s with a freer and more paint-loaded brush than he had ever used before; on occasion he worked with a palette knife, smearing and dabbing thick paint on the canvas. These paintings sold locally at moderate prices but attracted no notice outside Cedar Rapids. There were no offers of gallery shows besides those at the Little Gallery and no invitations to participate in museum exhibitions. With good reason Wood wondered whether his paintings were significant and why he painted the way he did. He worried when Rowan praised his work for its craftsmanship but said nothing about "the art of it."[53]

By 1930 Wood had become a completely different kind of painter; he had invented a brand-new hard-edged realist style and taken to painting historic midwestern subjects. Almost overnight, it seemed, he transformed himself into a regionalist, a painter dedicated to working with local themes in a style which drew heavily from pieces of Americana, from Currier and Ives prints, frontier photographs, and American folk painting. This transition, however, from one style to another, was not nearly as abrupt as historians have characterized it—or as it may appear in a book like this, where the reader goes from impressionist landscapes to *American Gothic* with a quick turn of the page. Wood never moved quickly. His transformation from an all-purpose painter to a dedicated regionalist was a slow, meandering process spread over a period of three or four years. It began with a series of historic Iowa murals he made in 1927; was accelerated by a trip in the fall of 1928 to Munich, where he studied the work of the Northern Renaissance masters; and ended with his painting of *American Gothic* in 1930. Only with the success of *American Gothic* did he gain the confidence to drop all other styles—allegory, Impressionism, and Art Nouveau—and be a full-time regionalist. In a few years' time he had become one of the country's most widely acclaimed painters of the "American Scene."

Wood always credited the Flemish and German old masters for having inspired his new style. In telling his own story he treated his discovery of these works as a pivotal moment in his life, as though it had been like a religious conversion. Wood goes to Germany, comes under the spell of the Flemish painters, and then returns home and paints regionalist paintings—so, at least, goes the legend. But this picture overlooks other major influences in Wood's life in the late 1920s, particularly those writers whom the artist praised for having "created a different attitude toward things midwestern."[54] It was these writers, such as Sinclair Lewis, Jay Sigmund, and Ruth Suckow, who inspired Wood to paint the same regional themes they wrote about. It was they who raised Wood's consciousness as a midwesterner and stirred up the artist's desire for a new style, which the Flemish painters then helped him devise.

Probably the most important intellectual influence on Wood in the late 1920s was Jay Sigmund. Six years older than the painter, Sigmund was a self-made man of letters and a remarkable member of the Cedar Rapids artistic community. He had never gone to college or abroad and made his living as an insurance salesman. But in his spare time he read Verlaine, Rimbaud, Baudelaire, and Whitman; kept up with contemporary fiction; and wrote his own verse and short stories about Iowa's natural beauties, about rural farmers, villagers, and small-town ways. Having sprung from the late-nineteenth-century writers of local color, Sigmund was adept in his use of dialects, in his descriptions of the land, and in evoking the eccentric and gnarled personalities bred by rural living. He was fascinated by the insular patterns of country life.

35 Jay Sigmund and Edward Rowen visiting in "Sodtown," Iowa, with the Price brothers and Fred Bruce, the kind of rural people Sigmund knew well and wrote about in his poetry. One of the Price brothers was a bone player and Bruce was a blacksmith in Waubeek. (Mr. and Mrs. James Sigmund)

A few years before Wood took on his new style, Sigmund lauded the artist's small, impressionist paintings of the Iowan countryside because they portrayed the unsung beauty of the barns and pasturelands. He wrote a poem about Wood, characterizing him as "a new son dreaming on the plain."[55] We know from Paul Engle, still a poet in the making during this period, how encouraging such remarks were to Wood and other local artists. Sigmund led both of them to take pride in making art from local subject matter. He chided Wood for painting laundry on clotheslines in France, rather than in Iowa. Sigmund insisted that where one was born and where one lived were more important than places one had visited.[56] To prove his point, he took friends with him as he tramped along the Wapsipinicon River, the territory where he had grown up, introducing them to its history and pointing out the indigenous features of the old stone houses. He also invited them to his house in Waubeek, a tiny town on the Wapsie where farmers still lived by nineteenth-century customs and ways. Wood found Sigmund's enthusiasm for Iowa's history contagious. Before his trip to Munich, Wood spent parts of two summers in Waubeek, in 1927 and 1928, making paintings of midwestern scenes—corn shocks and, in one instance, quilts on a clothesline.

Sigmund was Wood's first close contact with a regionalist, someone who firmly believed artists should create art from local and indigenous materials. But Wood also knew other Iowan regionalists, if not personally, then through their writing. These authors, active in the late 1910s and 1920s, were following in the footsteps of Hamlin Garland and mining the Midwest for literary subjects. One of Garland's young successors was Ruth Suckow, whose short stories and novels about rural Iowa, like Sigmund's writings, had a profound effect on Wood's decision to become a regionalist. Suckow's work gained a national audience in the late 1920s and 1930s, when her essays and short stories were published by H. L. Mencken in *Smart Set* and *American Mercury* and when her novel, *The Folks* (1934), became a Literary Guild selection. Suckow wrote clearly and thoughtfully about the problem of regionalism and articulated in terms Wood found attractive the reasons artists should stop fleeing their roots and the "folk" they grew up with. Suckow perceived "a kind of intellectual and aesthetic civil war" going on between those who fled provincial culture—by, for example, adopting "the French manner of painting" and clapping "it down upon a sprawling American subject"—and those who were taking "their own place as artists, as intellectuals, among the folks—the place which they themselves have almost forfeited."[57] Suckow's sympathies clearly lay with the latter group, represented by those

who wrote for the *Midland*, an important mouthpiece for Iowan literature. With most of its material focused on rural and small-town life, the *Midland* (1915–33) offered a lively and highly respected alternative to those little magazines in the East that were supporting experimental literature or dealing with urban themes. Both Sigmund and Suckow published in it regularly.[58]

Wood's first important exploration of specifically Iowan subject matter was in murals commissioned by Eugene Eppley for his hotels in Sioux City, Waterloo, Cedar Rapids, and Council Bluffs. In 1926 and 1927, Wood decorated the restaurants of these hotels—the "Corn Rooms," they were called—with a midwestern landscape theme he would repeat in his regionalist style in later years: a panorama of harvested cornfields stretching deep into space, dotted with corn shocks and an occasional barn, windmill, and farmhouse. The paintings were done in Wood's loose, brushy style, in light blond colors on eight-foot-high canvases affixed to the walls.

The murals created for the conference room in the Council Bluffs hotel, the Hotel Chieftain, are even more interesting in pointing toward Wood's 1930s regionalist work, for they reflect two of the most prominent characteristics of Wood's mature work: they are historical in theme and based on mid-nineteenth-century American sources. Created with Edgar Britten, a painter friend who lived in Studio House, these murals represent scenes from the early Mormon settlement of Kanesville, later called Council Bluffs. One mural depicted the entrance to Kanesville, a landscape scene of covered wagons passing over a rough trail toward a settlement in the distance; the second mural showed the settlement as it would appear to a new arrival: a few streets lined by log and frame buildings, the tents of Indian encampments pitched on the outskirts of town. Wood took the first mural entirely from an Englishman's mid-nineteenth-century engraving of early Kanesville; the second from a very primitive 1849 townscape of Kanesville painted by George Simons.[59] In taking a theme from local history, borrowing heavily from early American artifacts, and, in the townscape, using a bird's-eye view of a panoramic landscape done in a self-consciously primitive style, Wood had invented all the ingredients for a major work like *Stone City*, painted three years later.

He had also begun to make figure paintings that look forward in type to *American Gothic*. In 1928, before the Munich trip, he painted a portrait of David Turner's eighty-four-year-old father in which there is already some of the hardness and detail that would dominate his regionalist work. He called the painting *John B. Turner, Pioneer* and posed his model in front of

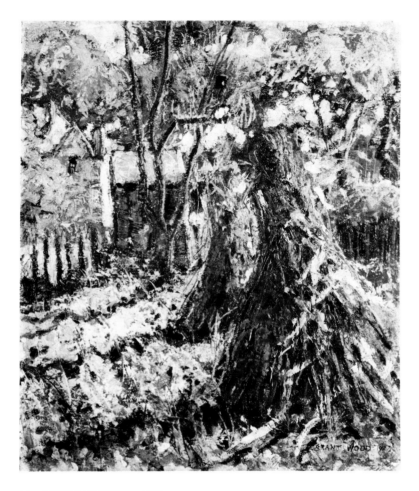

36 CORNSHOCKS 1928
Oil on composition board, 15 × 13 in.
Eugenie Mayer Bolz

Wood's paintings of corn shocks and harvest scenes in 1927 and
1928 are his first depictions of a subject that would become one of his
trademarks in the 1930s.

**37 CORN ROOM MURAL (detail), HOTEL MONTROSE, CEDAR RAPIDS
1926**
Oil on canvas, 80 × 183 1/2 in.
*Cedar Rapids Museum of Art, Gift of John B. Turner II in memory of Happy Young
Turner*

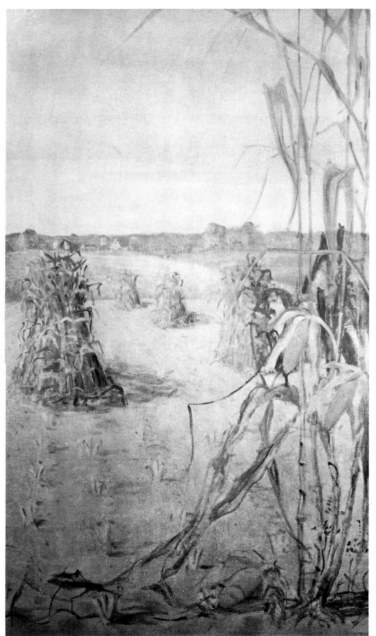

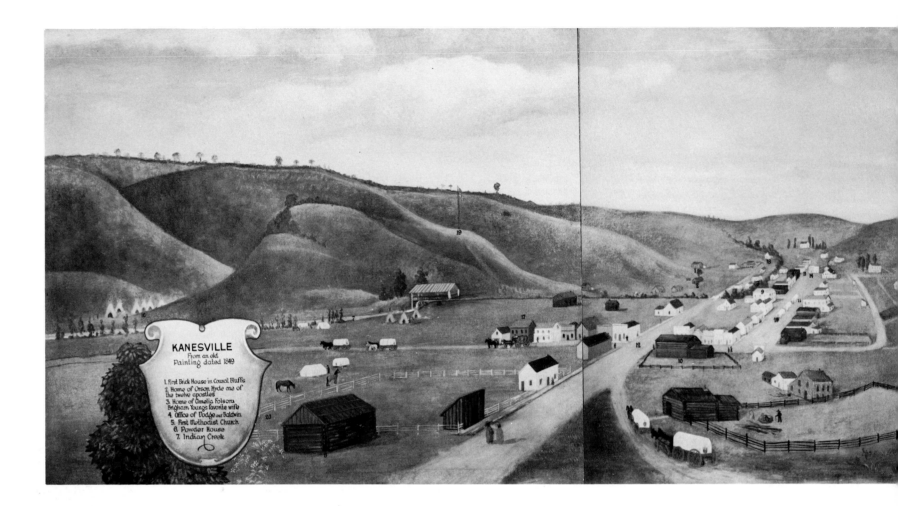

KANESVILLE

From an old
Painting dated 1849

1. First Brick House in Council Bluffs
2. Home of Orson Hyde one of
the twelve apostles
3. Home of Amelia Folsom
Brigham Youngs favorite wife
4. Office of Dodge and Baldwin
5. First Methodist Church
6. Powder House
7. Indian Creek

an 1869 map symbolizing the old man's roots in early Iowa. The map is of Linn County, where John Turner had settled in the 1880s and lived out his life. Through the map, Wood clearly wanted to convey the man's pioneer past, and in his stern face, something of the resolute pioneer character.

Before Wood studied the Flemish masters, then, he had begun to paint midwestern subjects—cornfields, historic Iowa, the pioneer—and had shown an appreciation for old American maps, engravings, and primitive paintings. He had started on a new direction. With his usual versatility, however, he was working on several tracks at once, one of them in the art of stained glass. In January of 1927, Wood had received the prestigious commission to create a memorial window to honor American war dead. Twenty-four feet high, the window was to be made for

the entry hall of a new building that housed not only the veterans' headquarters, but also the town government and city auditorium. The Cedar Rapids Veterans Memorial Building, as it was called, was the tallest and most prominent edifice in town. Wood designed the window in Cedar Rapids and supervised the making of the stained glass in Munich, where he spent three months in late 1928.[60]

It was on this trip that Wood looked at the paintings of Memling, Holbein, and Dürer in Munich's Alte Pinakothek. He studied Memling in particular, he said, because he was impressed "by the lovely apparel and accessories of the Gothic period" and by the fact that the paintings often showed local people in contemporary dress.[61] He liked the crystalline realism of the Flemish artist; it reminded him of the way he himself had

38 KANESVILLE MURAL, HOTEL CHIEFTAIN, COUNCIL BLUFFS, IOWA 1927
Oil on canvas, 6 × 24 ft.
Dr. and Mrs. Milton D. Heifetz

worked as a child, before his teachers insisted that his work be soft and evocative. He also felt that the Flemish artists were "decorative painters" who organized their canvases by repeating shapes and patterns. He resolved to attempt a neo-Flemish painting. Ever the revivalist, Wood did not hesitate to borrow from the Renaissance as he had in the past from academic art, Art Nouveau, and Impressionism.

But he did not do so instantaneously, as the legend might have us believe. He moved slowly, mulling over what he had seen. In the meantime he worked on the academic composition of the stained-glass window and painted his customary canvases of picturesque winding streets and old buildings to bring back with him to Cedar Rapids.

39 Wood and the German craftsmen who made the Memorial Window in Munich, fall 1928. (Nan Wood Graham)

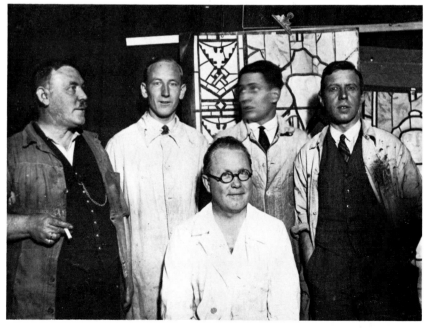

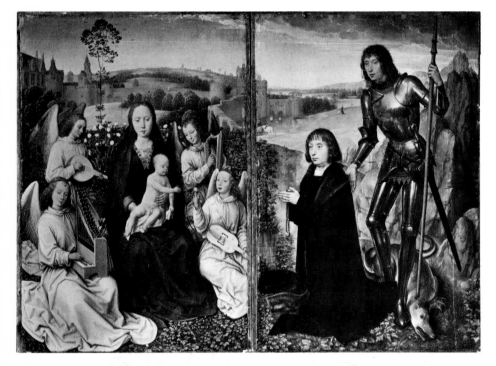

40 Hans Memling (c. 1433–94), *Virgin and Child with Musician Angels and St. George and Donor* (diptych), Alte Pinakothek, Munich.

41 Christian Schad, *Baroness Vera Wassilko*, 1926, private collection. Some art historians have insisted Wood saw and was influenced by Neue Sachlichkeit, or New Objectivity paintings, when he was in Munich. But it was not Wood's habit to study contemporary art. If he did chance upon examples of Neue Sachlichkeit painting like Christian Schad's, he may well have been heartened by their heightened realism, but he would have had no sympathy with their disgust, cynicism, and social criticism of the Weimar Republic.

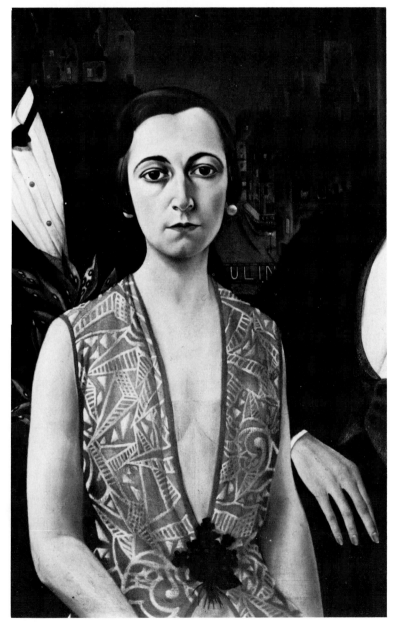

42 JUDGE M. D. PORTER 1929
Oil on canvas, 23 1/2 × 19 1/2 in.
Helen M. Porter

mentator put it, "rather like a 'Mona Lisa' against an Iowa landscape."[62]

Woman with Plants was a compelling image and aroused more interest than any single painting Wood had created in the past. It was the first work of his to be accepted by the jury for the annual exhibition of American painting and sculpture at the Art Institute of Chicago. When exhibited thereafter in Cedar Rapids, Wood's friends greeted the painting warmly because it was

43 PORTRAIT OF FRANCES FISKE MARSHALL 1929
Oil on canvas, 40 3/8 × 30 in.
Cedar Rapids Museum of Art, Gift of Frances Marshall Lash, Patricia Marshall Sheehy, Barbara Marshall Hoffman, and Jeanne Marshall Byers

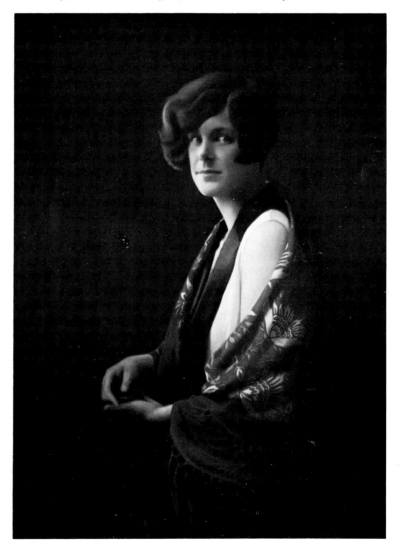

When shortly after his return Wood exhibited his Munich paintings and a few portraits at the Little Gallery, few would have predicted his imminent change in style. Only a work like *John B. Turner, Pioneer*, where he used a tighter brush than he had before, foreshadowed his future direction. During the year he continued his decorating commissions, painted two or three straight society portraits, and composed a few canvases in his impressionist style. Eventually he got around to trying a neo-Flemish painting—in *Woman with Plants*, for which he used his mother as his model and posed her against a distinctively midwestern landscape. He painted the picture with glazes on composition board, in imitation of the old masters' techniques. He stiffened her outlines, gave her face descriptive detail, and made her costume into simple decorative patterns, all lessons he had absorbed from the Flemish painters. She looked, as one com-

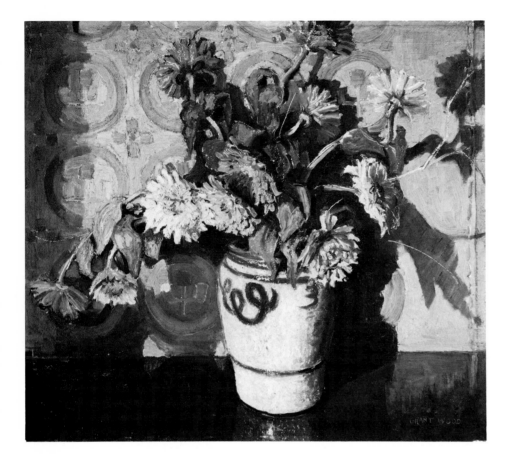

44 CALENDULAS c. 1928–29
Oil on composition board, 17 1/2 × 20 1/4 in.
Private Collection

45 WOMAN WITH PLANTS 1929
Oil on upsom board, 20 1/2 × 17 7/8 in.
Cedar Rapids Museum of Art, Cedar Rapids Art Association Purchase

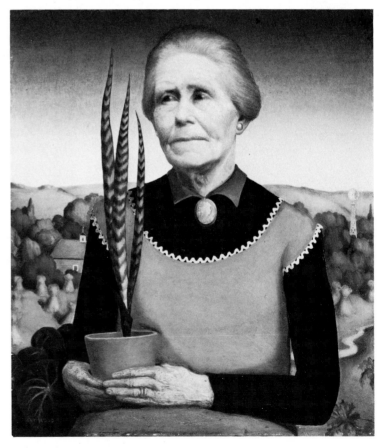

so obviously about the Midwest. Wood's painting is "unique," claimed the *Cedar Rapids Gazette*, "in that it has a landscape background with typical Iowa scenery including corn stalks and a red barn." Ed Rowan, more specific in his praise, put public pressure on Wood to do more works in this new vein. Wood was, he said in his newspaper column, now "doing with pigment what Jay Sigmund is doing with words." He then gently prodded Wood to put aside the paintings he had brought back from Munich and to recognize that "here in Iowa—not in Europe," lay the artist's life work. "Let him reflect on canvas the scenes we know and love—fleeting glimpses of a rural beauty that is passing with the year," and let him paint local people, "each sitter patterned, as it were, against that phase of life in Iowa which has gone into the making of that sitter's individual history."[63]

Read today, these words sound like a prescription for *American Gothic*, painted the year after *Woman with Plants* and accepted for exhibition at the 1930 juried annual in Chicago. It was the fourth painting in the artist's new style, following upon *Woman with Plants*, *Arnold Comes of Age*, and *Stone City*. To the artist's astonishment, *American Gothic* was an overnight success. The couple with a pitchfork appeared in rotogravure sections of newspapers throughout the United States and elicited major critical comment. For the first time Wood enjoyed a success far beyond the confines of Cedar Rapids. He felt completely confirmed in his direction and his new style. He now regretted the years he had "spent searching for tumble-down houses that looked 'Europy,'" rather than seeing the artistic possibilities of "cardboardy frame houses on Iowa farms" and the obvious patterns "in the rickrack braid on the aprons of the farmers' wives, in calico patterns and in lace curtains."[64] He now dismissed his impressionist paintings as "wrist work," done spontaneously without mental thought or careful planning, and reveled in the fact that he was developing an indigenous American style that borrowed features from Sears and Roebuck catalogues, Currier and Ives prints, handmade quilts, frontier photographs, and old-fashioned country atlases. He had "really found himself," the artist told his friend and supporter, Ed Rowan, in the early 1930s.[65]

By the most circuitous route, Wood had become a regionalist, encouraged every step of the way by a responsive local community. With the help of his businessman patrons, he had been able to set up an artist's studio and make his living working with his hands and in the arts. With Jay Sigmund as his mentor he had overcome his inferiority complex about being in the Midwest and working with regional themes. And in the company of supportive friends and associates—Sigmund, Edward Rowan, Bruce McKay, and Marvin Cone—he had become convinced that the arts could thrive in the Midwest. He now set out to prove the case.

46

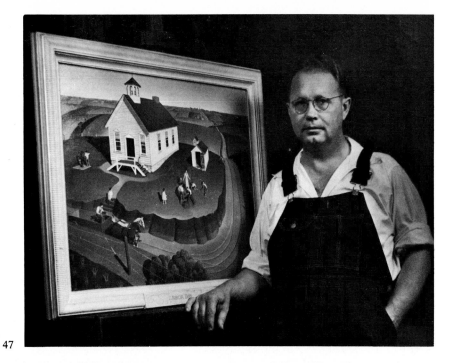

47

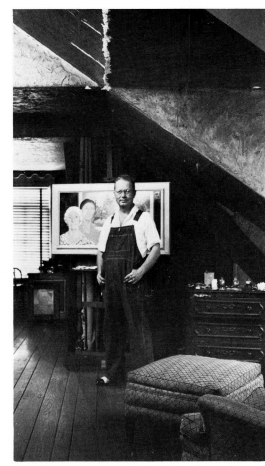

48

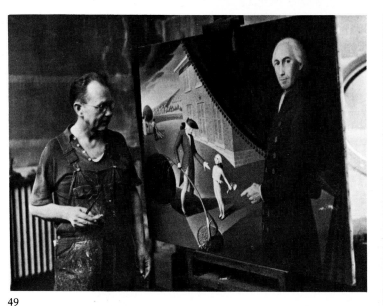

49

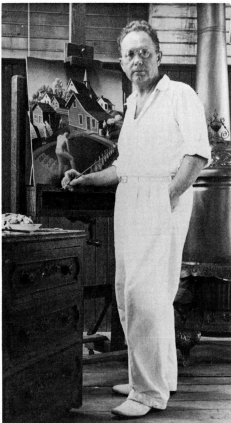

50

46–50 Grant Wood in front of *Midnight Ride of Paul Revere* (1931), *Arbor Day* (1932), *Daughters of Revolution* (1932), *Parson Weems' Fable* (1939), and *Spring in Town* (1940). (46–48: Cedar Rapids Museum of Art Archives, Gift of John B. Turner II in memory of Happy Young Turner; 49: Nan Wood Graham; 50: Edwin B. Green Collection, Davenport Art Gallery, Davenport, Iowa)

III. THE REGIONALIST 1930–1942

In December 1934, *Time* magazine hailed Wood as a major figure in a new school of American realist painting. On the cover was a Thomas Hart Benton self-portrait and inside, a feature article opening with a photograph of Wood and John Steuart Curry, both in farmer's overalls. Castigating the "spurious" American followers of Matisse and Picasso who had "cheerfully joined the crazy parade of Cubism, Futurism, Dadaism, Surrealism," the magazine praised the emerging resistance to such "outlandish art." This opposition was led by a few artists in the Midwest who offered "direct representation in place of introspective abstractions." Of the painters discussed—Benton, Wood, Curry, Charles Burchfield, Reginald Marsh, Ivan Le Lorraine Albright, and Charles Sheeler—the article singled out Wood as "the chief philosopher and greatest teacher of representational U.S. art." Having established a midwestern art colony and become an influential teacher, Wood was a "fervid believer in developing 'regional art.'"[66]

In the four years since painting *American Gothic*, Wood had emerged as the acknowledged leader of regional painting. The hometown artist had become a national figure. He now received invitations to be on art juries and to contribute paintings to major exhibitions of contemporary art. In 1932, his *Daughters of Revolution* was in the first biennial exhibition at the Whitney museum in New York; two years later, he sent *Dinner for Threshers* to the Carnegie International at Pittsburgh, where it was voted the third most popular painting. By the time he made a whirlwind visit to New York City, in the fall of 1934, his reputation had preceded him. Christopher Morley, one of the editors of the *Saturday Review of Literature*, gave him a private luncheon; Ring Lardner's sister gave a dinner in his honor; and museum officials, writers, and journalists were invited to meet him at an afternoon tea. It was at this latter event that Wood met the painter Thomas Hart Benton and the New York critic Thomas Craven, who became his most vocal supporter in the art press.[67]

Wood's fame was based on his multiple accomplishments in the early 1930s. Driven by the success of *American Gothic*, and by the regret he felt for having wasted so many years on insignificant paintings, Wood developed as a regionalist on all fronts. In his studio he painted one work after another about farm life, small-town folk, and the local countryside, drawing upon childhood memories and a wide range of Americana. When he took on an occasional portrait commission—as, for example, the portraits of Mrs. Donald MacMurray and of Melvin Blumberg in

51 Grant Wood with John Steuart Curry at Stone City, summer 1933. (Courtesy of John W. Barry)

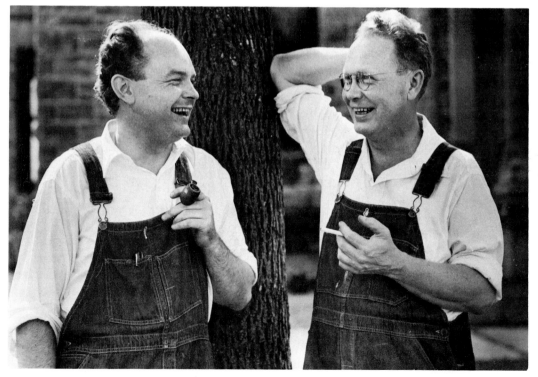

52 PLAID SWEATER 1931
Oil on composition board, 30 × 25 in.
Melvin R. Blumberg, Clinton, Iowa

53 PORTRAIT OF MRS. DONALD MacMURRAY 1932
Oil on composition board, 20 1/4 × 23 5/8 in.
William C. Sexton

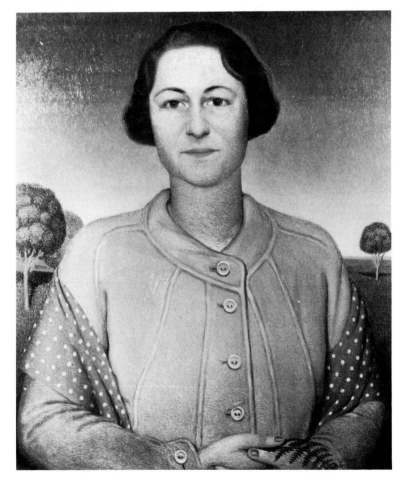

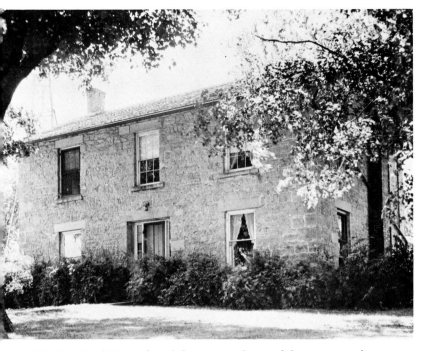

54 Wood and McKay based the exterior design of the Armstrong house on the Eugene Doe house in Waubeek, built in 1860.

Plaid Sweater—he did not revert to his academic portrait style but painted it in his new hand. In his decorating assignments, which he still did for extra income, he expressed his pleasure in local materials by painting murals of farm life and by designing a home based on nineteenth-century vernacular architecture. In his teaching of aspiring artists he worked out a kind of regionalist pedagogy, developed first at the Stone City Art Colony in the summers of 1932 and 1933 and then through his courses at the University of Iowa. For the general public he relayed his regionalist theories through lectures and interviews with members of the press.

Of all the famous midwestern regionalists, Wood was the most committed and thorough. Virtually everything he did investigated some aspect of indigenous experience, which is why *Time* magazine characterized him, and not others, as the "chief philosopher" of the regional movement. In 1932, when Wood designed a new home for Robert and Esther Armstrong, he shunned the neocolonial, East Coast–based style he had used earlier and turned instead to local examples of mid-nineteenth-century Iowan buildings. Along with Bruce McKay and Esther Armstrong, Wood studied and measured old stone houses in Waubeek and Anamosa, structures which Jay Sigmund had first helped him appreciate. He took the design of a fireplace, the

55 Robert C. Armstrong house, 370 34th Street S.E., Cedar Rapids, built by Wood and Bruce McKay, 1932–33.

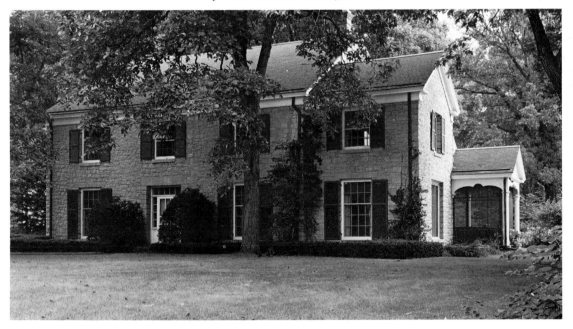

board-and-batten walls, moldings, and cornices from one house; the windowpanes, thick walls, and shutters from another; and the design for the veranda from yet another. Arrangements were made to build the house of tan limestone quarried at Stone City, the very site that had provided stone for the original mid-nineteenth-century structures. When the house was completed, Wood helped Mrs. Armstrong furnish it with local antiques, many of them from the nearby Amana colonies. The Amana people, whose villages had been founded in the nineteenth century as religious communal societies, had always been good

56 Front entrance way, Robert C. Armstrong house.

57 Interior, Perkins' Tavern near Anamosa, 1855, provided the inspiration for the paneling, baseboards, woodwork, doors, hardware, and fireplace in the Armstrong house. (Courtesy of Mrs. Robert C. Armstrong)

craftsmen with a strong sense of tradition. After 1932, when they voted to adopt a free-enterprise system and modernize, some were willing to sell their antique furnishings.[68]

The Armstrong home, the most original and distinctive house Wood ever designed, demonstrated his new commitment to local and regional history. But his most zealous efforts to revive local architecture—and, at the same time, to give birth to a midwestern regional school of art—were directed toward Stone City, a beautifully situated village that had become, for all practical purposes, a ghost town. Located in the steeply banked valley of the Wapsipinicon River, not far from Anamosa and Waubeek, Stone City had thrived in the late nineteenth century because of the limestone quarried from its hills. Its prosperity, however, was short-lived, as the introduction of portland cement halted the demand for limestone. By the early part of this century, the town, with its picturesque stone buildings, was virtually abandoned.

58 Ten ice wagons brought to Stone City for the art colony stretched along the horizon from "Adrian's Tomb" to the Green mansion. These were quickly decorated and made into gypsy homes for teachers and students. (Courtesy of John W. Barry)

In the summer of 1932, Wood, Ed Rowan, and Adrian Dornbush, an art instructor at the Little Gallery, took over some of the abandoned buildings in Stone City and established a summer art school and colony. The experiment was a bold one. The buildings were not in good condition; the Depression was at its height; they had no financial backing; and of the three founders, only Rowan had any business or administrative experience. But they had enthusiasm and dedication to make up for their handicaps. Given Wood's success, they were convinced the time was right to establish an art colony in the Middle West. They wanted for their region what the East already had in Woodstock, New York, and the Southwest had in Taos, New Mexico. The Depression, they reasoned, would work in their favor because artists who could not go abroad or to art centers in the East might manage to travel regionally. Cedar Rapids artists Marvin Cone, Arnold Pyle, and David McCosh volunteered to teach alongside Wood, Rowan, and Dornbush. No one received a salary, and Coe College agreed to accredit the courses. Brochures announcing the venture were sent throughout the middle states while Wood, Rowan, and Dornbush made personal appearances at art clubs in Iowa to recruit students.[69]

The colony lasted two summers, 1932 and 1933, and was remarkably successful in its appeal to young artists and in its *esprit de corps*. Students came from all over the Midwest and stayed from one week to the entire term (six weeks the first year,

eight the second). They all pitched in to convert a large stone mansion into their new school. Built in 1883 by J. A. Green, one of the former quarry owners, the mansion—with its high ceilings, carved marble fireplaces, and painted ceilings—provided dormitory space, dining and living rooms, and, in the basement, a frame shop. The icehouse became an exhibition gallery and the wine cellar became a rathskeller (called "The Sickle and Sheaf"). Some of the art colony lived in the dorms, but others had more colorful accommodations. Adrian Dornbush made his room out of a nearby water tower (dubbed "Adrian's Tomb"), while Wood bunked down in one of ten ice wagons parked along the edge of the property. Donated by an ice company, the horse-drawn wagons were obsolete as delivery vehicles but perfect as gypsy residences for members of the colony. Wood decorated his wagon with a mock nineteenth-century landscape, in which a stag stood on one rocky bluff and an Indian stood on another and looked out over a mountain range. Reminiscent of paintings by the Hudson River school, the design was inspired, Paul Engle recalls, by one of the painted ceilings or overmantels in the Green mansion.[70]

The summer colony at Stone City was Wood's most explicitly regionalist venture and fulfilled a dream he had harbored since trying to establish a Latin Quarter in Turner Alley. Then he had wanted to form a community of kindred spirits; now he had a more specific agenda. He expected the Stone City colony to foster self-confidence in young midwestern artists and to show them, by example, that it was possible to make art out of

59 Ice wagons at the Stone City colony. (Davenport Art Gallery, Davenport, Iowa)

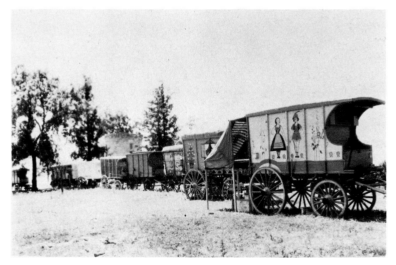

60 Wood painted his ice wagon with an old-fashioned and deliberately primitive mountain scene. The interior of his wagon, however, was completely modern, all surfaces painted in a shiny silver aluminum paint. (Davenport Art Gallery, Davenport, Iowa)

the "barrenness" of the Midwest. He wanted them to have the stimulus and role models he had never had: a community of working artists and courses designed to encourage them to stay and study in the region in which they were reared. Any artist was welcome, he said. He didn't want them to paint "an endless succession of red barns, silos, and corn shocks," but to grapple with "a subtle quality that extends over a large but quite homogeneous area, and that manifests itself in a thousand elusive but significant ways." Regionalism for Wood was a matter of commitment to locale, not of style; painters could be as "conservative, as eclectic or as radical" as they chose.[71]

Such was the thrust of the Stone City colony brochure; but other assumptions underlay its curriculum and the day-to-day activities of the school. First, the program discouraged any kind of abstract art or subjective, imaginary painting. Artists were expected to paint what they could see—rural landscapes and country figures. Students took painting trips to small villages and farms, or set up their easels in the countryside. At school, they worked from the model, sometimes local girls who posed in the nude (sprayed with insect repellent to keep away the flies!) or other village characters that Sigmund brought from Waubeek. Furthermore, there was a conscious attempt to instill interest and pride in folk and grass-roots culture. The rathskeller was decorated in mock German-peasant motifs, like those used by the Pennsylvania Dutch or the Amana colonies. Some artists wore lederhosen as their painting costume; others followed Wood's habit and wore farmer's overalls. In the evenings, the colony gathered to hear Jay Sigmund read his poetry, or musicians playing the dulcimer, fiddle, or accordian, or recitals of Negro spirituals.

At the height of the Depression, when few people had money to travel, the colony provided stimulus and excitement for the

61 Edward Rowan at home in his "chalet" ice wagon. (Davenport Art Gallery, Davenport, Iowa)

62 The students at Stone City created an Old World ambiance in "The Sickle and Sheaf," the art colony's rathskeller. (Courtesy of John W. Barry)

local community, not simply for the artists. It was educational, entertaining, and a noble attempt, like so many populist experiments in the 1930s, to bring the arts to grass-roots America. Every Sunday the students and faculty put on a public exhibition of the previous week's work, all affordably priced. People came from all over the state to pay a dime admission for the opportunity to mingle with artists, view their art, marvel at the customized ice wagons, and enjoy chicken dinners, community sings, and band concerts. At any given time during the summer there were forty to fifty artists in attendance, but on Sundays, visitors numbered in the hundreds.

The Stone City experiment focused national attention on the visual arts in Iowa, which, it seemed to some observers, were burgeoning under Wood's leadership. Despite his legendary shyness, Wood was increasingly called upon to explain what was happening in the Midwest and to talk about his plans and goals. Newspaper reporters asked for interviews and lecture committees invited him to speak. No intellectual, Wood had nevertheless picked up enough from his discussions with Sigmund and Rowan, and from his reading of Ruth Suckow and the *Midland*, to be able to promote a loose and rather crude theory and history of regional painting.

Wood's earliest explanation of his new art, presented to midwestern lecture audiences in 1931 and 1932 after the suc-

63 The faculty at Stone City Colony and Art School, summer 1932 or 1933. Wood, who taught advanced painting, is in the center; Adrian Dornbush, another painter, is to Wood's immediate right; Arnold Pyle, teacher of frame making and painting, to his lower right; Marvin Cone, who taught figure drawing, sits in front of Wood; and Edward Rowan, who gave lectures on art, stands behind the stone ornament. Florence Sprague, the instructor of sculpture, stands at the right. (Courtesy of John W. Barry)

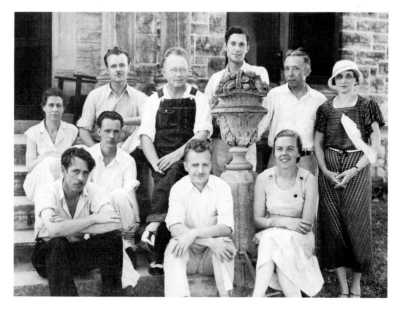

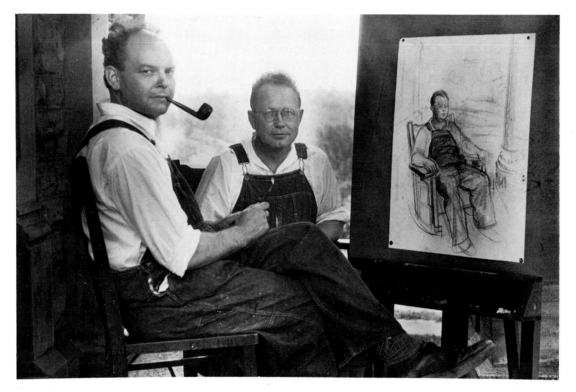

64 Wood and John Steuart Curry in Stone City, summer 1933. Curry drew
the portrait of Wood on the easel. (Courtesy of John W. Barry)

cess of *American Gothic*, was a highly simplified history of the
twentieth century that encapsulated his own life story. The first
wave of modern art, he explained, had been the Mission style
(another term for the Arts and Crafts movement), which cleared
away the exaggerations and sentimentality of Victorian art and
introduced a new simplicity. It failed, however, to create a
lasting American movement in art. Then came European mod-
ernism, which gave the artist "a new force, a new drive and a
lot of valuable tools."[72] Modernism taught artists to abstract
their forms and to stress the decorative over the literal, but,
Wood complained, Americans imitated the French modern
styles and never created one of their own. Now, in the 1930s,
Wood believed painters in the Midwest were creating a new,
truly American school of painting, following in the footsteps of
those regional writers who had led the way. The new school of
painters took on American themes, generally narrative ones,
and appealed to wide audiences because they used familiar
subjects presented in more literal terms than did modernists.

Aware that the return to narration and subject matter was
suspect in avant-garde circles as simply a new form of illustra-
tion, Wood believed regionalist painters could escape that de-
rogatory judgment if they imposed modern decorative qualities
and abstract design upon their subjects. In that way artists
could avoid creating what he called "merely tinted photo-
graphs" and make significant American art.[73]

After the Stone City experience, Wood began to promote
Regionalism on a nationwide scale. He became convinced that
the art colony held the secret of fostering art-making in the
American provinces. City artists, Wood observed, had a natural
community in their large numbers and proximity to one anoth-
er. Regional artists, however, had to come together in art cen-
ters such as Stone City to bolster each other's confidence and
provide a sense of common mission. By the mid-1930s Wood
was so excited by his concept of the "regional art center" that he
proposed that the federal government should establish a num-
ber of them, perhaps in universities, in various sections of the

country. He envisioned a situation like that in medieval times, when "Gothic architecture grew out of competition between different French towns as to which could build the largest and finest cathedrals." From rivalry between numerous local art colonies or centers, Wood believed, "a rich American culture will grow."[74] To implement his idea, Wood worked on both Curry and Benton, two other midwestern painters of provincial America, to come back home and provide role models for the younger generation. At that time Curry, who had begun his career in Kansas, lived in Westport, Connecticut, and Benton, a Missouri-born artist, lived in New York. Determined to get these two men back to the Midwest, Wood was instrumental in securing Curry a teaching post at the University of Wisconsin in Madison (1936) and put pressure on Benton "to come out here and live where you belong."[75] In 1935 Benton moved back to Missouri to take a major mural commission and a teaching job at the Kansas City Art Institute. The three men, who had only a passing acquaintance with one another, now were close enough to visit and become friends. Each ensconced in a major midwestern state, the three became known to the American public as the "triumvirate" of Regionalism.

Wood's vision extended far beyond the Midwest and included regional art centers fostering cultural activities throughout the country. Wood was not a "booster," as he put it, for any single locale or region.[76] Although his home base was in the Midwest, and he generally used his own territory to illustrate how Regionalism worked, he envisioned Regionalism as a *national* movement, with each region supporting its own artists. Wood's regionalism was less a revolt against urban centers and industrialization, as it has recently been argued, than it was a revolt against homogenization and the blurring of regional differences that these forces were bringing in their wake.[77] Wood was not against cities but "against the tendency of artists to ignore or deny the fact that there are important differences, psychologically and otherwise, between the various regions of America." To Wood:

Each section has a personality of its own, in physiography, industry, psychology. Thinking painters and writers who have passed their formative years in these regions, will, by care-taking analysis, work out and interpret in their productions these varying personalities.[78]

In early 1934, Wood took his dream of the regional art center from Stone City to Iowa City. The move meant the end of the summer colony but the beginning of something much more ambitious, an academic program at the University of Iowa (then called the State University of Iowa). Wood's association with the university began through the Public Works of Art Project (PWAP), the first of the New Deal's federally funded art efforts. This short-lived program (January–June 1934) provided relief to artists by hiring them to paint murals for public buildings. Cedar Rapids provided two key people to the PWAP, individuals experienced in bringing art to the people and working with the community. Ed Rowan left the Little Gallery to become an assistant director of the PWAP in Washington, D.C., and Wood became state director of the program in Iowa. The university, hearing of Wood's appointment and anxious to have some association with the state's famous artist, arranged for Wood to create PWAP murals at the campus in Iowa City, an easy train commute from Cedar Rapids. Wood was put on a modest salary, and his students received academic credit for their work from the university and relief checks from Washington, D.C. When the PWAP ended in June 1934, the university appointed Wood for a three-year term as an associate professor in the art department to finish a mural program then under way for the library at Iowa State College in Ames and to create new murals for buildings on campus.[79]

The arrangement was ideal for both parties. For Wood, the university offered a prestigious opportunity to continue what he had begun at Stone City. He envisioned the university becoming a model for regionalist art programs, a place where students worked with teachers on communal projects and became fully prepared for professional life. His teaching projects were collective enterprises (like "Imagination Isles" had been a decade earlier), with students working under his supervision on murals dealing with themes from history and everyday life. But because such courses were only for advanced students, Wood devised another course to get his ideas across to a broader audience. Always the populist, Wood set up an "art clinic" on Saturdays, open to anyone who sought professional advice and academic credit. He arranged the clinic so students could work wherever they lived for three weeks and then meet in a medical amphitheater on campus one Saturday a month to receive criticism of their work. The clinic was enormously popular, attracting in one term over two hundred students.[80]

For the university administrators, hiring Wood represented the first long-term appointment of a "liberal" to the art faculty and a first step in the modernization of the school's very traditional studio curriculum.[81] The Department of Fine Arts in the early 1930s was still dominated by Charles A. Cummings, the man who had established the department in 1909. Trained in the French academic tradition, Cummings taught the methods of the Ecole des Beaux-Arts and had successfully resisted any

pressures to change his pedagogy. Although he had left Iowa City in 1927, a number of his students remained on the faculty and carried on his philosophy and influence.[82] Wood's appointment, therefore, brought new ideas and considerable controversy to the department. It added to the university's growing reputation in the mid-1930s as being a lively training ground for the arts and an up-and-coming institution. It was during this period that the university pioneered programs granting academic credit and advanced degrees in studio work and creative writing. During Wood's early years on the faculty, the university initiated the B.F.A. and M.F.A. degrees and began the famous Iowa Writers Workshop. In 1939, when *Life* magazine covered the "flowering" of the arts in Iowa, it favorably compared the "learn by doing" programs at Iowa with the "old line" programs at Yale, dominated by history and theory, where most "students never paint at all."[83]

Wood not only offered a new and fresh pedagogy; he also complemented the work being done in the English department, which had a strong regionalist bent. Throughout the 1920s the regionalist little magazine, the *Midland*, had been based at the university and edited by John Frederick, a member of the English faculty who, in 1925, took on the young Frank Luther Mott as his coeditor. In 1930 Frederick took the magazine to Chicago but Mott, who had written *Literature of Pioneer Life in Iowa* (1923) and was working on his Pulitzer Prize–winning *History of American Magazines*, continued teaching at the university and was there when Wood arrived. With their common interest in Iowa's history, the two men quickly became friends—setting a pattern for Wood, whose best friends in Iowa City were writers, not artists. Writers like Mott and Paul Engle, who joined the faculty in 1937, were an adventuresome and forward-thinking group on campus and had a keen appreciation for their new colleague's paintings. They invited him immediately to join the Times Club, a private club of three hundred members whose sole purpose was to invite creative thinkers to come and talk with them. The club attracted such speakers as Robert Frost, Carl Sandburg, Henry Wallace, and Lincoln Steffens. Mott did most of the inviting and enlisted Wood's help in getting Christopher Morley to campus. It was during Morley's visit—when Mott and Wood could not find a suitable place to entertain him—that the "Society for the Prevention of Cruelty to Speakers" was born. The S.P.C.S. took over a floor above a restaurant across the street from the university to use as a club room for entertaining speakers before and after lectures. Not surprisingly, Wood offered to do the decorating. With his typical humor and delight in reviving styles of Iowa's past, he transformed the

65–66 Two views of the clubroom of the Society for the Prevention of Cruelty to Speakers, which Wood decorated in Victorian revival. (Figs. 65–74 courtesy of the Office of the State Historical Society, Iowa State Historical Department)

nondescript space into a combination Victorian parlor and dining room. Though Wood once characterized the S.P.C.S. room's decor as "the worst style of the Victorian period," it was, in fact, a lovingly and carefully executed piece of work. The room was adorned with floral wallpaper and carpet, black walnut furniture upholstered in plush red velvet, a parlor organ, and a

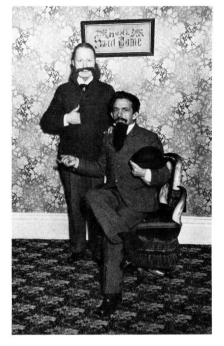

67 Grant Wood and
 Thomas Hart Benton

68 John T. Frederick

69 Frank Luther Mott

70 Dorothy Pownall

71 John Erskine

72 Thomas A. Craven

73 Sterling North

74 Gilbert Seldes

marble fireplace. On the walls Wood hung vintage photographs, chromolithographs, and Currier and Ives prints. An old red-velvet-covered album was made ready to display photographs—not vintage pictures but neo-Victorian snapshots of members of the S.P.C.S. and of visiting speakers.

An after-lecture party for Thomas Hart Benton inaugurated the room in January 1935. Wearing a false beard and mustache, Benton posed with Wood for a photograph and then played the harmonica for the assembled club members. The S.P.C.S. was a grand success until the university asked the group to close down because it was not open to the general public and offered too much competition to other lecture programs on campus. The photo album is witness to the fact that, while it lasted, the club enlivened Iowa City culture considerably, attracting Steven Vincent Benét, Sterling North, MacKinlay Kantor, and Nicholas Longworth Roosevelt, among others. W. C. Handy came to give a blues concert and Langston Hughes to read poetry. Though she never actually came, even Gertrude Stein agreed to speak to the club. While she was in America for a lecture tour, she was persuaded in December 1934 to come to Iowa by complex negotiations between her and Mott. Helpful in her decision was a photograph sent her which showed some S.P.C.S. members sitting around a dinner table wearing white roses and calling themselves the "Rose is a Rose Club." On the night of her scheduled appearance, however, there was a heavy winter storm. At the last minute a telegram arrived at the packed lecture hall saying that Stein's plane had been grounded in Waukesha, Wisconsin, and that she would have to break the engagement.[84]

Grant Wood's first few semesters at the university were the easiest. He felt welcome and people were interested in his ideas, so much so that colleagues asked him on several occasions to write for their publications. The most important of these writings was the essay he wrote and published with Mott. "Revolt Against the City"[85] brought together ideas Wood had been developing in lectures and interviews since *American Gothic*. Until recently, he reported, Europe and New York had dominated American art, but now artists had broken free from their colonial dependency on Paris and New York and explored native materials. The Great Depression, he felt, had been good for American art because it fostered self-reliance, weakened the power of the big cities, and decentralized art-making. Quoting a poem from Jay Sigmund, he explained how artists in his region had discovered that the farm belt was not "a drab country inhabited by peasants, but a various, rich land abounding in painting material." At the end of his essay, he outlined his vision that artists would discover the artistic potential of every province of the country. "The hope of a native American art lives in the development of regional art centers and the competition between them."[86]

"Revolt from the City" exuded confidence about the regionalist movement and congratulated midwestern painters and writers on their achievements. Even artists in the East who once thought of the Midwest as "uninteresting," Wood said, now were "eager for news and information about the rich funds of creative material which this region holds."[87] There was no clue, in the essay, that some critics and artists were beginning to oppose Wood's grand vision. Beginning in 1935, the year the essay was published, Wood experienced the first serious criticism of his ideas and his art, criticism that would steadily increase in the following years and slowly gnaw away at his self-confidence. At the time of his first New York one-person exhibition—at the Ferargil Galleries in 1935—intellectuals found his reputation overrated and criticized his too-sweet charm and decorative mannerisms.[88] In the same year, twenty-one of the students working under him on mural projects funded by the government signed a petition criticizing his leadership and sent it to Washington, D.C. They didn't like Wood's collective enterprises, where artists worked together on murals of Wood's designs; they wanted the freedom to work on their own, independently conceived projects.[89] Wood was very hurt and resigned from his government post immediately. Even in the student newspaper, the *Daily Iowan*, Wood came under attack. Articles questioned whether Wood was really the "liberal" artist he was cracked up to be. His recent election to the National Academy of Design struck one writer as signaling the artist's decline as a dissenter. The fact that Wood now spent a great deal of time lecturing and writing seemed to another observer to reveal an equally unfortunate change. "From an individualist, fighting a 'colonial' attitude in art, he has become a respectable university professor." The article warned Wood not to forget "that an actor who doesn't act, an author who doesn't write, and an artist who doesn't paint do not long remain great."[90]

The student reporter was correct in his concern. Wood was less productive in the late 1930s than he had been in the years immediately following *American Gothic*. He completed small projects—drawings for prints and book illustrations—but produced very few easel paintings; in 1937 and 1938, the artist did no paintings at all. In short, the late 1930s were troubled years for the artist. For the first time in his life, Wood, so loved and supported in Cedar Rapids, and then at Stone City, began to engender animosities in both his public and private life. Not

75　Studio photograph of the artist's mother,
　　Hattie Weaver Wood. (Nan Wood Graham)

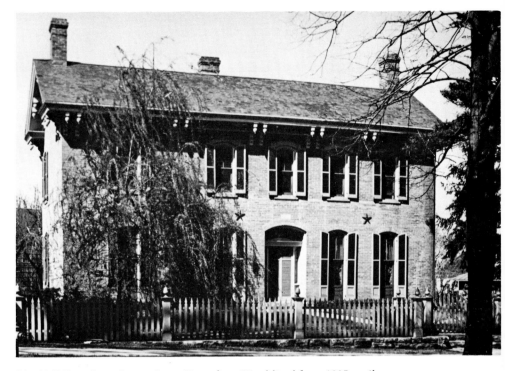

76　1142 East Court Street, Iowa City, where Wood lived from 1935 until
　　his death in 1942. (Cedar Rapids Museum of Art Archives, Gift of
　　John B. Turner II in memory of Happy Young Turner)

77　Living room of Wood's Iowa City home. (Cedar Rapids Museum of Art
　　Archives, Gift of John B. Turner II in memory of Happy Young Turner)

only were there the first signs of opposition to Wood's art and his concept of Regionalism, but there were troubles at home which destroyed his peace of mind.

Most of these stemmed from his late and unhappy marriage, a match which took everyone by surprise and alienated him from friends in Cedar Rapids. Marriage had always seemed out of the question for Wood. He had been very happy to live with his mother, for whom he had an intense affection, and he was devoted to his sister Nan, who by the 1930s lived in the West with her husband, Edward Graham. Although the Cedar Rapids press occasionally deemed him one of Cedar Rapids' most eligible bachelors, Wood never took time for romance. Then, out of the blue, he fell in love with Sara Maxon, a Cedar Rapids woman with a sketchy career as an actress and light opera singer. At the time they met, sometime in late 1934, Sara was a choral leader and gave voice lessons in Cedar Rapids. She was glamorous and gregarious—tall, silver-haired, a flashy dresser, and theatrical in manner and speech. She impressed Wood with her kindness to his mother, who had suffered a heart attack and needed nursing. Furthermore, as a fellow artist, Wood felt she understood his ways. Despite warnings from David Turner and other Cedar Rapids friends who viewed the two as badly mismatched, Wood and Sara decided to marry in a private ceremony at her son's home in Minneapolis. Wood was forty-four and she forty-nine, a grandmother by her son of a previous marriage. A

few months after their March 1935 marriage, the Woods left 5 Turner Alley, where Wood had lived for eleven years, to settle in Iowa City. His mother went with them but died a few weeks later. It can hardly be coincidence that Wood, who always needed the care and emotional support of one or two close companions, married the very year his mother's health failed.

Wood's short married life—about three years—was emotionally tumultuous and far more lavish and extravagant than his years at Turner Alley. He and his wife lived far beyond his university salary. They moved to 1142 East Court Street in Iowa City, into an 1858 brick home that had fallen into disrepair. Motivated by his newly developed interest in Victorian Iowa, Wood studied old photographs of the house and meticulously restored it, furnishing the public rooms with antiques he had collected or which had come down in his family. He had, by this time, collections of ironstone china, amber and flint glass, and majolica. When he couldn't find exactly what he wanted, he would create pieces that harmonized with what he had. Like contemporary architects working in modern styles, Wood wanted a completely designed and coherent environment. He made a coffee table out of a large, oval Victorian frame to echo the form of his *Portrait of Nan*, which hung over the fireplace. He also designed an overstuffed chair which, when pushed up to its matching ottoman, became a chaise lounge. It was streamlined, without cushions, and functional, but with its flowered fabric and long fringe completely in harmony

78 The Grant Wood lounge chair. (Photo courtesy Edwin B. Green Collection, Davenport Art Gallery, Davenport, Iowa)

with Victorian furnishings. Calling it the "Grant Wood Lounge Chair," a Cedar Rapids company marketed the invention without much success.

In his new house Wood was surrounded by people. First his mother and then Sara's son, daughter-in-law, and grandchild lived in a second-floor apartment, and the household help lived in. He entertained far more stylishly than he ever had in Cedar Rapids, and there seemed to be a constant stream of guests at the house, including visiting writers and artists who came to lecture on campus. Wood had made a twenty-foot-long dining-room table that easily seated fifteen to twenty guests. On one football homecoming weekend at the university, for example, Wood had sixteen houseguests, chartering a bus to take them to and from the stadium and setting up cots for the men to sleep in the barn.

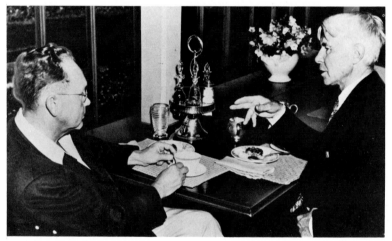

79 Wood entertaining Carl Sandburg at home in Iowa City. (Courtesy of Joan Liffring-Zug)

Not only Wood's new domestic and social life, but also his fame made it impossible for him to concentrate on major new paintings. He was besieged with invitations to lecture, to loan works, and to jury exhibitions. Flattered by the attention, he had a hard time sorting out the worthwhile occasion from the less important one. By 1935 he had signed a contract with a major publishing firm for his autobiography and another with a New York agent who booked nationwide lecture tours on which the artist talked about his paintings and Regionalism. He was caught in a dilemma he would never resolve. His fame and the alluring invitations that went with it worked against the very principles he believed in. He could not be both a practicing regionalist—staying at home and painting, serving as a model for the younger generation—and a national spokesman for Re-

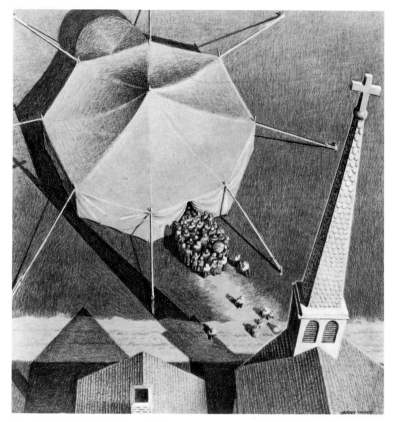

80 O' CHAUTAUQUA 1935
Pencil and colored crayon on paper, 15 1/2 × 14 1/2 in.
Collection of Phillip Grace

Drawing for book jacket of Thomas Duncan's novel *O' Chautauqua*.

gionalism, touring the country preaching its ideals. It seemed as if he never had time to paint anymore and that his life was riddled with projects he could not finish, like his biography and projected plans for new mural series at the university.

The mounting costs and time demands of his new life-style forced Wood to change the kind of art that he made. After 1934 the bulk of Wood's work took the form of prints and illustrations and other short-term projects that were quick and easy sources of income. He took on assignments for book jackets and did a series of crayon-and-charcoal drawings for *Farm on the Hill*, a children's book by Madeline Darrough Horn, the wife of a university colleague.[91] Though less memorable than Wood's drawings, Horn's story was an ideal vehicle for the artist. The adventures of two town boys visiting their grandparents' farm for a summer gave Wood an opportunity to rework his favorite cast of characters: Grandma sewing, Grandpa eating popcorn, the hired hands doing their chores, and the farmyard animals, depicted in highly stylized and witty drawings for the book's endpapers. Wood's most original illustrations, however, were

those he made for a special edition of Sinclair Lewis's *Main Street*.[92] Lewis's book, long a favorite of Wood's, was seventeen years old and already a classic when Wood's illustrated edition appeared in 1937. Wood invented a drawing for each of the central characters, recapturing, for one brief moment, the humor and delight in small-town types that had animated *American Gothic*.

Wood also took up lithography in the late 1930s. Between 1937 and 1941 he made nineteen lithographs for Associated American Artists, a highly successful New York firm that sold original prints at popular prices through mail-order catalogues (five dollars per print or six for twenty-five dollars). Established in 1934 during the hard times of the Depression, Associated American Artists sought to give artists employment while making original works of art available to the general public at reasonable prices. Each artist was paid a fee for his work and the

81 PLOWING ON SUNDAY 1938
Conté crayon, ink, and gouache on paper, 23 × 21 in.
Museum of Art, Rhode Island School of Design

Drawing for book jacket of Sterling North's novel, *Plowing on Sunday*.

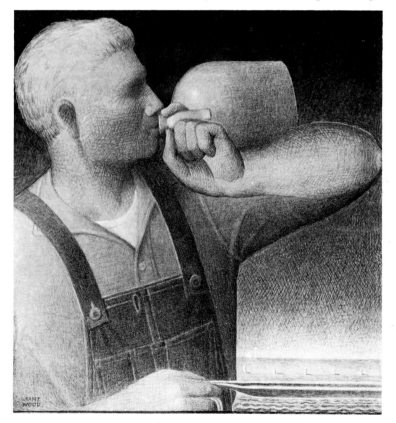

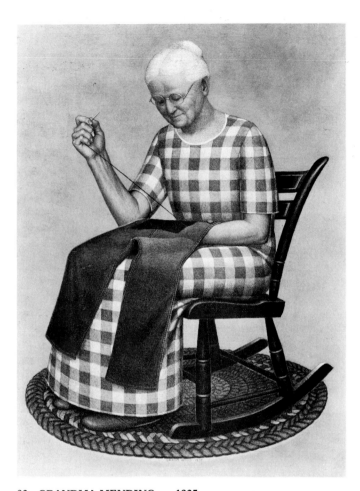

82 GRANDMA MENDING 1935
Crayon, gouache, and colored pencil on paper, 26 1/4 × 19 1/2 in.
The Warner Collection of Gulf States Paper Corporation, Tuscaloosa, Alabama

lithographs were printed according to the number ordered, though it was guaranteed that no printing would go beyond two hundred fifty. For his prints Wood generally used the themes he had become known for: farming, the changing seasons, and small-town life. He seems to have envisioned a series covering the months of the year but never got beyond *January, February, March, July 15*, and *December Afternoon*. In *Shrine Quartet*, Wood made a male companion piece to his painting *Daughters of Revolution*, and in *Honorary Degree* he spoofed himself. The recent recipient of an honorary degree, Wood depicted himself as a short and stubby figure flanked by two long, lean administrators. The artist stands in a ray of light streaming through a Gothic window and receives a Gothic-arched hood, both obvious references to *American Gothic*.[93] Another print, *Sultry Night*,

was Wood's only "regionalist" nude: a naked farmer at the end of the day bathing himself with sun-warmed water from a horse trough. Because the post office warned the directors of Associated American Artists that the image was indecent and should not be distributed through the mail, it was offered for sale over the counter but not listed in their catalogue, and only a hundred prints, rather than the usual two hundred fifty, were pulled.

Associated American Artists was a very savvy and pragmatic business venture, its success mirrored in the plush New York galleries the firm opened at 711 Fifth Avenue in 1939. The two founders, Reeves Lewenthal and Maurice Liederman, created an organization that was partly like a New Deal relief program for artists, with a populist commitment to bringing art to grass-roots America, and partly business, reflecting their

83 GRANDPA EATING POPCORN 1935
Crayon, gouache, and colored pencil on paper, 26 1/4 × 19 1/2 in.
The Warner Collection of Gulf States Paper Corporation, Tuscaloosa, Alabama

Wood drew *Grandma Mending* and *Grandpa Eating Popcorn* for *Farm on the Hill*, a children's book by Madeline Darrough Horn.

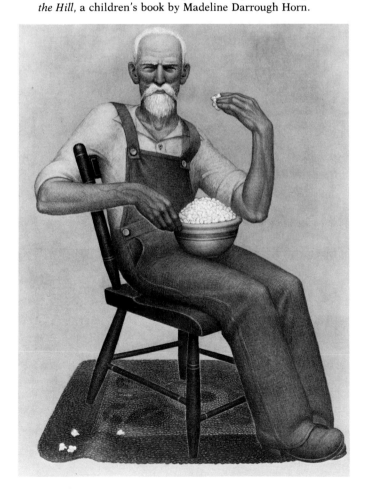

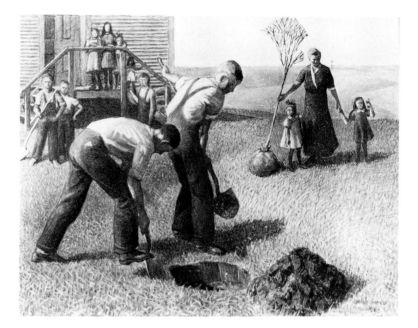

84 TREE PLANTING GROUP 1937
Lithograph, 8 1/2 × 11 in.
Cedar Rapids Museum of Art, Gift of Happy Young and John B. Turner II

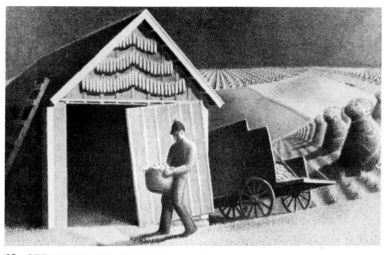

85 SEED TIME AND HARVEST 1937
Lithograph, 7 1/2 × 12 1/4 in.
Cedar Rapids Museum of Art, Gift of Happy Young and John B. Turner II

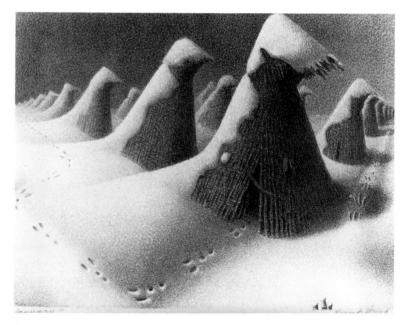

86 JANUARY 1937
Lithograph, 8 7/8 × 11 7/8 in.
Cedar Rapids Museum of Art, Gift of Happy Young and John B. Turner II

entrepreneurial instincts for commercial profits. They appealed to their subscribers' patriotism by urging them to buy and support American artists who made prints of native themes and subjects (in the 1930s the gallery supported only those artists who painted the American scene); and they appealed to everyone's sense of economy and desire to collect by offering bargain-table prices, inexpensive frames and portfolios to hold the prints, and special sales at Christmastime. Using the techniques developed by the big mail-order houses, they put out catalogues to merchandise their original, signed lithographs to households and museums across the country.

With his small-town mentality and populist leanings, Wood was very comfortable with this nonexclusive, "booster" approach to selling art and made Lewenthal and Liederman his agents. He came to rely heavily on these two men, as he once had relied on David Turner. He asked them for financial advice, frequent advances, and emotional support and let them sell his art. Although Wood had been represented for a time by the Ferargil, and then the Walker, galleries in Manhattan, he harbored a deep distrust of regular galleries and "crafty dishonest dealers."[94] Since his first success as an artist he had worried about being exploited by the art market. After *American Gothic* was reproduced everywhere without the artist's permission, he became fastidious about copyrighting his paintings. He had himself photographed in front of each work before he exhibited it and used the photograph to copyright the painting. He also resented seeing his work change ownership, with commissions going to the gallery arranging the sale but with no monies going to him. In 1939, when Lewenthal arranged for the sale of *Parson*

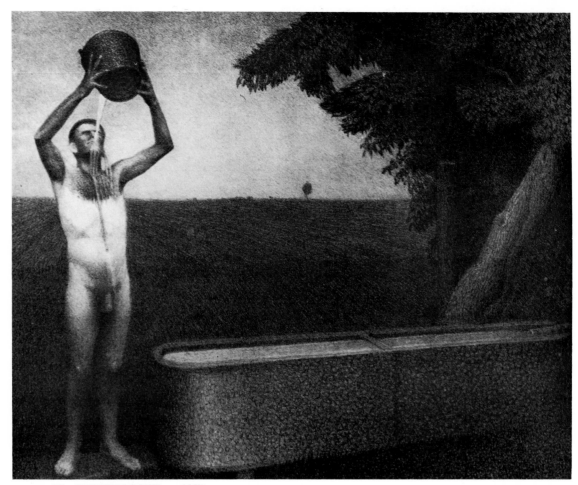

87 **SULTRY NIGHT** 1937
Lithograph, 9 × 11 3/4 in.
Cedar Rapids Museum of Art, Peter O. Stamats Collection

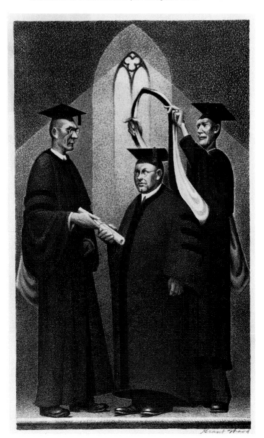

88 **HONORARY DEGREE** 1937
Lithograph, 11 3/4 × 7 in.
The Fine Arts Museums of San Francisco,
Achenbach Foundation for Graphic Arts

Weems' Fable, he announced to the press that there would be a resale clause written into the contract granting the artist half of the increase in value each time the painting was sold. Although Wood withdrew the clause when the painting was bought by Mr. and Mrs. John Marquand, the famous writer and his wife, it was a daring idea at the time, and remains so today; only one state, California, has embodied the concept of a resale clause in legislation.[95]

Wood relied heavily on Lewenthal to help him find ways to pay off his debts in the late 1930s. To the artist's embarrassment, the government had discovered that he had neglected to pay income taxes for three years and asked for back taxes. Furthermore, after much unhappiness, the artist had separated from his wife in 1938 and divorced her a year later, a proceeding which deepened his financial difficulties. Lewenthal aggressively sought work for his artists and not only commissioned

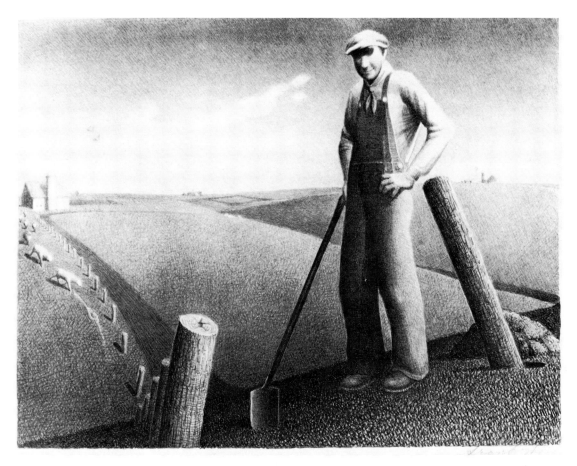

90 IN THE SPRING 1939
Lithograph, 9 × 12 in.
Cedar Rapids Museum of Art, Gift of
Happy Young and John B. Turner II

89 FERTILITY 1939
Lithograph, 9 × 12 in.
The Fine Arts Museums of San Francisco, Achenbach Foundation for Graphic Arts,
Gift of George Hopper Fitch

91 JULY FIFTEENTH 1939
Lithograph, 9 × 12 in.
Cedar Rapids Museum of Art, Gift of Happy Young and John B. Turner II

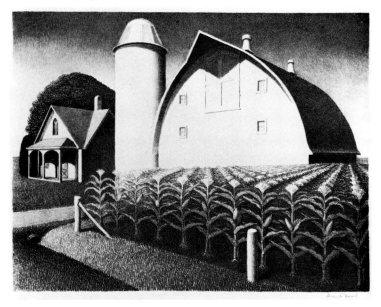

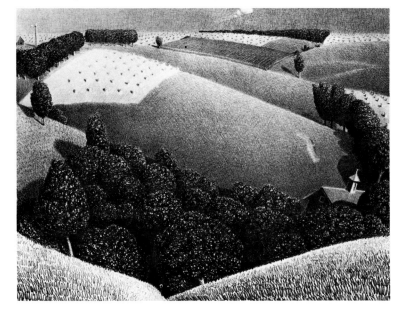

prints for them to make, but also negotiated contracts for them with large business firms. Lewenthal defended this practice, a controversial idea at the time, by arguing that he was giving his artists a way to make a living and giving businesses a chance to upgrade their images. Through Lewenthal Wood executed a number of works for commercial patrons, just as he had once worked for private parties in Cedar Rapids. One of his last prints, for example, *Family Doctor*, was made for Abbott Laboratories, a pharmaceutical firm in Chicago which offered, through its house magazine, free prints to doctors to frame for their offices. Wood's design for a fabric, a bird's-eye view of Iowan hills, was part of a project Lewenthal had arranged to market artists' textiles, but it seems never to have gone into production. The two biggest commissions Wood received took him to California and North Carolina. For the latter commission, which also included Benton, Curry, and other artists, Wood traveled to Durham for the American Tobacco Company. "Instead of pretty girls," Wood wrote his sister, "Lucky Strike is going to reproduce paintings by American artists in their advertisements." Wood died before he got anything done for the project.[96]

The California commission was one of Lewenthal's most extravagant projects and resulted in *Sentimental Ballad*, a maverick painting for Wood. Lewenthal convinced Walter Wanger, a Hollywood film producer, to hire nine American artists to create paintings about *The Long Voyage Home*, a film based on Eugene O'Neill's one-act play of that name. Wanger paid the artists to come to Hollywood, watch the movie being made, see

rushes, meet the cast, and create, in separate studios on the lot, appropriate works. Wood's painting shows seven tipsy sailors on shore leave getting teary-eyed and sentimental as they sing a familiar ballad. One of the sailors in the film was played by the young John Wayne (the tall figure in a checkered jacket). With the other commissioned paintings, *Sentimental Ballad* toured the country in a twenty-six-city exhibition to promote the film. Though the movie was not a success, the project was a lucrative one for Wood, who received $10,000 plus expenses.[97] With this commission in 1939, plus the sale of *Parson Weems' Fable*, the artist began to get his financial affairs in order.

Parson Weems' Fable was the first easel painting Wood had completed in three years and it seemed to everyone, including the artist, that he had finally mended from the emotional strains of his marriage and made a new start in life. In early 1940, however, the artist entered upon a period of trouble at the university which once again made his life difficult. For a few years Wood had felt at odds with new, younger members in his department who, he felt, were critical of his art and were undermining his influence on the curriculum. While married he seems not to have done much to meet this new challenge, but once freed from the problems of his marriage, and back on his feet psychologically, he went on the offense. In a letter to the Director of the School of Fine Arts in January 1940, Wood stated that he was unhappy with the direction the Department of Graphic and Plastic Arts was taking under Lester Longman, its chairman, and that Longman, an art historian, was introducing too much theory and history into the curriculum, a "fact-memo-

99 **SPRING PLOWING (drawing for textile design)** c. 1939
Tempera on paper, 16 × 38 in.
Mr. and Mrs. Ernest Johnston Dieterich

100 SENTIMENTAL BALLAD 1940
Oil on masonite panel, 24 × 50 in.
The New Britain Museum of American Art (Charles F. Smith Fund)

rizing approach" that stifled "the creative spirit."[98] Wood felt that Longman interfered with the studio curriculum about which he was not qualified to judge and disparaged Wood's art. In subsequent meetings and letters, Wood insisted that the university remove Longman from the chairmanship or that the department be split into two parts, history and studio, with Wood chairing the studio program.

The deans at the university found themselves asked to adjudicate a very nasty dispute. Wood was absolutely right in claiming that a serious and deep-seated rift had developed in the department and that a number of his colleagues were deeply and publicly opposed to his art and his pedagogy. But the deans also had no desire to ask Longman to step down, and even if they had, they knew that administration was not Wood's forte. Yet at the same time they did not want to lose Wood; he was the university's most prestigious artist.

Longman, who clearly opposed Wood's methods of teaching and did not have high regard for his art, explained the problems to the deans. Wood, he felt, was not a good artist. He had won only one art prize in his entire career (a bronze medal for *American Gothic*) and was not doing enough new work to uphold his national reputation. In the classroom, Wood encouraged students to paint his way and denied them creative license to follow other styles and approaches. Furthermore, he had students working on private commissions for academic credit. Wood believed in studio experience, but had no tolerance for the art history and courses on aesthetics Longman was introducing into the curriculum. Most of all, Longman felt Wood was too much in the public eye, that it was unprofessional for an artist to be such a media figure, with *Time* and *Life* magazines covering his activities.[99]

While many of Longman's objections were exaggerated by the intensity of the dispute, there was a very real problem with Wood's teaching, which, by the late 1930s, had become dogmatic and doctrinaire. Indeed, had Wood and the other midwestern regionalists been more flexible as teachers, and more

conciliatory toward modern art, their cause might well have survived another decade and encouraged a second generation of regionalist artists. Wood had always said that regionalism was a state of mind and could accommodate any style "as conservative, as eclectic or as radical as it may be."[100] But he was never as catholic in practice as he was in word. Paintings, he felt, had to be figurative if they were to convey meanings to others, and their modernism should come through stylizing contours and repeating forms, not through pure abstraction or free expression. By the late 1930s he was demanding that students employ the same painting procedures he followed, leading to the charge, leveled by his adversaries, that he was doing nothing more than producing legions of little Grant Woods. He taught students to do preliminary drawings on brown wrapping paper, his favorite material, and insisted on a kind of rule of thumb, the principle of "thirds," he called it, to teach students how to make strong compositions. If they divided each edge of their paper or canvas into thirds, he taught, and made every major line of the composition fall along a line joining any two of those points, their picture would be dynamic and interesting. "I used to fight against the idea of mechanical devices in a painting," he told a reporter, "but after I began teaching I found that a simple device like this is of great help to beginners."[101]

Wood's use of mechanical devices, sketches, and particularly the occasional photograph led his campus detractors to their most vicious charges. They claimed Wood was a fraud and could not draw. They asserted that drawing from a photograph rather than a live model, a practice so commonplace today no one would question it, was "unethical." The charge was totally malicious, particularly when leaked to a *Time* magazine reporter in an effort to discredit the artist's national reputation. The "leak" brought a reporter to campus to see whether there was any truth to the matter and caused so much concern and unrest that a dean finally volunteered to sit for a portrait to be painted by Wood in the presence of witnesses in order to bring the rumors to a halt.[102] The *Time* reporter, however, realized she had no story, that Wood did know how to draw, and the artist was never subjected to the test. By now, however, so sensitive was Wood to the charge that his work was "photographic" that he asked the director of the Davenport Art Gallery not to show *Victorian Survival*, an early regionalist work based on a tintype of a family aunt.[103]

The bitter struggle that ensued between Wood and the art department, with the university administrators in the middle, can be followed in great detail in the records of the university.

Longman solicited letters from those museum directors, critics, and teachers willing to assert the insignificance of Wood's work and his poor standing in the art world and to commend Longman's capabilities as an art educator. Wood, on his side, asked his friends John Reid, the president of National Oats in Cedar Rapids, and Reeves Lewenthal to plead with the university on his behalf. The president and deans made independent inquiries in an effort to sort matters out.

Amidst the local passions and departmental politics, the participants could hardly see the larger struggle of which their conflict was but a small skirmish. In the late 1930s and early 1940s an ideological and cultural battle was emerging in the United States, a battle over nothing less than the future direction of American art. There was a concerted effort amongst painters and critics everywhere to dispute every form of American Scene painting and to assert the primacy of international avant-garde styles, particularly Surrealism and abstract art. Even persons once tolerant of Wood's position and that of his fellow regionalists had come, by 1940, to find their pro-America, anti-Europe stance untenable. Times had changed. The early 1930s had provided an environment sympathetic to Wood's regionalism. The country's isolationist foreign policy and the New Deal's populism and heralding of the common man had supported Wood's program for grass-roots art communities and expression. By 1940, however, with the threat of Fascism abroad, working in small regionalist enclaves and painting local scenes seemed anachronistic. For many people in the art world, particularly younger artists and critics, the moment called for something radically different. They sought an art that was freely expressive, one that could be used to address worldwide crisis and explore personal and psychological needs. Some of them believed that Regionalism was not only inadequate but dangerous and stifling, that it constituted a kind of American Fascism. They drew parallels between the regionalist's figurative art, his celebration of the common folk, and his anti-modern art views and similar prejudices in the official state art of Nazi Germany. Such sentiments, held by intellectuals who had come to equate populist ideals with incipient Fascism, would, in less hysterical times, have been seen as inflammatory and narrow-minded. None of the regionalists ever espoused, as Hitler's government did, a purge of modern art from the country or the institution of a national culture glorifying militarism and state ideals. The regionalists were never that destructive, political, or programmatic. Their art was rooted in traditional democratic ideals, not those of modern totalitarianism. But as it happened,

the portrait of the regionalist as a dangerous reactionary took hold and accounts in large measure for the way the regionalists have fared in intellectual circles ever since.

At some fundamental level, Wood realized that the fortunes of Regionalism, along with his influence and position at the University of Iowa, would depend on which side prevailed in this broader struggle. Consequently he fought hard, battling to keep alive his dream of an indigenous, figurative art and to maintain the university's place as a regional learning center. In the meantime, his departmental colleagues, especially those trained in the East, viewed modern art as a personal expression that transcended geographical and national boundaries. They held different ambitions for the place of the university in the arts. Wood wanted an art unique to each province; his colleagues wanted an art that participated in the international mainstream. Indeed, they wanted to reinstate what Wood had rejected when he became a regionalist: the study of European modern styles, which Wood felt fostered a dependent, or colonial, attitude toward Europe.

Wood suffered a great deal from the swift change of sentiment in his department. When he had arrived at the university in the mid-1930s, he had been the first "liberal" painter to earn a permanent appointment. Now, only a few years later, he was labeled a reactionary and newcomers to the faculty, although they never went so far as to say it, would have welcomed his resignation. Ironically, it was those faculty members who were attracted to the university because of its up-and-coming reputation—young, broadly educated artists and art historians from the East—who most detested what Wood stood for. One of these was the late H. W. Janson, the eminent art historian, whose first teaching job was at the University of Iowa. The subject of modern art was so taboo at Iowa that Janson was fired in midsemester 1939 for having taken his students on a two-day field trip to see the big Picasso exhibition in Chicago. The students, in turn, organized a Beaux Arts ball with Picasso-inspired decorations and costumes. Janson always maintained that Wood helped convince the dean that Picasso was pernicious material and was indirectly responsible for the dismissal.[104] When Lester Longman, the department chairman, protested the decision, the young instructor was reinstated. But Janson never forgot the incident and wrote three articles in the 1940s and 1950s highly critical of Wood and Regionalism. In one he leveled the kind of charge that totally collapsed Wood's influence and reputation in the 1940s: "Many of the paintings offi-

101 Studio portrait of Grant Wood, c. 1940. (Peter A. Juley and Son Collection, National Museum of American Art, Smithsonian Institution)

cially approved by the Nazis recall the works of the regionalists in this country."[105]

The controversy over Wood's position at the university was never fully resolved. In 1940–41, Wood requested and received a year's leave of absence to get away from the turmoil and to give the administration time to consider his ultimatum that he either chair a separate studio department or resign. During the year, the administrators came up with an awkward but face-saving compromise. They offered Wood the title of University

Professor of Fine Arts, a position in the School of Fine Arts but independent of the art department. Students would sign up for his courses through the director of the school, not through the department chair. Wood accepted the offer but before the plan got far under way became seriously ill. Exploratory surgery revealed that he had inoperable cancer of the liver. He died two months later, on February 12, 1942, one day before his fifty-first birthday.

Nine months after his death, as an adjunct to the annual exhibition of painting and sculpture in which *American Gothic* had first been shown, the Art Institute of Chicago presented a memorial exhibition of the artist's work. (It was Wood's first museum exhibition, and his last one in a major city museum until 1983.) In the anti-realist, anti-Fascist climate of 1942, Grant Wood's work enraged critics, with only a few coming to his defense. Although he had suffered criticism before, especially at the time of his 1935 gallery exhibition in New York, it had been for his provincial subject matter, decorative mannerisms, and tight, overly literal drawing. Now that America was at war against totalitarian governments on two fronts, critics saw in his work the dangers of zealous nationalism and isolationism. Charles Bulliet of the *Chicago Daily News*, who had been one of Wood's first admirers, said the artist was "small-souled" and had "a shrewd sense of showmanship and a sort of pictorial demagoguery."[106] Fritzi Weisenborn of the *Chicago Times* said Wood's fame had been fostered by "the insistent beating of the drums for an isolationist America." His art made no contribution to society but simply culminated "a trend of escapist and

102 **JANUARY** **1940**
Oil on masonite panel, 18 × 24 in.
The King W. Vidor Trust

isolationist thought and action which was popular with some groups yesterday, but which is definitely obsolete today."[107]

Wood, of course, was not around to respond to such criticism, the most negative ever to have been leveled against him, but he had heard enough of it before he died to be deeply affected. Although he dug in his heels at the university, continued to give nationwide lecture tours, and proudly received honorary degrees for his achievements, privately he suffered grave doubts in his late years about his talent and artistic contributions, which only added to his difficulties in producing major new work. He had plenty of ideas but in the new climate found it hard to work and had to depend on close friends to pull him through long periods of despondency and inertia.[108] In the face

of the new internationalism that had made Regionalism such a dirty word, he came to regret the term and said it sounded too "geographical" and restrictive.[109] In his late paintings and prints he tried to respond to the charge that his work was overly illustrative and detailed. Determined to make the abstract design of his paintings and prints outweigh their factual content, he aimed in his last works at a stronger simplification of form and an imposition of a much more rigorous sense of order, applied so heavy-handedly at times that it is at odds with the artist's basic love for detail and his power of observation. In *January*, for instance, a composition he did first as a lithograph and then three years later as a painting, he makes wonderful observations: the mounding of the snow in the direction of the

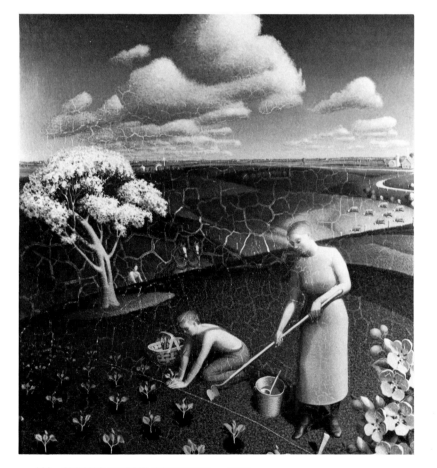

103 **SPRING IN THE COUNTRY** 1941
Oil on masonite panel, 23 × 21 1/2 in.
Courtesy of Mr. and Mrs. Cornelius Vanderbilt Whitney

104 **SPRING IN TOWN** 1941
Oil on masonite panel, 26 × 24 1/2 in.
The Sheldon Swope Art Gallery, Terre Haute, Indiana

prevailing winds, the rabbit tracks, and the tips of last year's plants poking through the snow. But all this detail has been subordinated to an overriding imposition of order and repetition that one feels is mechanical and strained. The corn shocks too perfectly echo one another and are lined up as if laid out on a mathematical grid. One feels the same strain and accommodation in Wood's last two works, *Spring in the Country* and *Spring in Town*, in which he tried to recapture some of the pastoral magic of earlier works like *Fall Plowing* and *Spring Turning*. But the artist's style had deadened. He had become too self-conscious about design, too concerned that every curve, diagonal, and form reflect others and fit an abstract pictorial system.

As death approached, Wood was struggling to make his works more universal and monumental in design; he was also trying to keep Regionalism alive and relevant to the changing times. Although he never wavered from his principal conviction—that art should originate in the painter's experience of home and locale—the war had convinced him and other regionalists, like Thomas Hart Benton, that the artist now had a new mission and a larger responsibility—to create paintings that gave Americans pride in their country's achievements. With Benton and other like-minded Americans, Wood shared the worry that the country did not have enough self-identity and enough pride in democracy to combat the fervent nationalism of Germany. To combat lethargy and to jar people "awake to the real worth of what they possess in the way of life," Wood felt the regionalist painter should go on painting "the simple everyday things that make life significant to the average person," so that people would be reminded of "what we stand to lose."[110] *Spring in the Country* and *Spring in Town* were examples of the direc-

tion he felt the regionalist should pursue. They conveyed "the picture of a country rich in the arts of peace; a homely, lovable nation, infinitely worth any sacrifice necessary to its preservation."[111]

His sentiments were noble, and many Americans would have agreed with them. But the modern art community found the new ideological justification for regionalism hopelessly dated, wrong-headed, and dangerous. In the early 1930s Wood's gentle art of "simple everyday things" and his re-creations of local and regional history had served America well. Amidst general economic collapse and widespread insecurity, Wood's paintings had made people take pride in who they were and where they had come from. His works were fables for hard times, assuring Americans—particularly midwesterners—that they had a collective identity and a shared past. His idyllic landscapes spoke reassuringly of peace and plenty; his figurative paintings made common life in rural and small-town America important and worthwhile.[112] Even Wood's vision of artistic communities spreading across the land, with students and teachers working cooperatively, was allied with the longing people experienced during the Depression to come together and work collectively. But in the next decade, a period of global war, Wood's art was perceived as too gentle, too benign, and too parochial for the times, his ideas about teaching and working in concert as inhospitable to individual expression. To his great disappointment his young contemporaries disdained what he represented and called for a more heroic, tragic, and psychological art. Wood's regionalist vision—a populist program for cultural renewal—was incapable of answering to the new demands and proved remarkably short-lived.

Colorplates and Commentaries

OLD SEXTON'S PLACE 1919
YELLOW DOORWAY, ST. EMILION 1924

From the end of World War I until 1929, Wood painted dozens of small pictures in his impressionist or "early style." Some were created in the countryside around Cedar Rapids, but many were made on Wood's four trips to Europe in the 1920s. Like hundreds of other American artists in the early twentieth century, Wood felt it mandatory to travel abroad and soak up old-world atmosphere, experience bohemian life, and spend all his time making paintings to bring back home to sell. He would seek out a site that interested him and paint it on a small panel of composition board in a loose, brushy style that he referred to as "impressionistic."[1] He painted *en plein air* and completed a picture in a few hours. Sometimes he made two or three paintings a day; sometimes he simply made sketches to bring back to Cedar Rapids and translate into bigger paintings. Once back home, he or an assistant made a simple wood frame for each painting out of window and screen-door moldings, painted it white, and sometimes antiqued it with gold radiator paint.

All of these early paintings are timid and self-conscious. Wood's temperament—that of a tidy and meticulous craftsman—kept him from ever being able to fully adopt (or even understand) the Impressionists' sensuous style, their elimination of drawing and modeling, and their innovations in painting the substance of light. Wood used the Impressionists' choppy brush and bright colors very superficially, working in such small scale and with such deliberation that we are far more conscious of structure and form in his paintings than we are of light and color. Even in the late 1920s, when his style loosened somewhat—he began to apply paint with a palette knife in an assortment of colors to build up surfaces of encrusted paint and then incise them with a sharp instrument—an academic crafting of the forms in terms of light and shadow works against the abandon and spontaneity he affects on the surface.

Furthermore, Wood's use of the Impressionists' high-keyed colors, blue shadows, and paint-loaded brush often seems at odds with his somber choice of subject matter. The Impressionists and their followers generally painted the contemporary landscape and modern life, employing the paint-filled brush to convey the movement of people in bustling boulevards and cafés or the action of sunlight in gardens or river scenes. But Wood ignored action and daily life to paint quiet and remote scenes. His tendency was to choose subjects that romantic artists long before him had deemed quaint and picturesque: cobblestone streets; quiet city squares, fountains, and parks; old-world houses, gothic churches, and medieval gateways. In Iowa he looked for the same kind of evocative or time-worn subjects: old barns, farmhouses, or secluded views of Indian Creek near his home in Kenwood Park.

Wood's love of nature and fascination with architecture, two themes which dominate his later work, stand out in these early paintings, but neither is presented from an original or compelling point of view. What one experiences more profoundly is the artist's struggle for ease and competence with his medium. Taken as a group, his early paintings show him trying to make the style his own, restlessly experimenting with different pictorial angles on his subjects and with a variety of brush strokes and textures. Yet even after a decade of working in this fashion, there is little sense of resolve in his work. It is all the more to his credit, then, that he gathered his courage and abandoned the effort altogether, inventing instead a completely new style and subject matter, one much more in keeping with his own interests and temperament. When he did, he turned his back on his early work, referring to it as a period when he had been seduced by fashion into painting in a "foreign" style that had nothing to do with his own talents or life. His reaction was a strong and angry one, but not atypical for the times. In the late 1920s and early 1930s a number of artists who painted the "American scene" experienced the same revulsion against modern European styles, which they felt had been foisted upon them by elitist tastemakers. Their invention of a more readable and down-to-earth art of local people and places reflected their desire to make art a broad communal experience, which they were convinced (rightly so, history has shown) could not be achieved through the difficult and more private language of modernism.

Plate 1
OLD SEXTON'S PLACE **c. 1919**
Oil on composition board, 15 × 18 1/8 in.
Cedar Rapids Museum of Art, Gift of Happy Young and
John B. Turner II

Plate 2
YELLOW DOORWAY, ST. EMILION **1924**
Oil on composition board, 16 1/2 × 13 in.
Cedar Rapids Museum of Art, Gift of Happy Young and
John B. Turner II

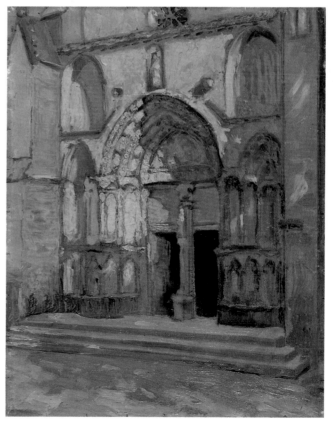

MEMORIAL WINDOW
1927 – 1929

Of the many commissions Wood received in the 1920s, none was more prestigious than the stained-glass window for the new Veterans Memorial building in Cedar Rapids. Begun in 1925, the building was designed as a towering city landmark signifying Cedar Rapids' growth and prosperity. Built downtown, on an island in the Cedar River, the tall building symbolized those virtues of which Cedar Rapids' boosters were most proud: good government, flourishing trade, culture, and patriotism. It housed the town hall, the Chamber of Commerce, and a cultural center—a large civic auditorium furnished with a $35,000 pipe organ intended to create, in the words of one of the commissioners, a "Mecca for music lovers of the community."[2] Patriotism motivated the inclusion of two "memorials" within the building. At the top of the building's tower the architects created a replica of the Tomb of the Unknown Soldier, which, when lit at night, could be seen for miles around. At street level, dominating the entry hall, was Wood's twenty-four-foot-high stained-glass window memorializing the war dead of America's six wars. Having received the commission in January 1927, Wood took his full-scale drawings in the fall of 1928 to Munich, where craftsmen under the supervision of Emil Frei, a glassmaker from St. Louis, manufactured the glass.

Both the building and its memorial win-dow are eclectic in style, merging neoclassicism and academic realism with the streamlined look of 1920s modernism. The building is classical in its symmetry, its decorative columns, its central tower bracketed by two wings, and the copy of the Tomb of the Unknown Soldier set on the top; it is clearly modern in its relatively clean surfaces and clarity of structure. (Such a strange mixture of skyscraper modern and Beaux-Art academism is enjoying a revival today in Philip Johnson's recent skyscraper designs, which incorporate classical forms and motifs.) Wood similarly mingles modern and academic vocabularies in the window, calling upon modern design in the extremely stylized and abstracted upper half of the window, at the same time looking to classicism for the prototype of the allegorical figure of the Republic, and then employing a kind of academic realism for the six standing figures below. While the allegorical figure in the heavenly sphere is abstracted and flattened, the soldiers in the earthly sphere are three-dimensional and stand firmly against a dense green bank of oak leaves and acorns, symbols of their sturdiness and dependability.

Such eclecticism, prevalent in 1920s provincial America in a period *before* modernism became universally adopted, incorporated community values into public buildings and monuments through the symbolic functions of historic styles. Each style carried meaning. The structure's classicism signified that this was a dignified, high-minded, public building; the "temple" or replica of the Tomb of the Unknown Soldier at the top of the tower announced the community's patriotism, while the simplicity and modern look of the building conveyed that the town was progressive and up-to-date. Similarly, Wood called upon different styles in his window to convey his message. To represent the Republic he naturally turned to classical allegory, but to convey that she is weightless, an abstraction residing in a spiritual realm, he used the flattened and decorative stylizations of modernism for her figure and the clouds around

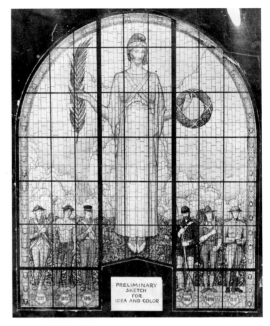

106 STUDY FOR **MEMORIAL WINDOW** 1927
Watercolor, 24 × 18 1/2 in.
Private Collection

her. Below, where he wants to convince us that this is a memorial to human beings, to men who once lived and gave service to their country, he uses all the traditional techniques of academic draughtsmanship to portray the figures in the round: he puts each in a different uniform and in a slightly different pose so that they appear to stand in flesh and blood before us.

These are lofty sentiments, of course, and in its historicism, rhetoric, and patriotism Wood's window is in keeping with other memorials erected by veterans' groups after major wars. What distinguishes it from others, however, is Wood's restraint. He used none of the weeping figures, dying soldiers, or heroic military scenes other artists might have brought to the project. Wood's memorial is solemn but not melodramatic or sentimental. Indeed, there is a deliberateness of design, a clarity of parts, and a richness and variety of color here that is very satisfying.

105 A recent photograph of the Veterans Memorial Building, Cedar Rapids, Iowa.

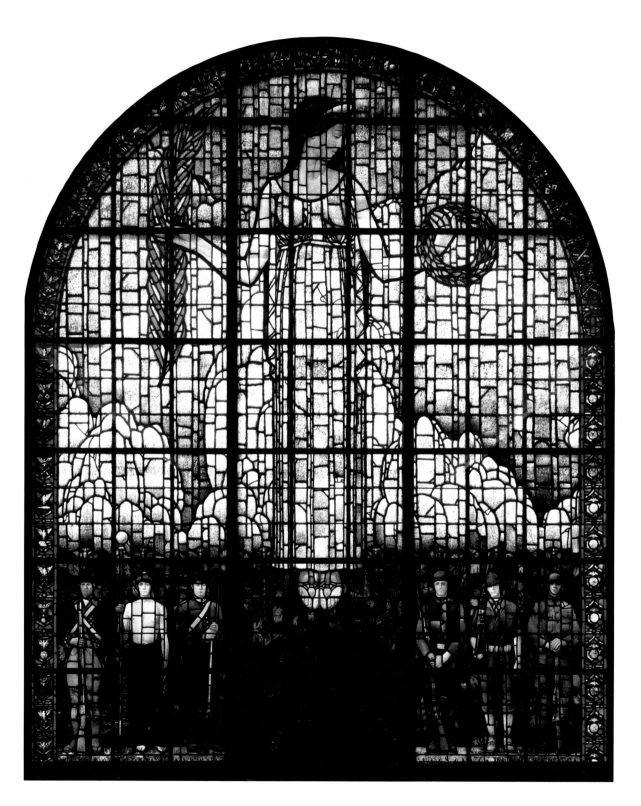

Plate 3
MEMORIAL WINDOW **1927–29**
Stained glass, 24 × 20 ft.
Cedar Rapids Veterans Memorial Building

PORTRAIT OF JOHN B. TURNER, PIONEER
1928 – 30

Although he never enjoyed it, Wood was often pressed into painting portraits—sometimes because he needed the money and sometimes because he found it hard to say no to friends. One of his finest portraits, *John B. Turner, Pioneer*, was of the aging father of Wood's major patron, David Turner, pictured against a vintage 1869 map of Linn County, Iowa. "Two old maps," the sitter called the portrait, proclaiming his eighty-four-year-old face as antique as the map behind him.

John B. Turner, Pioneer is generally said to have been painted after *Woman with Plants*, a misconception perpetrated by the artist when he signed and dated the work twice: 1928 in the lower left corner and 1930 on the man's sleeve. All the evidence, however, points to the major portion of the work having been done before Wood went to Germany for the last months of 1928. It was exhibited at the Little Gallery in early 1929 alongside the paintings Wood brought back with him from Germany.[3] Most likely Wood then reworked the portrait in 1930, after having developed his post-Munich style. Given his perspective at that time (he painted *American Gothic* in the same year), he might well have been dissatisfied with the portrait because it had none of the geometries and decorative qualities of his new style. Wanting to endow the work with the flavor of this new direction, he probably strengthened the lines of the composition and put the portrait in a gold frame with an oval rather than a square format. The new frame emphasized the roundness of the old man's head and gave the portrait something of the Victorian look the artist had conveyed in *American Gothic*. After reframing the painting, he signed and dated it 1930 along the lower right edge. Only in recent years, when the oval frame was removed, did the 1928 date come to light.

This portrait was the first figural work in which Wood tried to capture "the midwesterner," a distinct character type he felt had developed out of the struggle to conquer the frontier. Wood described the midwestern type as embodying the strength and determination of the pioneer grafted onto the puritan austerity of his East Coast ancestry. (Wood's definition was Anglo-Saxon to the core and took no account of other groups who had settled the Midwest, such as the Czechoslovakians, who had a large colony in Cedar Rapids.) Turner had come to Linn County as a young man in the 1880s, a few years after the map behind him had been made. The city of Cedar Rapids, where Turner spent most of his adult years, appears just to the left of the old man's head; scenes of early homesteads and public buildings that Turner would have encountered upon his arrival form a border at the right. By purposefully contrasting the modern-day, prosperous businessman with his frontier beginnings, Wood clearly was trying to convey something of the extraordinary progress that the Midwest had experienced in this one person's lifetime, a progress of which he felt midwesterners could be proud. In the strong, square-jawed face and direct, humorless gaze of John B. Turner, he suggested the resolute pioneer spirit he believed had made such progress possible. Twice more in the next two years Wood tried to portray the essence of the midwesterner, first in *Woman with Plants* and then in *American Gothic*, the painting that best expressed Wood's conception of the frontier heritage.

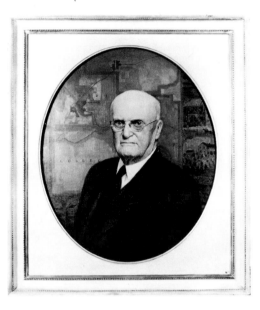

107 **PORTRAIT OF JOHN B. TURNER, PIONEER (in oval frame) 1928–30**
Oil on canvas, 30 1/4 × 25 1/2 in.
Cedar Rapids Museum of Art, Gift of Happy Young and John B. Turner II

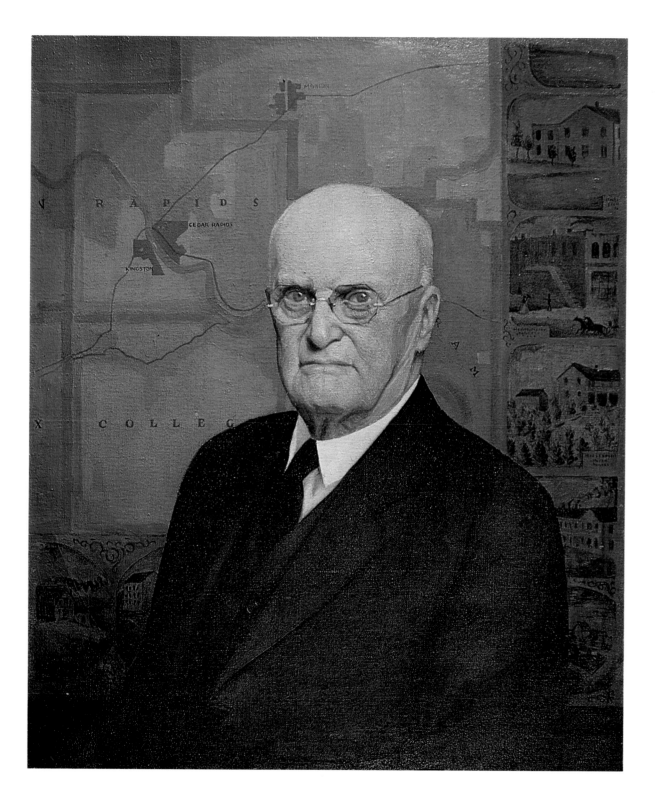

Plate 4
PORTRAIT OF JOHN B. TURNER,
PIONEER 1928–30
Oil on canvas, 30 1/4 × 25 1/2 in.
Cedar Rapids Museum of Art, Gift of
Happy Young and John B. Turner II

WOMAN WITH PLANTS 1929

In the fall of 1928 Wood spent three months in Munich working on the Memorial Window. Though he painted an assortment of *plein air* canvases to bring home with him, he was also restless and unsettled about his paintings, which increasingly seemed repetitive and unoriginal. Though pretty, they had none of the lasting importance or weighty sentiments of the Memorial Window. Furthermore, he was feeling pressure from home, particularly from Jay Sigmund, to be a regional painter, to paint the landscapes and life of Iowa rather than of Europe. The idea appealed to him. He had become a great admirer of Sigmund, Sinclair Lewis, and Ruth Suckow, who wrote so passionately about midwestern life, but as a painter he did not have the same descriptive and narrative language they commanded as writers. He knew how to use his impressionist brush to paint rows of cornshocks in blond sunlight, but had no way to conceptualize the Midwest, as the writers did, as archetypally provincial and rural, with its own history, human peculiarities, and landscapes. Wood knew how to speak of the poetic and transient in nature, but not of the typical and distinctive.

It was in this self-critical frame of mind that Wood studied Renaissance paintings in the Alte Pinakothek, trying to determine how the old masters had given stature and permanence to local models and landscapes. He was drawn to the realism and detail of the Northern masters—Memling, van der Weyden, and Dürer—and to the way they imposed decorative patterns upon their subjects. Wood was beginning to think that these qualities, rather than the splashy brushwork he had been using, were more attuned to his craftsmanlike nature and his training in modern design. Upon his return to Cedar Rapids, he began *Woman with Plants*, an experimental, neo-Flemish picture of a midwestern pioneer "type," a female counterpart to *John B. Turner, Pioneer*. While he painted the background landscape of the new work in his customary loose brush, he conceived the figure in terms of the lessons he had learned from his study in Munich. He combined ob-

servable detail, particularly in the face and hands, with deliberate stylization and patterning in the woman's dress. He hardened edges and bathed the figure in that sharp northern light that clarifies rather than softens a figure's form. He also experimented with an old-master painting technique, using oil glazes on panel. Having gessoed a piece of composition board, he painted the figure by continually applying thin layers of color mixed with varnish to achieve something of the old masters' translucent depth of color. In this he was, as usual, self-taught. His only lesson had been watching someone in the Alte Pinakothek use glazes in copying a Titian.[4]

The success of *Woman with Plants* lies in the extent to which it transcends portraiture, or, to put it in terms more akin to Wood's thinking, the extent to which it becomes an archetypal portrait of midwesternness. One only need compare the painting with a studio photograph of the artist's mother, the seventy-one-year-old model for the painting, to see how hard Wood worked to depersonalize and idealize Mrs. Wood and to make her into a kind of immovable, mute monument to her kind (see fig. 75). He asked her not to dress in modern clothes, as John Turner had done, but to wear country garb, an apron trimmed with rickrack over a simple black dress, with a cameo brooch at her neck. This costume afforded Wood the decorative patterns he had admired in Flemish works and, at the same time, made the figure look archaic and old-fashioned, a survivor, perhaps, from an earlier era.

Wood then composed the painting as a Renaissance portrait, a half-length seated figure against a hilly midwestern landscape with a deep azure sky fading to white at the horizon. He had his sitter assume a stiff pose and avert her gaze and prominently placed her rigid hands at the lower edge of the panel. Just as Renaissance sitters often held symbolic objects, Wood had his mother hold a sansevieria plant, commonly known as the snake plant or mother-in-law's tongue. The attribute is an obvious reference to Mrs. Wood's much-praised talents as a gardener (as are the begonia and geranium plants at her sides). More important, the

108 Hans Memling (c. 1433–94), *Portrait of a Man*, Statens Museum for Kunst, Copenhagen.

snake plant, well known on the frontier for its hardiness, signified the sitter's resilience and strength of character, qualities Wood felt were indigenous not only to his mother but to the midwestern pioneer as well.

The use of oil glazes, the Renaissance portrait format, and the new "decorative" realism were all in the way of experiment for Wood in 1929; he had no idea at that time that they would lead to a permanent change in style and materials. Yet he liked the results, as did his friends, and made a special frame for the painting, one covered in an old linen tablecloth to evoke the past, the feminine, and the hearth. He felt, as he later put it, as if he "had stumbled upon something that could bear some investigation."[5] He had stumbled, we might say, on a way to dignify midwestern material. *Woman with Plants* was a watershed picture for Wood, for it gave the artist the confidence that he could create a language as powerful as that of the regionalist writers he admired.

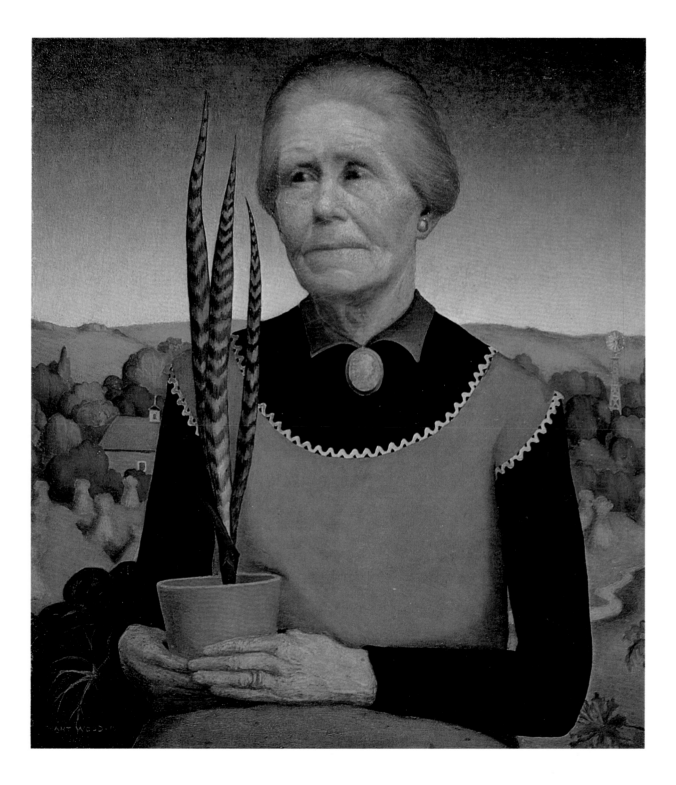

Plate 5
WOMAN WITH PLANTS **1929**
Oil on upsom board, 20 1/2 × 17 7/8 in.
Cedar Rapids Museum of Art,
Cedar Rapids Art Association Purchase

STONE CITY 1930

As eastern Iowans well know, Stone City is not a city at all, but a tiny village nestled into a medley of hills whose sloping walls part just long enough to form the narrow valley of the Wapsipinicon River. The town, some three or four miles from Wood's birthplace in Anamosa, received its name from the limestone quarries that flourished in the region in the late nineteenth century and that were the source of the distinctive tan stone used to build homes and public buildings throughout the area. Though burgeoning in the 1880s, the town's economy had collapsed by the turn of the century, when the use of portland cement sharply curtailed the demand for limestone. Stone City languished and became a sleepy, secluded community of abandoned stone buildings, occasional farmers, and stone workers.

Wood's painting, then, though seemingly a fantasy in its immaculately groomed surfaces, dollhouse-like structures, and miniature animals, is solidly based on a specific locale—and even more on a particular view. Today, from the same hill on which the artist stood, one can see the stone church to the left, the quarry that cuts deep into the facing hill, the buildings on either side of the river, and the

main road crossing the bridge and winding like a ribbon over the hills and out of view. It is easy to calculate how Wood compressed the scene in his painting, smoothed out surfaces, eliminated unwanted details, and stylized contours. Though he obsessively imposed order and patterns where there were none, Wood was in the main faithful to what he could see from his hillside perch.

In his new style, as in his earlier *plein air* paintings, Wood relied on fact. He continued to employ models whenever he painted the figure, studied specific landscapes and buildings, and used illustrations or photographs as visual aids. This was partly owing to his academic training but also reflected his sensibility. He was not a man of flights of fancy, nor did he think easily in abstract terms. Like his father, who once had returned a book of Grimm's Fairy Tales to a neighbor because he wanted his children to "read only true things," Wood, no matter how humorous or storybook-like his paintings became, depended upon hard visual data.

In later years, after his work became well known, Wood was criticized for his inability to draw freely, without the use of models or photographs. But in 1930, when he painted *Stone City* and was on the threshold of creating a new style, the self-realization that his "natural" tendencies, as he put it, "were toward the extremely detailed"[6] helped him change course and reject the impressionist brushwork he had been using. It was the first time the artist had seriously taken stock of his own proclivities and limitations, rather than taking his cues from others. His excitement in working out a personal style generated a burst of activity, and a stream of memorable canvases came off his easel, one after the other, for three years (1930–32). These were the most productive years of his life.

The artist's headiness in having "stumbled upon" a personal vision comes out forcefully in

109 Stone City, c. 1930–35. (Edward B. Rowan Papers, Archives of American Art, Smithsonian Institution)

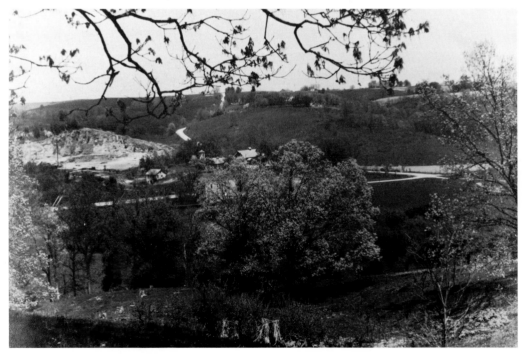

110 Residence of J. W. Richardson, lithograph from A. T. Andreas, *Illustrated Historical Atlas of the State of Iowa* (1875).

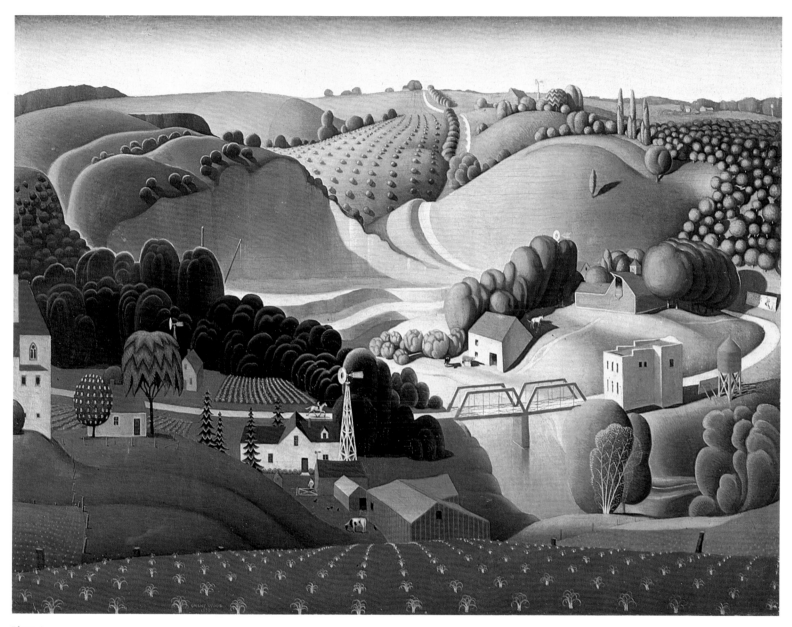

Plate 6
STONE CITY **1930**
Oil on composition board, 30 1/4 × 40 in.
Joslyn Art Museum, Omaha, Nebraska

Stone City, the first work Wood completely painted in his new style. The decorative geometries he had applied so cautiously to the figure in *Woman with Plants* he now applied with a gleeful abandon, riotously reducing everything to a rounded or rectilinear shape, sweeping surfaces clean of irregularities, and inventing a profusion of different patterns for trees and fields. It is as if he were redoing the hilly Iowan landscape in *Woman with Plants*, discarding in one fell swoop the painterly brush and soft atmospheric effects he had been cultivating for so long. In this respect, *Stone City* is a seminal painting; it sets a style the artist would refine and modify, but never fundamentally alter, for the rest of his life.

It was the Flemish painters, Wood always said, who gave him the impetus to create this new style. But it would be wrong to aggrandize and isolate that stimulus, as so many have done, and credit the old masters as Wood's only inspiration in 1929 and 1930, for Wood was too much the eclectic thinker and omnivorous borrower. While he wanted his new paintings to have something of the stature of the paintings in the Alte Pinakothek and had experimented with old-master ideas in *Woman with Plants*, he was equally concerned with being a modern painter and a regional artist of the Midwest. And indeed, *Stone City* reminds us less of Flemish paintings than of Art Deco decorations and American folk art—Folk Art Deco, we might call it, applied to the rural landscape. There is a *moderne* look to *Stone City*, and a self-conscious, folksy primitivizing that arises from very different impulses from those acting on Hans Memling.

Like other Art Deco designers, Wood was inclined, in the 1930s, to superimpose many of the principles of modern design on the scenes he painted. He had no inclination to become an abstract or cubist artist, but he did want to design his canvases in a modern style. In evolving a style of artificial geometries, clean surfaces, and relentless patterns, he was like the Art Deco decorators of his day. For Wood this development came naturally. He had, after all, learned the fundamentals of modern design from his Arts and Crafts training, and he had gone on to make a living as a decorator and craftsman. It was only a short step for him to return to turn-of-the-century design principles, in which Art Deco had its roots, and apply them in an updated, stylized fashion to his Iowan scenes. He called his new style, appropriately enough, "decorative."[7]

Wood wished his painting to be not only "decorative" or deco and modern, but also midwestern and American in character. He wanted his paintings to recall, no matter how indirectly, American and particularly midwestern visual traditions. It is no accident, then, that *Stone City* conjures up homemade quilts, mid-nineteenth-century American folk paintings, and illustrations of farms and farmlands on old midwestern maps and in atlases. These were exactly the kinds of materials he consulted and thought about as he became a determined regionalist. As a boy, Wood's mother recalled, Grant had always said that "cornfields in spring look like black comforters tied in green yarn."[8] Now he painted *Stone City* with that same image firmly in mind, while looking to a different American source for the bird's-eye view and the conscious primitivizing of the figures and block-like buildings. Here he was quoting from nineteenth-century folk paintings of rural landscapes or, more probably, from those hundreds of crudely done lithographs of farms that are found throughout the Midwest on vintage maps and in county atlases. Drawn hastily by commercial artists, these lithographs adhere to a common formula. The scenes are drawn without subtlety of perspective or modeling; they are conceived as if viewed from above and map out, in amateur, childlike terms, a particular farm, its inhabitants, outbuildings, crops, and husbandry. These images, along with Currier and Ives prints, old family photographs, line drawings in Sears and Roebuck catalogues, provincial nineteenth-century architecture, and a host of other American visual sources, came as a great discovery to Wood around 1930. As the Flemish had convinced him to paint the local scene, these American materials convinced him to try to create an indigenous painting style. Not only had he found this new style by 1930, but he had a new mission.

OVERMANTEL DECORATION 1930

In the late 1920s and early 1930s Grant Wood helped design and decorate several new Cedar Rapids homes. For one of them, a neocolonial house built for Mr. and Mrs. Herbert Stamats, a local publisher and his wife, Wood created a witty and intentionally archaic family portrait to hang over the fireplace. Like other works of this extraordinarily busy and productive year, the painting blends together a host of early American sources. In discovering his native style, the artist had become an avid student of Americana.

The very idea of an "overmantel" revives the eighteenth- and early-nineteenth-century custom of placing large painted panels, usually of landscapes, over the fireplace. But the scene within this particular overmantel—the tiny, four-member family strolling in old-fashioned dress in front of their brand-new home—is not colonial, but nineteenth century. One thinks immediately of similar scenes of Currier and Ives prints, which we know the artist admired and helped collect for his patron, David Turner. But an even more immediate inspiration, Wood said, was an old oval platter that his family owned.[9] This was probably a piece of Staffordshire blue china, the kind made in England for the American trade in the first half of the nineteenth century, which reproduced scenes of famous homes and buildings and which were surrounded by lush floral borders, precisely the format Wood adopted for his overmantel. Even the elliptical shape of the painting he took from the platter. To make the painting fit into the rectangular space over the fireplace, he painted a beige floral "mat" around the picture, which makes it appear that the family scene has been slipped into a nineteenth-century photo album.

How quaint this picture is, then, with its modern family dressed in nineteenth-century clothes and greeting one another in front of their new home, surrounded by an immaculately tended landscape. Everything is in perfect order. The groomed trees attend the scene as if they were on stage, each one wearing an exotic headdress of feathers, plumes, or cotton balls. But there is more to this scene than its obvious fancy and charm, for this painting is, in many ways, a companion piece to *American Gothic*, which the artist had just finished. Just as *American Gothic* chronicled the traditional austerity and work ethic of Iowa's rural folk, the overmantel speaks to the prosperity and growth of Cedar Rapids' industrial class in the 1920s. As such, it tells us a great deal about the changing times in 1930 Iowa.

Imagine the two paintings hung side by side—the austere, hard-working couple in *American Gothic* confronted by their wealthy and relaxed urban counterparts. The tension between the two scenes would be highly charged, tantamount to a stand-off between two completely different cultures and world views. The rural couple's closed lips, wary eyes, and readied pitchfork mark them as being on the defensive, guarding their home from alien intruders. The city family, on the other hand, relaxed in its comfortable, even luxurious, setting, is at ease with the world, with leisure and modern living.

111 "Boston Court House," Blue Staffordshire platter from J. & W. Ridgeway's *Beauties of America* series. (David and Linda Arman)

This hypothetical confrontation of the insular rural world defending itself against modern life was very much on the artist's mind in 1930. In his own intuitive fashion, Wood grasped the profound tension midwestern culture was experiencing in his lifetime due to the intense growth of industry and the arrival of modern machinery, mass communications, and new money. There were, Wood recognized, not one, but two very separate cultures in the Iowa of 1930, both of which he knew well. There was the country culture into which he had been born—unschooled, untraveled, and insular—and the city culture to which he had migrated—industrial, wealthy, and educated. It was a tension the artist explored in several important pictures. In the impact of modernization on the patterns, habits, and values of rural folk, Wood recognized a dialectic fundamental to his age. It was not Wood's nature to be polemical or to condemn either culture; he could too readily see them both with an ample measure of humor and wit. But if we strip away the humor and note the number of times he affectionately painted the rural scene, we feel Wood's regret for the inevitable passing of a way of life he cherished.

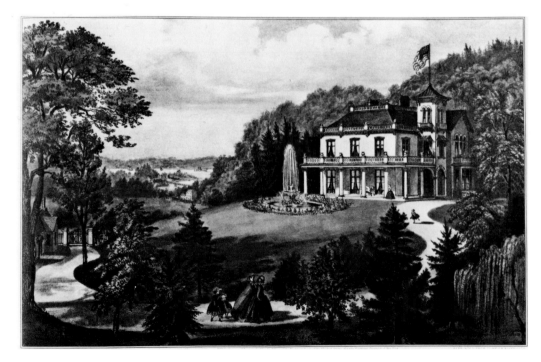

112 Lithograph by F. F. Palmer for Currier and
Ives, *Life in the Country—Evening* (1862).

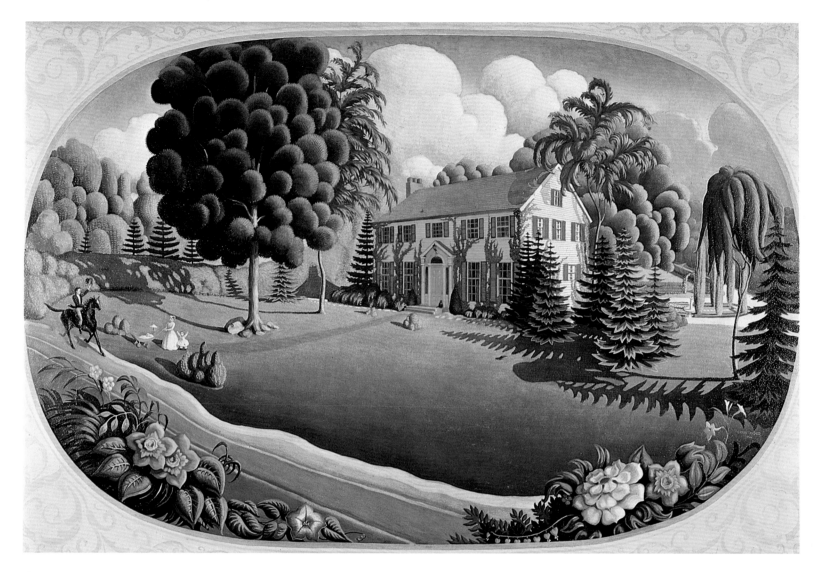

Plate 7
OVERMANTEL DECORATION **1930**
Oil on upsom board, 41 × 63 1/2 in.
Cedar Rapids Museum of Art, Gift of Isabel R. Stamats in
memory of Herbert S. Stamats

PORTRAIT OF MARY VAN VECHTEN SHAFFER 1930

PORTRAIT OF SUSAN ANGEVINE SHAFFER 1930

Wood painted the portraits of the two young Shaffer girls, just as he had the Stamats overmantel, as part of a larger home-decorating assignment. In both cases the families, who lived only a few homes away from one another in Cedar Rapids, hired Wood as an interior designer and commissioned him to paint family portraits. The artist obliged but painted the overmantel and Shaffer portraits in two completely different styles, each appropriate to the period decor of each home: the overmantel was an Americana decoration to fit into the Stamatses' neocolonial home; the portraits of the girls were neo-Elizabethan in keeping with the Renaissance decorations Wood had created for their new home. The Shaffers had just bought a large brick, neoclassical structure, built in the early twentieth century, which had tiny-paned casement windows and recalled seventeenth- and eighteenth-century English country houses. Wood decorated the house with a baronial flavor, fitting out the dining room as if it were a late-medieval or early-Renaissance hall—stuccoed walls, ceiling decorations, wooden panels on the doors, and heavy wooden table and chairs—and painting neoclassical decorations on the doors to the library as if they led to an eighteenth-century European drawing room (see fig. 34).[10]

The portraits of Mary and Susan Shaffer complement this decorating pastiche of premodern European styles. Knowing that the Van Vechten Shaffer family was one of the wealthiest families in town, and having just studied late-Gothic and early-Renaissance painters in Munich, Wood painted the two girls as if they were the children of a fifteenth- or sixteenth-century nobleman. Thinking no doubt of painters like Albrecht Dürer and Hans Holbein, he silhouetted the two girls' portrait busts against plain, dark backgrounds, gave full play to the intricate detail and finery of their clothing, and inscribed their names in gold with the date—ANNO DOMINI MCMXXX—across the top. To add his own modern flourishes, he created a halo of light behind each head and introduced touches of pink and blue in the shadows of the girls' dresses.

The most memorable passages in these two small portraits are the clothes, the crocheted bib of Mary's dress and the delicate stitchery of Susan's cap. As a designer of jewelry, furniture, houses, and interiors, Wood had a healthy respect for handiwork and re-created these pieces of finery in full detail, spelling out their intricacies and workmanship. But it was not just the craftsmanship of the needlework that interested Wood. By 1930 he had become interested in clothes for two other reasons: first, because they could be easily stylized and reduced to patterns, or what the artist called "decorative adventures," and second, because dress could be used to amplify not only his sitters' class and station in life, but also their heritage and values.[11] His experience in painting his mother as a country woman in *Woman with Plants* had taught Wood how important costume could be as a narrative device. From then on, much like a theater director, he would choose what he wanted his models to wear, seeing to it that his choices lent themselves to decorative stylizations *and* conveyed appropriate information about the sitter. The elaborate finery that the two little girls wear in the Shaffer portraits, like the frilly costumes on the Stamats family in the overmantel, clearly identify these wealthy patrons as belonging to a class set far apart from that of Wood's own family and heritage. These people are not identified with the land or nature—the mark of a true midwesterner, in Wood's lexicon—but are a new breed whose homes and costumes speak of prosperity, materialism, and the rapidly changing social structure of the Midwest.

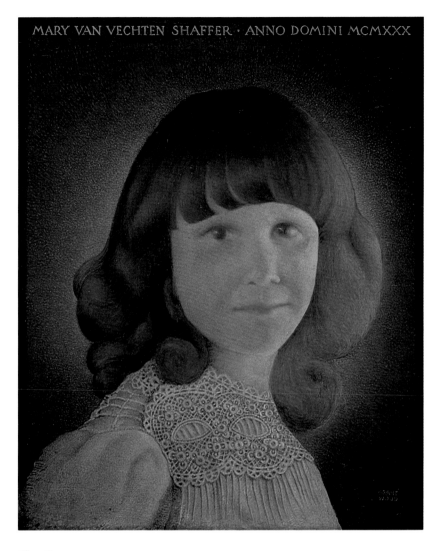

Plate 8
PORTRAIT OF MARY VAN VECHTEN SHAFFER
1930
Oil on composition board, 15 1/4 × 13 in.
Private Collection

Plate 9
PORTRAIT OF SUSAN ANGEVINE SHAFFER
1930
Oil on composition board, 15 1/4 × 13 in.
Mrs. I. Stuart Outerbridge, Jr.

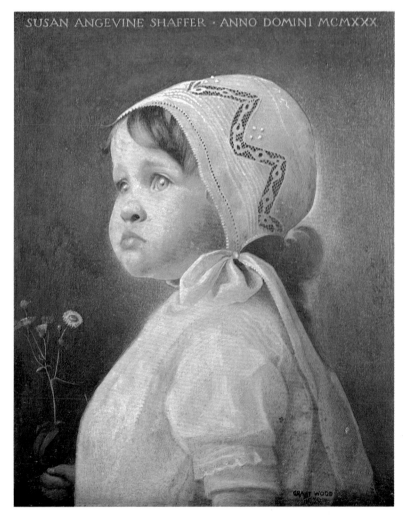

APPRAISAL 1931

In 1929 Robert and Helen Lynd published *Middletown*, a sociological study of small-town America based on their fieldwork in Muncie, Indiana. A classic study of the period, it maintained that the interval between 1890 and 1925 was probably "the era of greatest rapidity of change in the history of institutions."[12] It was during those years that the Industrial Revolution "descended upon villages and towns, metamorphosing them into a thing of Rotary Clubs, central trade councils and Chamber of Commerce contests for 'bigger and better' cities."[13]

Passages in *Middletown* might well be illustrated by Grant Wood paintings or writings by Sinclair Lewis or Ruth Suckow. All three of these midwestern artists were keenly conscious of what modernity was doing to provincial America, which had been, until the beginning of the twentieth century, insular and agrarian; each was also aware of the ever-widening gulf developing between those who lived in the country and had not yet been "modernized" and those who lived in the towns and cities, entranced with their new mobility and gadgets. In *Main Street*, Sinclair Lewis draws attention to the simple meals, warm hospitality, and the lack of pretension of the farmers who live on the outskirts of Gopher Prairie, the town whose denizens pride them-

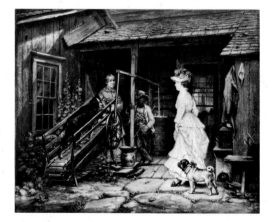

113 Edward L. Henry, *Capital and Labor*, 1881, The New-York Historical Society, New York City.

selves on elegant dinner parties, fancy cars, the town library, literary club, and thespian group. Ruth Suckow saw the clash between the old and new ways as more tragic, delineating the sadness and human toll that resulted when the horse-and-buggy farmer confronted the values of his car-driving, city-dwelling children.

Wood's views on social change present themselves in a series of paintings contrasting the rural world with that of the city. From his allegorical study *Adoration of the Home* (fig. 27) in 1921 to his paintings *Spring in the Country* (fig. 103) and *Spring in Town* (fig. 104), completed just before his death, Wood used his art to compare the activities and livelihoods of country and city dwellers. His most dramatic and significant rendering of the theme was *Appraisal*, in which a country woman stands face-to-face with her city counterpart. She appraises the city woman's stylish hat, who in turn looks down and appraises the "natural" dress of the Plymouth Rock rooster in the farm woman's arms.[14] The simple lines of the farm woman's worn and misshapen coat, held together by her only jewelry—a safety pin at the neck—contrasts sharply with the bulging, fur-trimmed coat and glistening pearl earrings of the city woman. The farm woman's plain knitted cap coming down over her forehead parodies the city lady's chic cloche hat with its glittering crystal pin.

Wood seems more interested in describing the confrontation than in predicting an outcome, but his sympathies are clearly with the farm woman, whose territory has been invaded by this creature from another planet. With obvious glee, he points out the beauty of the chicken's coat of striped feathers compared with the dead animal trim on the woman's coat and contrasts the strong, aggressive stance of the farm woman with the soft, pudgy, double-chinned figure of the overstuffed visitor.

We're given no sure reason for this dramatic encounter, but most probably a transaction is taking place. The city woman has come to buy a fresh farm fowl for Sunday dinner and will pay for it with money from her fancy beaded bag. The country woman "provides," as one historian has observed, while "the city

114 When first painted and exhibited, *Appraisal* included a wire fence in the foreground. Not to his liking, the artist cut it off and made his painting horizontal rather than vertical.

woman consumes."[15] The painting is Wood's update of a confrontation popular in nineteenth-century Victorian painting: the rich visiting or buying goods from the poor. In *Capital and Labor*, for example, by the late-nineteenth-century American artist E. L. Henry, a wealthy young lady visits the home of a poor older woman. Bedecked in her Parisian fashions and accompanied by her pedigree pug, she appears like an apparition to the poor woman whose mutt dog slaves to churn the butter by treadmill, the artist's all-too-obvious metaphor for poverty. In Wood's reprise of this familiar theme, it was not the issue of money and class that animates the confrontation, but the challenge of modernity to agrarian life. Whereas in Henry's painting we are made to feel sorrow

Plate 10
APPRAISAL 1931
Oil on composition board, 29 1/2 × 35 1/4 in.
Anonymous Collection

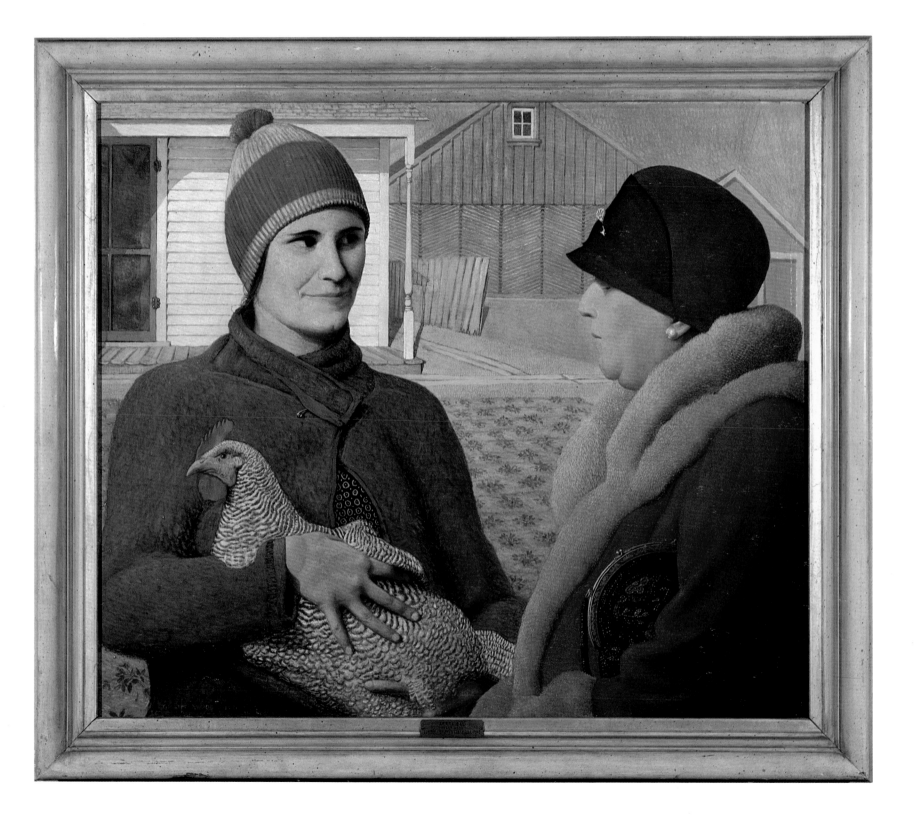

for the poor and anger toward the rich, in Wood's painting we feel there is something genuine and good about the poor and laugh at the silliness of the rich. One feels the same understated prejudice at work in Wood's two drawings, *Draft Horse* and *Race Horse*, a comparison between a work horse and a show horse (see figs. 208 and 209). The country horse, seen against a barn and natural landscape, is sturdy and muscular, as is the farmer who lovingly feeds him; the city thoroughbred and his jockey are both sleek and thin-limbed and show off for the crowd in the bleachers of a racetrack. The one belongs to the natural world of flowering trees and manual labor, the other to the modern world of faceless crowds and leisure; on the farm, pretty dandelions "litter" the foreground, while in town unsightly peanuts and trash take their place.

Wood's most sober assessment of modernity's impact on country living was in *Death on the Ridge Road*, an unusual painting in that it conveys its message through images of machines. The painting depicts a bright red truck cresting a hill and coming upon a sleek limousine passing a slow and pokey Ford in the other lane. The three vehicles are traveling a steeply pitched and curving "ridge road," a passageway the settlers originally carved out along high ridges to cross the territory by wagon. Once rough and muddy, the road is now paved to accommodate car travel and lined with fences to keep intruders from the fields and animals from the road. In its hard asphalt finish, the road has become a kind of modern battlefield surrounded on either side by the farmer's lush, verdant fields. As a historian has shown recently, the battle taking place on that paved road is the same kind of confrontation we see in *Appraisal*, the fast-moving modern world clashing with that of the slower pace and simpler ways of agrarian living.[16] The rural world, represented not only by the landscape but also by the slow-moving Ford, the plain, sturdy car of farmers, is being overtaken by the aerodynamically sleek and streamlined sedan, a symbol for the fast-paced, sophisticated styles of modern living. The speeding car seems completely out of place in the country landscape, as does the truck, a sign of modern commerce, and the telephone lines, representing the intrusion of new technology. The disparity between modern machinery and the natural landscape, the storm brewing in the skies, and the funereal crosses formed by the telephone poles all betray Wood's gloomy prognosis for the impact of modernity on midwestern life. We don't know if the vehicles will crash, but we do know they are on a collision course, the artist's metaphor for the social upheaval of his own times.

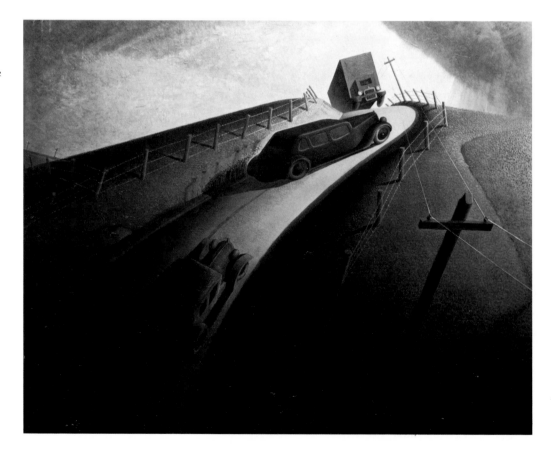

116 **DEATH ON THE RIDGE ROAD** 1935
Oil on masonite panel, 32 × 39 in.
Williams College Museum of Art, Gift of Cole Porter

115 DRAWING FOR **DEATH ON THE RIDGE ROAD** **1934**
Pencil and chalk on paper, 31 1/4 × 39 in.
James Maroney, New York

THE BIRTHPLACE OF HERBERT HOOVER 1931

In *The Birthplace of Herbert Hoover*, we vault the gigantic leafy crown of an oak tree, pass over a bridge, and enter an ordinary, quiet, and shaded street in small-town mid-America. On the lawn of the nearest house we see a tiny figure, our pictorial guide, who points to the building behind him. He is a familiar character in the history of art; his prototypes abound in nineteenth-century American paintings and prints, in which a standing figure points out the important sights in a landscape—Niagara Falls, a mountain view, or a building of interest. Here Wood uses the figure as a deliberate piece of theater, to evoke the flavor of an older American pictorial tradition and to draw our attention to an otherwise ordinary, nondescript structure.

The figure is pointing to Herbert Hoover's birthplace in West Branch, Iowa. The birthplace, however, comprised only the small, rearmost portion of the sprawling, three-part house in the center of the painting. When Hoover was born in 1874, this part of the house was a freestanding, three-room board-and-batten cottage. Hoover lived there for six years before his family sold the cottage and moved to a bigger house. Eventually, R. Portland Scellers bought the property and made major alterations. In 1890, to accommodate his wife and five children, he turned the cottage to one side, moved it back on the lot, and then moved a two-story house from elsewhere in town to

117 Hoover Birthplace, Herbert Hoover Historic Site, West Branch, Iowa, 1982.

the cottage's original site. He joined the two buildings with a walkway and added siding all around to give the house uniformity of surface. Parts of the Scellers family lived in the house during Hoover's early career as a statesman—he became nationally known for his chairmanship of the American Relief Commission in Europe during World War I and served as secretary of commerce under Calvin Coolidge—and during his term as president of the United States. Only in 1935, two years after Hoover had left the White House, did the Hoover family reacquire the property and hire Bruce McKay, Wood's good friend and associate in Cedar Rapids, to move the cottage back to its original site and restore it to the way it looked in 1874.[17]

When Wood painted his picture, Hoover was in the third year of his presidency and Iowa's most famous citizen, the first native son to occupy the White House. His presidency had given West Branch, the tiny Iowa town where he had lived until he was orphaned at age ten, national prominence. Immediately after Hoover's presidential nomination by the Republican party in June 1928, Americans began to pilgrimage to West Branch and tour the "birthplace," as it was called. The cottage quickly became, as happens with the homes of most American presidents, a national shrine. Hoover's first home, like the log cabin in which Abraham Lincoln was raised, had particular appeal because it was so small and humble, "a symbol," as one historian put it in 1929, "that American democracy still lives."[18] Built in 1870 by Hoover's father, a village blacksmith, the house, even in its adulterated state, confirmed one of America's most central and abiding myths: that in the United States any citizen, no matter how humble his origins, can rise to occupy the country's highest office.

Hoover made good use of his modest beginnings in his presidential campaign. Two months after his nomination he launched his midwestern campaign at the annual community picnic in West Branch, giving nationwide publicity to his birthplace and hometown. He and Mrs. Hoover began the day by

eating "an old fashioned Iowan farm breakfast" prepared by Mrs. Scellers in the birthplace cottage, then the house's kitchen, and by being photographed at the door of the house.[19] Next they visited the graves of Hoover's parents and drove by farms and other sites Hoover knew as a boy. In the meantime, some eighteen thousand people gathered at the picnic grounds of the small town to hear Hoover speak, and during the course of that year another seventeen thousand visitors signed the birthplace guestbook. Mrs. Scellers obligingly let people tour the Hoover cottage for a dime admission and on the weekends set up a souvenir stand on her front lawn. In 1929 the Daughters of the American Revolution graced Mrs. Scellers's front lawn with a native boulder and a plaque which read "Birthplace of Herbert Hoover, First President of the United States Born West of the Mississippi River." (The pink rock with the DAR marker can be seen in front of the house in the painting.) So fascinated had the public become with Hoover's humble frontier beginnings that a replica of the original birthplace was reconstructed and exhibited in 1929 and 1930 at the Iowa State Fair in Des Moines. Two-thirds of the fair's visitors, it was estimated, went through the structure.[20]

It wasn't President Hoover, but the sanctification of the Hoover birthplace, that inspired Wood to paint this picture. Always interested in American legends, and particularly legends native to the Midwest, Wood was intrigued with Hoover's story. West Branch was just southeast of Cedar Rapids and easy for Wood to visit as he gathered ideas for his picture, in September of 1931. He undoubtedly knew that local artists had already depicted the structure, always drawing it as a freestanding cottage, reconstructing it in their minds as they thought it looked when the president was born.[21] Wood eschewed this idea no doubt as too sentimental, pious, and conventional. With his keen interest in midwestern history and architecture, he would have been taken with what had since happened to the cottage and the way it had been absorbed

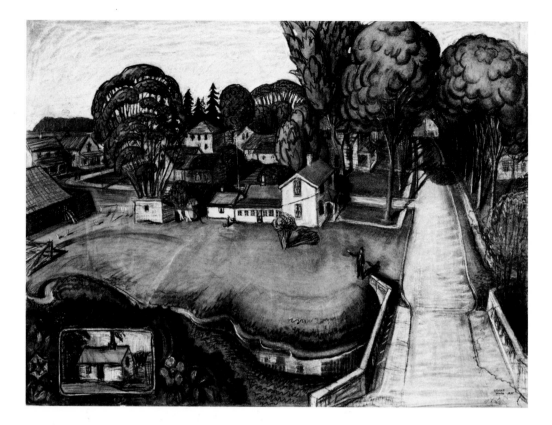

118 DRAWING FOR **THE BIRTHPLACE OF HERBERT HOOVER** 1931
Chalk and pencil on paper, 39 3/8 × 29 3/8 in.
Private Collection. On loan to The University of Iowa Museum of Art

into a larger and more substantial home by a later generation. For Wood the modified house documented more than Hoover's humble birth: it symbolized the frontier's giving way to small-town America. Wood's first idea for his painting was to make this historical development explicit, showing both the 1870s structure and the contemporary view of the house, a device he knew from his study of nineteenth-century atlases and prints. When earlier draughtsmen had made drawings of farms and residences for county atlases, they sometimes included, in an insert, a view of the log cabin or sod hut that had formerly stood on the site in order to point out the material progress made by a family on a particular property. Wood did the same in his preparatory drawing for *The Birthplace of Herbert Hoover*, putting a tiny view of the original cottage in the lower left to contrast with the conglomerate structure shown in the center

of the painting. But in the finished work Wood eliminated the cottage altogether and dramatized the ordinariness of the Scellers house, letting it speak its own history. Using his usual brilliant light to spotlight and isolate the structure, Wood placed center stage this most ordinary and unexceptional house on an immaculate lawn of green and surrounded it by the most luxuriant shade trees and bushes. Except for the accident of a single birth, no one would have cared about it. He intentionally spoofed the American habit of enshrining meaningless monuments, yet at the same time he offered his own kind of homage to midwestern history and vernacular architecture. With his knowledge of building styles, Wood seems to have delighted in the hodgepodge quality of this late-nineteenth-century, do-it-yourself complex—a structure that says so much about the Midwest's effort to transcend its rude and simple beginnings.

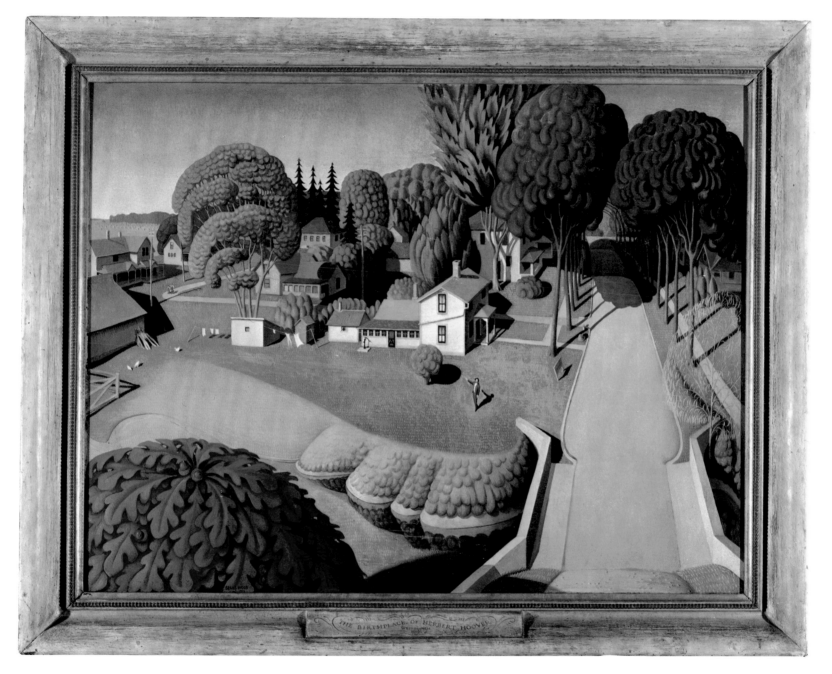

Plate 11
THE BIRTHPLACE OF HERBERT HOOVER **1931**
Oil on composition board, 29 5/8 × 39 3/4 in.
The Minneapolis Institute of Arts and the Des Moines Art Center

MIDNIGHT RIDE OF PAUL REVERE 1931

So through the night rode Paul Revere;
And so through the night went his cry of alarm
To every Middlesex village and farm,—
A cry of defiance, and not of fear,
A voice in the darkness, a knock at the door,
And a word that shall echo forevermore!
For, borne on the night-wind of the Past,
Through all our history, to the last,
In the hour of darkness and peril and need,
The people will waken and listen to hear
The hurrying hoof-beats of that steed,
And the midnight message of Paul Revere.

 —Henry Wadsworth Longfellow,
 "The Landlord's Tale," *Tales of a Wayside Inn*,
 1863

Like most American children, Wood learned about Paul Revere's historic ride through Longfellow's famous poem. So taken was the young boy by Revere's call to arms to his fellow citizens against advancing British soldiers that he imagined himself the same kind of hero to farmers, "warning the people of a dreaded 'cyclone' and being handsomely praised when the storm was over and everyone had been saved."[22] Thirty years after his childhood fantasy, Wood painted his early hero in *Midnight Ride of Paul Revere*.

Because his painting is playful, reducing the hero to a tiny figure on a rocking horse, some claimed that Wood was being irreverent, that he had been influenced by the iconoclastic debunking mind-set of the 1920s. Some interpreters allied Wood with H. L. Mencken, who caustically ridiculed mass American tastes and idols, and with those historians who wrote brutally realistic biographies, turning Lincoln into "a small-town politician, Washington a land grabber, Grant a stubborn and conceited mule, and Bryan an amusing idiot."[23]

Although he was lighthearted, it is wrong to group Wood with the debunkers of the 1920s. He had much more in common with the Americana collectors and preservationists of the 1930s. His aim was not to destroy or demythologize American heroes and legends so much as it was, in his words, to save "bits of American folklore that are too good to lose."[24]

He wanted to instill new magic and charm into old fables so they would not, in the wake of the iconoclasts, be lost forever. He was concerned, the artist said in 1939, that "a valuable and colorful part of our national heritage is being lost as a result of the work of analytical historians and debunking biographers."[25] His attitude was, in some ways, like that of Constance Rourke, a historian who collected examples of American humor and published in 1931 a pioneering study arguing that Americans had a hitherto unrecognized indigenous literature of legends and myths. Although Wood was not an influential thinker like Rourke, he shared her conviction that America had a rich literature of legends and character types. His paintings of turn-of-the-century midwestern farm life were about regional lore, just as his paintings of American heroes were reinterpretations of national legends.

That Wood chose to depict a legend about Paul Revere, a colonial figure—and later, in 1939, a folktale about George Washington—is not surprising, for the artist was, like other Americans at the time, caught up in the country's mass enthusiasm for things of early-American vintage, particularly for colonial- and federal-period history, antiques, and architecture. In the late 1920s, we have seen, the artist designed neocolonial houses in Cedar Rapids and painted, for one of them, an overmantel, a colonial form of decoration. When in 1931 Edward Rowan invited him to inaugurate the "Better Homes Room" in the new facility for the Little Gallery, a room set aside to instruct people in home decoration, Wood created "an Early American Room with Tendency Towards Farmhouse Colonial." He was among those whom Russell Lynes described in his book on American taste as sustaining a neocolonial revival, one that became so fashionable that "wagon wheels became ceiling fixtures; cobblers' benches became coffee tables; black caldrons and kettles hung on irons in fireplaces."[26] To modernists like Lewis Mumford, this revivalism in the 1920s was sentimental and excessive. "The last touch of

absurdity," he observed in 1929, was a government bulletin suggesting "that every American house should have at least one 'early American' room."[27]

Midnight Ride of Paul Revere is, then, like early-American rooms in private homes or John D. Rockefeller, Jr.'s restoration of Williamsburg, Virginia—a part of a much broader neocolonial preservation movement. What confuses people, however, is Wood's whimsy and humor, which to those who take their heroes seriously seem contemptuous. Indeed, Wood is not sanctimonious about the American past and makes it clear that what unfolds, as we peer down from our bird's-eye perch, is not the "truth," but a storybook tale, a piece of childhood fantasy and make-believe. Painted in a deliberately American folk, or neolimner, style, the painting re-creates something of the wonder and delight the artist had experienced in learning the legend as a child. Wood imagined the New England town as colonial buildings made out of children's blocks and put his hero on a hobby horse (Wood borrowed one to use as his model). The landscape is totally make-believe; to many it looks more like Iowa than Massachusetts. It is an enchanted place in which roads and rivers glow as they ribbon their way through papier-mâché hills. The light in the painting is as unreal and magical as the luminescent road. The houses Revere has already visited, even those in the village several miles in the distance, are aglow in yellow light (no authentic candlelight here) and the moonlight mysteriously lights up only center stage, leaving the rest of the landscape in uncanny darkness. To enjoy this painting is to suspend belief and to surrender to its fantasy, rediscovering, perhaps, for one brief moment, the memories of childhood.

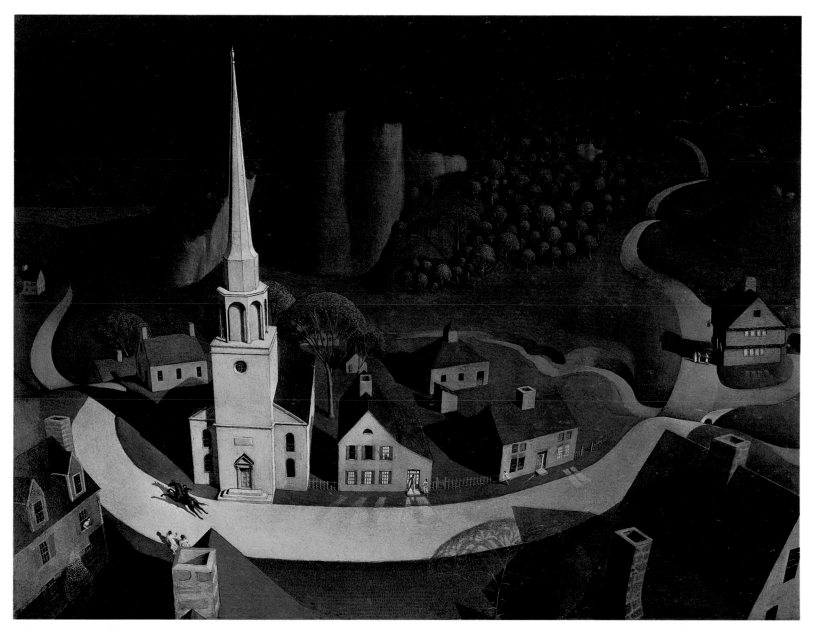

Plate 12
MIDNIGHT RIDE OF PAUL REVERE **1931**
Oil on composition board, 30 × 40 in.
Copyright © 1982 By The Metropolitan Museum of Art, Arthur
Hoppock Hearn Fund. Courtesy Associated American Artists,
New York

VICTORIAN SURVIVAL 1931

Like other of Wood's paintings, *Victorian Survival* is about culture shock, about the unbridgeable gulf between the rural, Victorian world in which he had been raised and the modern, urban one he lived in as an adult. It would be the burden of Wood's generation to be continually aware of how different the world of the 1930s was from what it had been in the 1890s. Artists felt obliged either to celebrate those differences—as did the Precisionists, who idolized the new technologies in paintings of steamships, locomotives, and factories—or to mourn them—as Wood did through pictures that address the tension and losses suffered by provincial America in adjusting to the modern age. If one looks through the humor, one sees in Wood's work the same sensitivity to accelerated change that can be found in Edward Hopper's and Walker Evans's images of decaying post–Civil War American architecture. All speak to the sturdiness, elegance, and independence of late-nineteenth-century America being displaced by the modern world.

In *Victorian Survival*, a lady sits for her portrait, appearing as she might in an enlarged late-nineteenth-century photograph. Painted in sepia tones, its corners rounded by a custom-made frame, the portrait would be at home with the daguerreotypes, red velvet family album, and stereopticon cards on the table in a Victorian parlor. For accuracy, the artist took his image from one of his own family photographs, a tiny tintype of his great-aunt Matilda. To accentuate her primness he made his Aunt Tillie appear much more stiff and self-contained in the portrait than the relaxed figure in the photograph. Her world, he wants us to understand, was exceedingly upright and private, guided by the strict rules and genteel proprieties of late-nineteenth-century America.

All the more shocking, then, to see a modern telephone where one expects a vase of flowers or a Bible. The phone, on the table to her right, mocks everything the woman represents. Whereas she is old-fashioned and set in her ways, the dial phone—whose long neck parodies hers—is the most progressive instrument of the day.[28] She is reserved and repressed, but the phone is perky and alive, stretching like a daffodil to the sun, inviting someone to pick it up and talk into its mouthpiece. There is no way, the artist suggests, for the prim Victorian world of the woman, closed to outsiders and expressions of emotion, to adjust to the jangling, intrusive world of the telephone. They are creatures from two completely different social systems; the phone is the victor, Aunt Tillie the victim.

Victorian Survival is a very biographical portrait for Wood. The woman represents a composite of his maiden aunts: not only Aunt Tillie, whom, despite the ring on her finger, Wood describes in his biography as unmarried, but also Aunt Sarah, his father's spinster sister with whom Wood spent a great deal of time as a boy. Aunt Sarah was literary and church-minded and felt it her obligation to educate the young boy by reading to him and taking him to church and, on one memorable occasion, to the theater to see *Uncle Tom's Cabin*. Wood found her both exciting and oppressive. She was more learned and aspiring to culture than others in his family, but she was also extremely austere. She pulled her hair back so tightly that he wondered as a child "how she could close her eyes at night."[29] Given the humor in this painting, there is no doubt but that Wood had mixed feelings about these arch Victorian types, including those presented in *American Gothic*. He could readily see their faults and excesses, but as he realized that their breed was disappearing, he became sentimental and memorialized them in his paintings.

119 Hattie Weaver Wood as a child. (Grant Wood Collection, Davenport Art Gallery)

120 Wood's appreciation for his Victorian past began early. As a high school student in 1908, he based this yearbook drawing on a photograph of his mother as a child. Twenty-three years later, Wood resurrected the same female type for *Victorian Survival*. (Grant Wood Collection, Davenport Art Gallery)

121 Matilda Peet, tintype, 3 1/2 × 2 1/8 in. (Grant Wood Collection, Davenport Art Gallery)

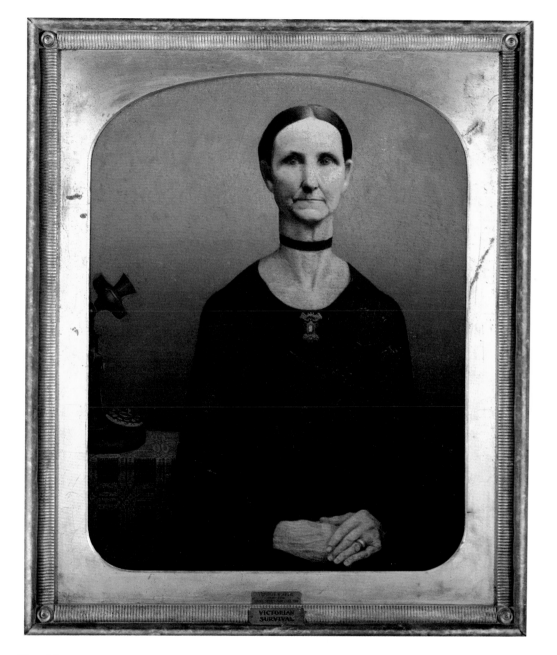

Plate 13
VICTORIAN SURVIVAL **1931**
Oil on composition board, 32 1/2 × 26 1/4 in.
Anonymous Collection

SPRING TURNING 1936

YOUNG CORN 1931

FALL PLOWING 1931

Wood's farm landscapes are, without a doubt, the most sensuous and passionate works he painted. Mingling eroticism with ecstasy, Wood made the relationship between the farmer and mother earth into a Wagnerian love duet. While mother earth is always the principal protagonist, overwhelming the farmer in scale and vitality, she is always loving and benevolent. In Wood's idyllic farmscapes, man lives in complete harmony with nature; he is the earth's caretaker, coaxing her into abundance, bringing coherence and beauty to her surfaces.

Wood's way of describing the earth's goodness and fertility is an obvious one; he turned the landscape into a gigantic reclining goddess, anthropomorphizing the contours of fields and hills so that they look like rounded thighs, bulging breasts, and pregnant bellies, all of them swelling and breathing with sexual fullness. Within nature's fecund forms, Wood tucks a tiny farmhouse, the home of those who tend and order this gigantic living force. Like artists or seamstresses, the farmers make abstract art out of their fields. In *Spring Turning*, farmers guide horse-drawn plows to fashion the earth's surface into a gigantic quilt; in *Young Corn*, the farmer and his children tend herringbone rows of new plants; and in *Fall Plowing*, the farmers have lovingly arranged tidy rows of corn shocks and plowed fields into perfectly parallel furrows. In the foreground, the plow, which makes the furrows, is caught in midstroke, the moist earth lifted and curled around its blade like a mouth in embrace. An extraordinary image, it is the most erotic passage Wood ever painted.

Having grown up on a farm and witnessed the planting, growing, and harvesting of crops, Wood had firsthand knowledge of nature's ways and the farmer's tasks and routines. There were, he knew, particular chores for each season and a fixed cycle of colors and textures in the fields. In the spring the velvety green fields were plowed under and prepared for seed; early in summer the same fields, dotted with new growth, were hoed and weeded; and in the fall, after the golden fields had been harvested, the farmer tilled the soil again to prepare the ground for spring. Wood became rhapsodic about this repeating cycle, finding in it a primal rhythm of midwestern life, a clock by which the indigenous folk lived. Though he was not a conventionally religious man, he was absolutely reverential toward the farmer, his work, and his relationship to the land. "The rhythms of the low hills," he said in his biography, "the patterns of crops upon them, the mystery of the seasons, and above all, a feeling for the integrity of the ground itself—these are my deep-rooted heritage."[30]

The farm Wood celebrates is that of his childhood, not the 1930s farm of tractors, trucks, and cultivators. The farmer does not ride a noisy, gas-engine tractor in Wood's paintings, but walks, as Wood's father did, in quiet solitude behind the horse-drawn walking plow, the kind of plow which stands, like a religious relic, in the foreground of *Fall Plowing*. This is "The Plow That Broke the Plains," to use the title of Pare Lorentz's movie of the period, the self-scouring steel plow invented by John Deere to help midwestern pioneers turn the rough and sticky prairie sod into farmland. It was this simple tool with its elegant lines, Wood marvels in *Fall Plowing*, that transformed uncultivated, tough prairie lands into bountiful fields of hay and corn.

Wood's benign, idealized view of nature was criticized in the 1930s for being too gentle and for ignoring the "dust storms and droughts, slaughtered pigs, unsown crops, or crops ploughed under" in the Depression.[31] But this was to suggest there was only one appropriate response to hard times: to paint them head on. Wood's response, as we have seen, was much more sentimental and optimistic. Although he was a great admirer of John Steuart Curry's bleak view of farm life— of tornadoes, floods, and vicious animals—his own art celebrated the beauties of the Midwest and mythologized the farmbelt as America's "fertile crescent." He painted visions of past peace and plenty, not records of hardships or tragedies. Call it escapist or nostalgic, this was a common artistic response running throughout the decade's films, mural paintings, and literature. Instead of giving in to the harsh reality of the times, one vanquished despair by conjuring up visions of better times. As a historian of 1930s mural painting has persuasively argued, the "sensibility of the 1930s" was to defy fear, to reject "realism in favor of hopes and dreams. . . . Depression America believed passionately in a verifiable, usable past of happiness and plenty."[32]

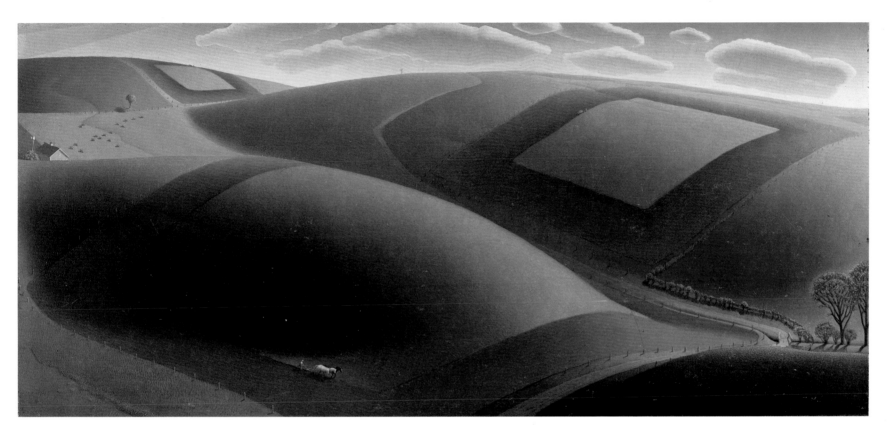

Plate 14
SPRING TURNING **1936**
Oil on masonite panel, 18 1/8 × 40 in.
Private Collection. Courtesy James Maroney

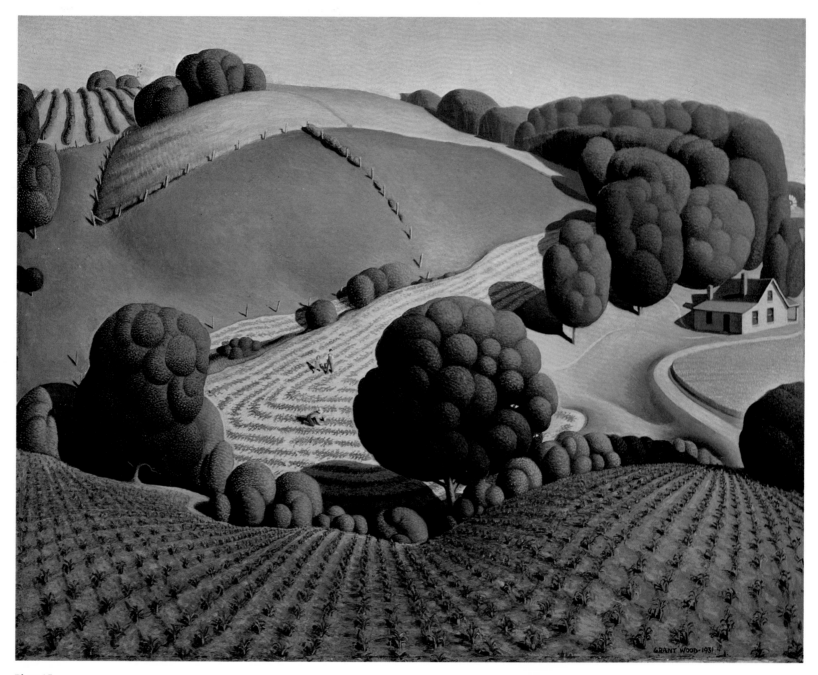

Plate 15
YOUNG CORN **1931**
Oil on masonite panel, 24 × 29 7/8 in.
Cedar Rapids Museum of Art, Cedar Rapids Community School
District Collection

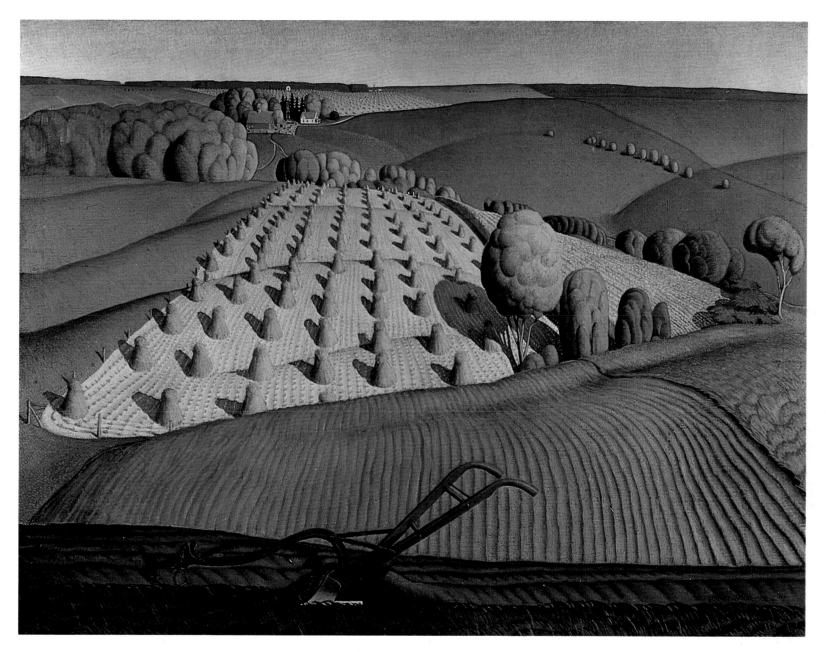

Plate 16
FALL PLOWING **1931**
Oil on canvas, 30 × 40 3/4 in.
The John Deere Collection, Moline, Illinois

FRUITS OF IOWA 1932

Wood looked at the Midwest very much as a cultural anthropologist might. He stressed the distinctiveness of different cultures, seeing each one as an amalgam of its own peculiar customs, mores, and sexual patterns. In Wood's view, farming was his region's dominant culture. When he painted the farmer and his family, Wood portrayed them not as particular individuals, but as typical members of a particular cultural type. He clothed them in generalized "tribal" dress (bibbed overalls for the men; long, simply cut dresses for the women) and presented them performing tasks typical of their age or gender; men worked in the fields, women in and around the house, children as helpers.

Wood's anthropology was not, however, the least bit scientific, as we can see in his wall decorations for the coffee shop at the Hotel Montrose. He romanticized the farmer and his family just as he did the farmscape. Their clothes are immaculate, their faces red from the sun, and their produce and farm animals as plump and healthy as the figures themselves. Indeed, plumpness is everywhere: the fat pigs and the cow's bulging belly, the rounded vegetables and melons, the matronly figure of the mother, and the chubby feet and fingers of the farmer's son all speak of natural goodness and wholesomeness. The key to their well-being, we are led to believe, is that they know the satisfaction of working the land. Their hands are dramatized in each and every panel: hands hold fruit and vegetables, hands feed chickens, and hands milk a cow.

What saves these paintings from oversentimentality is their good humor, a device Wood constantly used to keep from being idolatrous of his subject. Many of his regionalist colleagues aggrandized the farmer, classically idealizing his features and making him a heroic, herculean figure. Wood painted his farmers big—the figures are each about four feet tall—but kept his images lighthearted, the stuff of storybook tales, not classical mythology. The farmer here is big and burly, but hardly an Adonis; he wears a playful polka-dot shirt and has the corner of a red handkerchief peeking out of his pocket. At his feet there is a dainty daisy bush and two porky pigs with bright pink snouts, their legs too short and stumpy to hold up their chubby girth.

Given that these were decorations for a public dining room, Wood's funniest and most irreverent invention was the rear view of the cow being milked by the hired hand. The artist's original drawing for the painting shows the cow from the side, with the seated boy's back to the viewer, a much more decorous perspective. But in the final painting, it is the cow's backside that faces us. We cannot see the animal's head, only her fat rump and the sides of her warm belly, against which the boy nestles his cheek and whistles while he works. But what a magnificent rump it is! Perched on the most elegant and feminine of hoofs and divided down the middle by a tail that looks like a stylized paint brush, this bovine's body is a perfection of nature. Each side of the calico creature is a mirror image of the other. While one might think it poor taste to dine face to face with a cow's haunches, Wood made the experience utterly memorable.

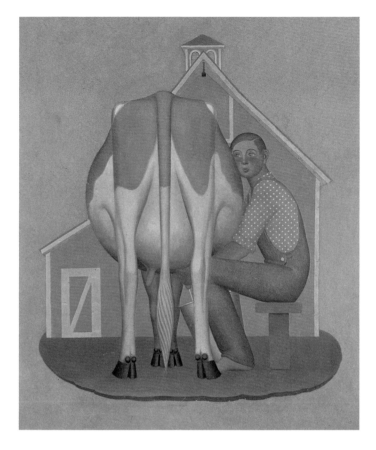

Plate 17
BOY MILKING COW 1932
Oil on canvas, 45 1/2 × 39 1/2 in. (image), 71 1/4 × 63 1/4 in.
(canvas)
Coe College, Cedar Rapids, Iowa, Gift from the Eugene C. Eppley
Foundation

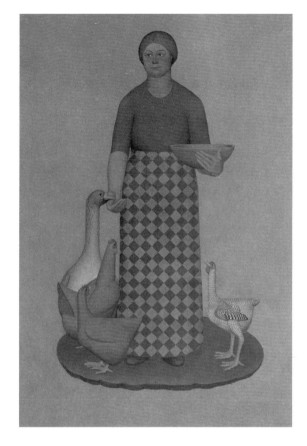

Plate 18
FARMER'S WIFE WITH CHICKENS 1932
Oil on canvas, 45 × 27 1/4 in. (image), 71 1/4 × 49 in. (canvas)
Coe College, Cedar Rapids, Iowa, Gift from the Eugene C. Eppley
Foundation

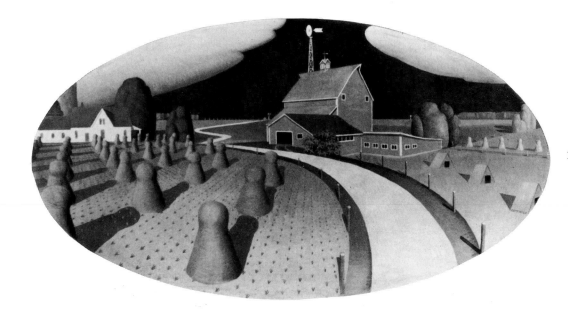

122 FARM LANDSCAPE 1932
Oil on canvas, 23 1/4 × 45 1/2 in. (image),
43 3/8 × 64 1/2 in. (canvas)
Coe College, Cedar Rapids, Iowa, Gift from the
Eugene C. Eppley Foundation

123 BASKET OF FRUIT 1932
Oil on canvas, 12 1/2 × 16 1/2 in. (image),
29 3/8 × 32 1/4 in. (canvas)
Coe College, Cedar Rapids, Iowa, Gift from the
Eugene C. Eppley Foundation

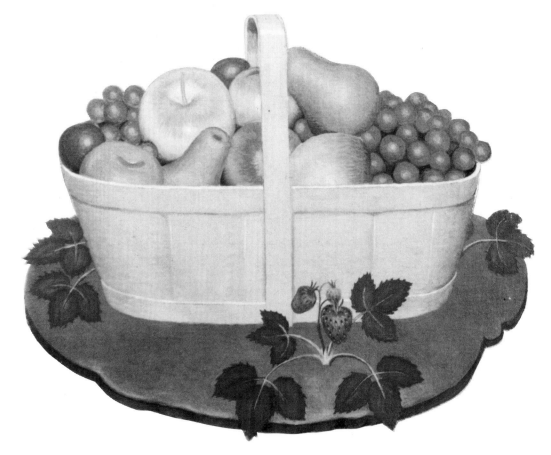

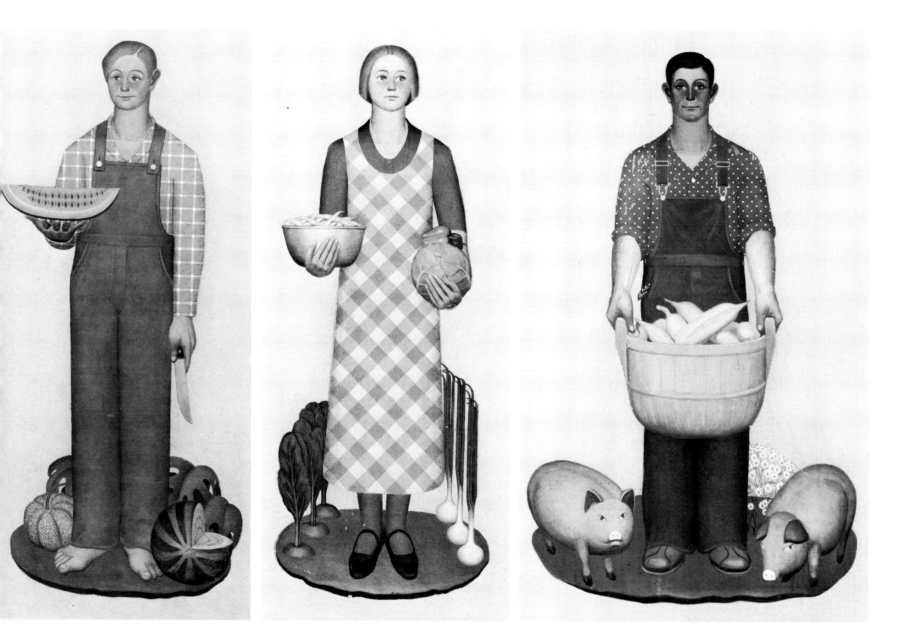

124 **FARMER'S SON** 1932
Oil on canvas, 45 3/4 × 19 1/4 in. (image),
71 1/4 × 38 3/4 in. (canvas)
*Coe College, Cedar Rapids, Iowa, Gift from the
Eugene C. Eppley Foundation*

125 **FARMER'S DAUGHTER** 1932
Oil on canvas, 45 1/2 × 18 in. (image),
71 1/4 × 38 3/4 in. (canvas)
*Coe College, Cedar Rapids, Iowa, Gift
from the Eugene C. Eppley Foundation*

126 **FARMER WITH PIGS** 1932
Oil on canvas, 46 1/4 × 28 1/2 in. (image),
71 1/4 × 49 1/4 in. (canvas)
*Coe College, Cedar Rapids, Iowa, Gift from the
Eugene C. Eppley Foundation*

DAUGHTERS OF REVOLUTION 1932

In 1932, many tea cups were raised, trees planted, lectures given, and colonial balls danced in honor of the bicentennial of George Washington's birth. And at least two important, but wildly divergent, paintings of George Washington were made during the year. One, a wide-eyed and vulnerable *George Washington*, was the last painting by Alfred Maurer, the New York Cubist painter, before he took his life; the other, by Grant Wood, depicted three smug women toasting an image of the heroic Washington crossing the Delaware. Though Washington's birthday had been a national holiday since 1857, this was a special year. The government's George Washington Bicentennial Commission, having been at work for six years, arranged international celebrations, put Washington's bust on two stamps, and saw to it that reproductions of Gilbert Stuart's Athenaeum portrait of the first president were distributed to classrooms across the country. Celebrations were held everywhere, the ones in Cedar Rapids typical of those held in towns and cities across the country. On the Saturday night before the holiday the Little Gallery sponsored their third annual Beaux-Arts ball featuring costumes "in the colonial garb of George Washington's administration." An exhibition at the gallery of costumes and books helped people invent their masquerades. Wood, who loved costume parties, was on the ball's organizing committee, served on the jury for costume awards, and won a prize himself for his getup as the man on the Quaker Oats box.[33]

That same evening the local chapter of the Daughters of the American Revolution, some 170 members strong, held a birthday dinner for George Washington at the Hotel Montrose. It was a tradition with the Daughters to hold colonial teas on Washington's birthday, often in eighteenth-century costume. The year before, the Cedar Rapids group had also decorated a window of the Little Gallery with eighteenth-century "relics"—a spinning wheel, a sampler, candlesticks, and oil lamps, all arranged around a portrait of Washington

and an American flag. During the bicentennial year they began each monthly meeting with four-minute talks on George Washington (for example, "Washington—the Christian," "Washington—the Leader of Men") and, as part of a national program, they planted a George Washington Memorial Elm on Island Plaza not far from the building where Wood had installed his Memorial Window. With an appropriate ceremony, they placed a plaque on the tree bearing the DAR insignia.[34]

This ceremony probably opened an old wound with Wood. Because of interference from the local chapter of the DAR and the Legionnaires, his Memorial Window, installed in 1929, had never been dedicated. The stone for the inscription, at the lower edge of the window, stood empty. After the window had been installed, a few Legionnaires and Daughters had caused a ruckus in Cedar Rapids about its having been manufactured in Germany. It was an insult to America's ideals and workers, they had insisted, to have had a memorial to the soldiers of the nation made in the country of its most recent enemy. The controversy became so heated that the memorial commission kept putting off the dedication until 1955, long after the artist's death.[35]

Wood therefore had several reasons to paint his *Daughters of Revolution*. First, he wanted to comment on the country's Washington mania. For this the DAR were a perfect vehicle, for they had long been visible nationwide for their annual celebrations of George Washington's birthday, but never more so than in 1932. Privately, Wood had another motivation; he wanted to settle an old account with an organization whose superpatriotism and superior airs had kept him from having been properly recognized for his work on the Memorial Window. There may also have been another kind of motivation, a purely artistic one. In 1930 Edward Rowan had mounted a large exhibition of the work of Charles Hawthorne, an Illinois-born painter, that included one of Hawthorne's finest works, *Three Women of Provincetown*. Wood could not help

127 Alfred Maurer, *George Washington*, 1932, Portland Art Museum, Gift of Mr. Jan de Graaff.

but have studied Hawthorne's work while it was in Cedar Rapids, for Rowan praised the painting highly and thought enough of the artist to raise $10,000 to purchase one of his figure paintings for the Little Gallery collection. (The Little Gallery paid $300 for *Woman with Plants*.) Somewhere in the back of Wood's mind there may well have been the challenge to do a midwestern version of Hawthorne's powerful painting of three New England matrons.[36]

Along with *Appraisal*, *Daughters of Revolution* represented Wood's first invention of urban rather than rural types. Knowing full well that the painting would be controversial, the artist did not dare use local models, although he did ask his friend Frances Prescott, the school principal under whom he had taught, to pose her hand and hold the teacup. Otherwise he sought information from the DAR annuals il-

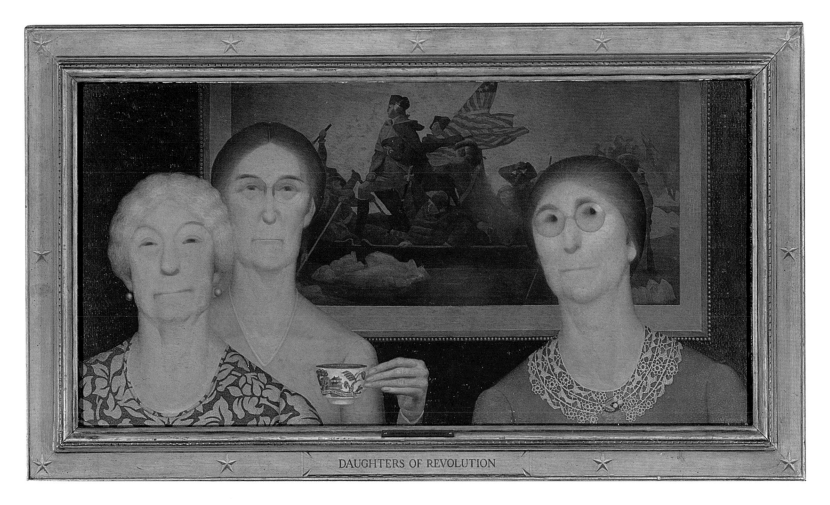

Plate 19
DAUGHTERS OF REVOLUTION **1932**
Oil on masonite panel, 20 × 40 in.
The Cincinnati Art Museum, The Edwin and Virginia Irwin
Memorial. Courtesy Associated American Artists, New York

lustrated with photographs of the association's officers and members planting trees and holding their teacups aloft. From these photographs he conjured up three Daughters and stood them against a framed reproduction of Emanuel Leutze's well-known 1851 painting, *Washington Crossing the Delaware*. A photograph of the painting had appeared in the *Cedar Rapids Gazette* on Washington's birthday in 1931 and may well have formed a part of the DAR's window in the Little Gallery that year.[37] The painting itself, over twenty-one feet long, had made national news in the fall of 1931 when the press discovered that it was not on permanent view but rolled up in the basement of the Metropolitan Museum of Art in New York. When museum officials agreed to show

it as part of the bicentennial celebrations of Washington's birthday but announced that the painting was neither "a masterpiece" nor "an accurate historical record" and would not be kept on permanent exhibition, patriots of all stripes, including the DAR, raised protests and offered to relieve the museum of the painting and place it in a public building where it could be viewed year-round.[38]

Wood's painting, spoofing the DAR's worship of Washington and their excessive pride in having descended from soldiers who fought in the Revolutionary War, was, the artist admitted, his only satire. Referring to the painting as those "Tory Gals," he characterized the DAR as "people who are trying to set up an aristocracy of birth in a Republic."[39]

To convey their false claims to nobility, he created a composition in which their tightly closed mouths, stiff poses, and unmoving eyes are played off against the gallant dynamism portrayed in the painting behind them. While Leutze's *Washington Crossing the Delaware* conveys heroic action, the Daughters' raising of a teacup is staid and inconsequential. The cup itself, a piece of Blue Willow china, is significant, for it implies, in this context, ancestral worship. Having been brought overland from the East by settler families, Blue Willow china was a much valued heirloom in the Midwest. Being a descendant of an original settler was almost as good as being a descendant of an infantryman in the Continental army.

The hand holding the teacup tells us more about the Daughters. It is ringless, which suggests the woman is a spinster, and it is thin and bony, looking very much like the chickens' feet in some of Wood's other paintings. All the women, in fact, with their long necks, toothless mouths, beaklike noses, piercing eyes, and perfectly rounded hairdos, bear more than a faint resemblance to farmyard creatures. It is hardly coincidence that their expressions are the same ones Wood later gave to the three chickens in *Adolescence*.

Wood also took a gibe, perhaps unwittingly, at the Daughters' xenophobic response to his Memorial Window having been made in Germany. For unbeknownst to the three ladies who sanctimoniously raise their cup to their favorite painting of Washington, it too had been made in Germany. Although the painter of *Washington Crossing the Delaware*, Emanuel Leutze, had spent long periods of his life in America and was a fervent patriot, he was born in Germany and had painted his famous picture, and a replica of it, while living and teaching in Düsseldorf. We cannot be sure that Wood knew these facts about Leutze, but it is tempting to think he did since Leutze's "Germanness" had been a topic of national controversy during the artist's lifetime. In 1918, at the height of anti-German sentiments in this country, Dr. Bernard J. Cigrand at the University of Illinois wrote an article claiming that *Washington Crossing the Delaware* had German blood in it. According to the caretaker of

128 Charles Hawthorne, *Three Women of Provincetown*, c. 1921, Mead Art Museum, Amherst College, Amherst, Massachusetts.

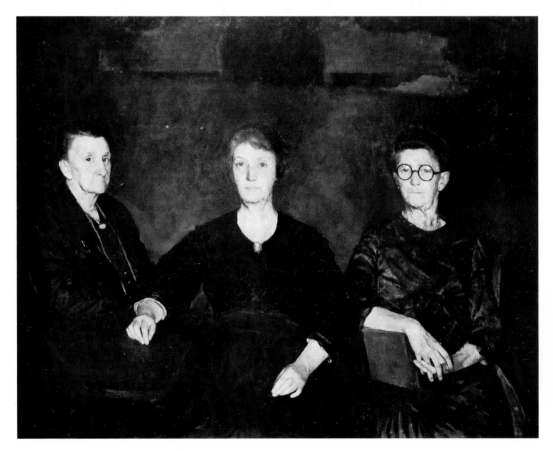

Leutze's birthplace, Dr. Cigrand reported, the artist had "used the Rhine" for his model of the Delaware and "'German soldiers' for models of the Americans."[40] Although there is excellent evidence to the contrary—Leutze used American students in Düsseldorf as models—the story was picked up by the press and widely printed across the country. It surfaced again in 1931 when newsmen discovered that Leutze's great icon was in storage at the Metropolitan Museum. Although museum officials were not concerned about the German content of their painting, the public was. At this point Will Low, a well-known artist, reported that Leutze had not only used German models for Washington's army, but posed a German laundress as the model for Washington![41]

Knowing of Wood's local troubles with the DAR and the national controversy over the use of German models in *Washington Crossing the Delaware* makes the artist's decision to pose the Daughters against Leutze's painting more delicious. It is his final vindication for the troubles he had suffered over the dedication of the Memorial Window. Even without such knowledge, however, the painting is spicy enough. It was hung in a specially made wooden frame with trompe l'oeil "American" stars along its edges and a trompe l'oeil cartouche with the title in the center. The painting attracted plenty of comment when it was exhibited first in the Whitney Biennial and then at the Carnegie International exhibition in Pittsburgh. Wood had carefully avoided libel suits by eliminating the word *American* from the title, calling the painting *Daughters of Revolution* rather than *Daughters of the American Revolution*. But this fooled no one and only sharpened the sting. Linking three such complacent faces with revolution was not just ironic but patently absurd!

As might be expected, various members of the DAR took offense, finding the painting "grossly unjust" and completely "unfair to many families that take pride in the fact that their fathers made possible this great nation."[42] Wood said the Daughters in Baltimore considered him a subversive "red" and were having him investigated by the Board of Immigration.[43] Several years later the San Francisco chapter of the DAR condemned the work as "disrespectful . . . scandalous . . . and destructive of American traditions" and demanded it be withdrawn from public exhibition at a local museum.[44] But all these protests came to naught, and many Daughters were reported as thoroughly enjoying the lampoon. After the success of *American Gothic*, the public had come to expect this kind of painting from Wood. *Daughters of Revolution* confirmed their impression of him as an incisive commentator on manners and stereotypes. Indeed, after *Daughters of Revolution* some people, particularly those in the East, typecast Wood as a satirist and took little notice of his affectionate landscapes and rural scenes. So well versed were they in H. L. Mencken, Sinclair Lewis, and Carl Van Vechten that they could only appreciate paintings that made the Midwest the butt of humor. Much of the present-day ignorance about Wood's range of subjects and versatility as a painter flow from this bias.

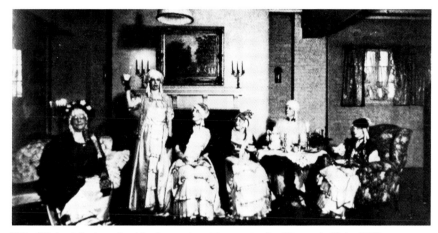

129 "Colonial play given by Lycoming Chapter in the Women's Club, Williamsport, Pa., in celebration of Washington's 200th Birthday Anniversary." (*DAR Magazine*, July 1932)

130 "The President General, Mrs. Hobart, and Distinguished D. A. R. Officials, at the Residence of Mrs. William McPherson, Elizabeth, N.J., just before the reception given by Boudinot Chapter." (*DAR Magazine*, April 1930)

PORTRAIT OF NAN 1933

Wood had asked his younger sister Nan to model for him on several occasions; she had posed for the allegorical figure in the Memorial Window and had drawn "her face out long" to become the dour and humorless woman in *American Gothic*.[45] Feeling, however, that she deserved better, he asked her to sit for a portrait; he wanted, he said, to make up for the abuse he had subjected her to in *American Gothic*.

In that painting, the artist had his sister pull her fashionably marcelled hair back from her face and put on a plain, old-fashioned dress. He made her into a character of his own invention. But in her portrait the artist wanted her to look as she always did, stylish and contemporary. To accommodate his "decorative" style he asked her to wear a bold pattern; the two of them fashioned a blouse to fit the artist's specifications. Wood carved a stamp out of a round of potato and printed large polka dots at regular intervals on an old bedsheet. Nan sewed the homemade fabric into a blouse, putting jaunty black ribbons at the shoulders to echo the scalloped waves of her hair.

Wood designed the portrait of his thirty-three-year-old sister along the lines of an early-American portrait, as if she were sitting in the eighteenth century for John Singleton Copley or Charles Willson Peale. He painted her in an oval—a shape favored during both the colonial and Victorian periods—seated in a Hitchcock chair. The green curtain behind her was held back by an antique drapery knob. In her hands he placed two rather odd attributes, a baby chick and a ripe plum. Both, the sitter has always maintained, were chosen for decorative reasons. The artist liked the chicken—which Nan had just bought at a dime store as a household pet—because it echoed the color of her hair. The plum reiterated the shape of the dots in her blouse and repeated the rose color of the wall behind her. Both items, however, must have had greater significance for the artist; he never chose attributes for his sitters on stylistic grounds alone. He undoubtedly liked the chicken because as it perched, young and vulnerable, in the cupped hand of his sister it conveyed her tenderness—and the plum because as an artistic convention fruit has always symbolized femininity. Furthermore, a farm animal and piece of fruit, both nature's goods, represented for Wood all that was beneficial and wholesome about the Midwest.

This was the only work in his mature style that the artist kept for himself. He liked it so much that he made it the centerpiece of his living room in Iowa City. He placed it over the fireplace and chose the rose fabric for a chair, the dark green drapes at the windows, and the flowered wallpaper to complement the colors and shapes in the painting. He also made a coffee table out of an oval Victorian frame to repeat the painting's shape.

Wood's fondness for the portrait, a tribute to his favorite sibling, was not always apparent to others. Many viewers in the East were convinced that Wood was a satirist, an H. L. Mencken of the Bible Belt; one of them, the critic Emily Genauer, saw in the portrait "all the bigotry, stupidity, malice and ignorance which are rife in the provinces, and are Wood's special targets."[46] Such remarks must have pained the artist, not only because they offered such an insensitive misreading of the painting, but also because they so clearly revealed the depths of the New York intellectual's prejudice against provincial America. He must have wondered how, in such a climate, he ever could get people to see what he valued in rural and small-town America.

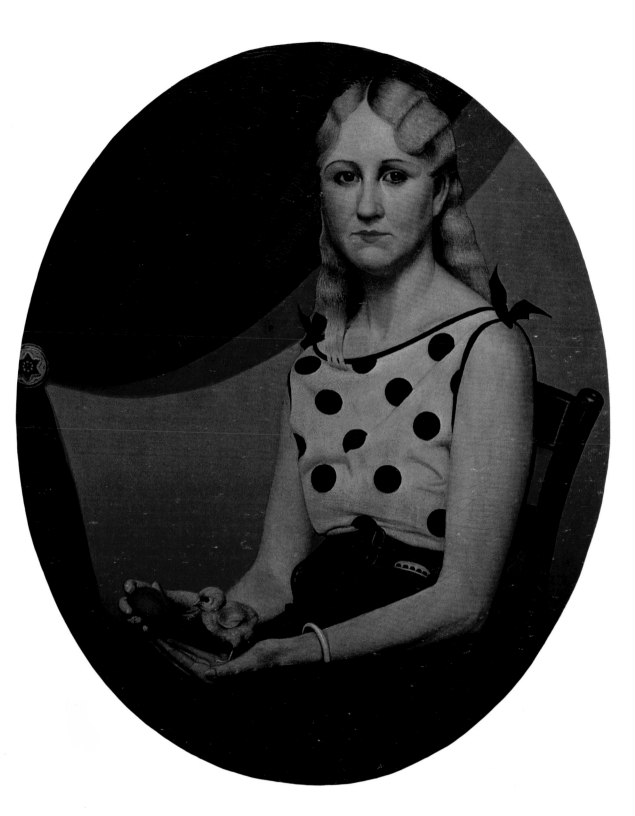

Plate 20
PORTRAIT OF NAN 1933
Oil on masonite panel, 40 × 30 in.
On loan to the Elvehjem Art Museum,
University of Wisconsin, Madison

ARBOR DAY 1932
DINNER FOR THRESHERS 1934

On the lefthand side of *Dinner for Threshers*, under the peak of the barn's roof, Wood painted the date 1892, the year he thought he was born. (For unexplained reasons Wood continually confused his birthdate, thinking it 1892 rather than 1891.) The painting was autobiographical, a recollection of Wood's memories of threshing dinners in the 1890s. Such dinners, we learn from Wood's unfinished biography, were annual events of tremendous excitement for farm families. One day in late July or August, after the grain had been cut and shocked, the threshing machine would arrive like an "immense fire-dragon," shaking the earth around it and calling the neighboring farmers to work with a blast of its whistle.[47] Each farmer would bring his own hayrack with which to pick up the shocks of grain in the fields and carry them in to be threshed. It was a communal arrangement that the farmers shared in for weeks, moving together from farm to farm to help their neighbors.

Every threshing day, on the dot of noon, the men swarmed in from the fields for dinner. The woman of the house had been busy preparing the feast for days in advance. Wanting her table to be as pretty and plentiful as possible, she brought out her best china and silver and prepared a banquet table by setting "three tables end-to-end in the sitting room, covering them with neatly overlapped cloths so that they looked like one. All available chairs, including the piano stool . . . were placed around the table." Young girls helped serve, and when there wasn't enough room at the table the sons in the family and the hired hand, as we can see from the painting, had to wait a second seating to get their dinner.[48]

Arbor Day depicts another annual event from the same period. On Arbor Day in the spring, a teacher and her students of all ages plant a tree outside their one-room country schoolhouse. In the corner of the school lot the little ceremony is taking place, the planting of the first tree to be seen for miles around. Wood painted the picture on commission from the Cedar Rapids school board as a memorial to two schoolteachers, one of whom was known to have planted a beautiful grove of trees, one each year on Arbor Day, to shelter and shade the country schoolhouse in which she had taught before coming to Cedar Rapids. Inspired by this story, Wood visited the teacher's former school and studied other rural schoolhouses in the environs of Cedar Rapids. He consulted, too, his own memories of going to a similar school as a young boy. Typically for Wood, he did not paint the rural schoolhouse of the 1930s, surrounded by full-grown trees, but as it looked in the 1890s, when it stood out on the barren landscape as the only community building in view. The painting, as a critic and friend of Wood's observed, was not only about the past, but about those "things that are fast being swallowed up in the modern civilization": the dirt roads leading to the one-room schoolhouse, the arrival of the students by foot and horse-pulled wagon, the hand pump for water, the shed for storing logs for the wood-burning stove, and the outhouse with its crescent moon on the door.[49]

Both of these paintings fill out Wood's anthropological picture of the farmer, showing him not only as a worker on the land but as a part of a larger community with its own institutions and festivities. As the artist celebrated the farmer's communion with nature, he also revered the rural family's participation in the annual rites, elevating them through his paintings into sacred rituals. In *Arbor Day*, Wood heightened the event by creating a stage, an island of land cut away from the surrounding roads and fields, on which he prominently placed the two most important "actors" in his rural drama: the schoolhouse and tree-planting ceremony. He then brilliantly lit the island, bewitching us with the magically glowing green grass, the pristine white schoolhouse, the figures frozen in action, and the immutable shadows cast upon the grass. Without aggrandizement of scale or melodrama, he rendered both the schoolhouse and the ceremony important and dignified.

In *Dinner for Threshers*, with the same sense of the dignity of the occasion, Wood called upon the traditions of Christian painting to sanctify the farmers' repast. He self-consciously based his design on early-Renaissance religious triptychs in which a sacred scene, usually depicting the Madonna and Child, appeared in the center panel, accompanied by saints or patrons in wings on either side. Often in these old-master paintings the figures are assembled in a pavilion or interior flanked by portals opening onto the landscape beyond. Wood ingeniously adopted this format, cutting, as it were, a farmhouse in half so we can witness the central event—the dinner—going on inside. In the "wings" of the painting we see auxiliary activities, the women cooking in the kitchen and the boys washing up on the porch. Although there are fourteen men at the table, there is no doubt that Wood presents the threshers' dinner as his midwestern version of the Last Supper.

Historian James Dennis has convincingly argued that these paintings of farm life should be seen within the great continuum of American art and literature which, since Thomas Jefferson, has depicted the good life as that of being in harmony with nature. They idealize, Dennis writes, the "fixed symbol of a yeoman tending his family farm by hand on a small-scale, subsistence level in complete harmony with his natural environment."[50] Wood's paintings also, we must add, contribute a peculiarly midwestern reworking of this agrarian myth: they are deeply imbedded in the history of the middle border and relay a vision of agrarian life that comes from a deep appreciation—held by many midwesterners of Wood's generation—for the human effort exerted in taming the prairie and founding a culture where before there had been none. In *Arbor Day*, Wood recounts for us the history of the Midwest. The cultivated fields and the farmer plowing in the background attest to the labors of the pioneers who turned sod into soil; in the middle ground, the schoolhouse signifies the next generation's founding of a community and institutions; and in the foreground the tree not yet rooted looks to the future—the beautification and civilizing of the countryside. Likewise, *Dinner for Threshers* rejoices not just in the fullness of agrarian life but in the establishment of community and social ritual on the frontier.

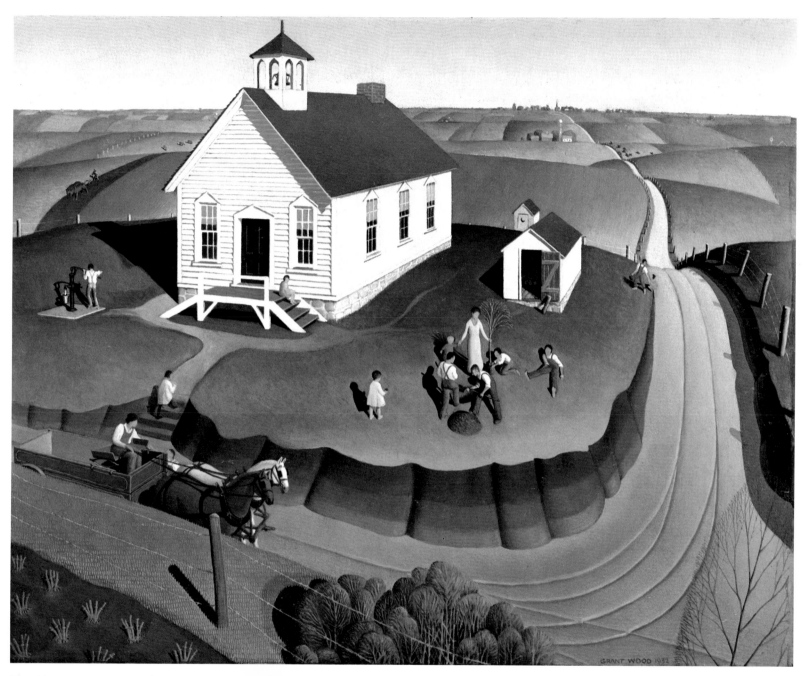

Plate 21
ARBOR DAY 1932
Oil on masonite panel, 24 × 30 in.
Suzanne Vidor

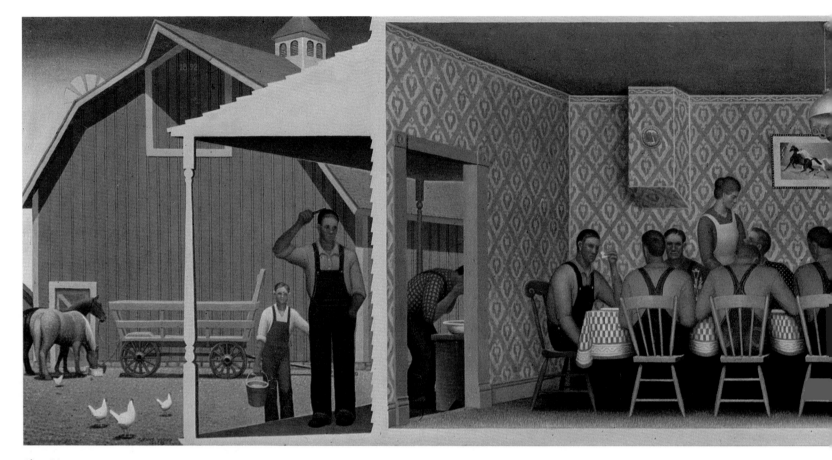

Plate 22
DINNER FOR THRESHERS 1934
Tempera on masonite panel, 20 × 81 1/16 in.
The Fine Arts Museums of San Francisco, Gift of
Mr. and Mrs. John D. Rockefeller 3rd

131 DRAWING FOR **DINNER FOR THRESHERS** 1934
Pencil on paper, 18 × 72 in.
Private Collection

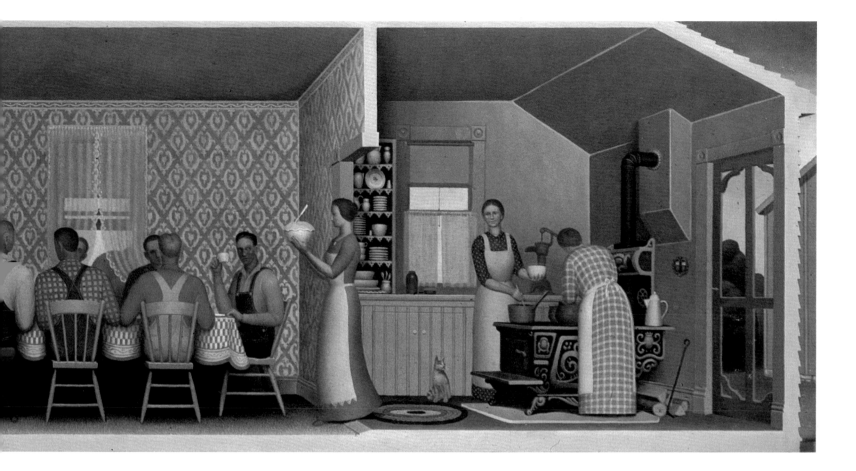

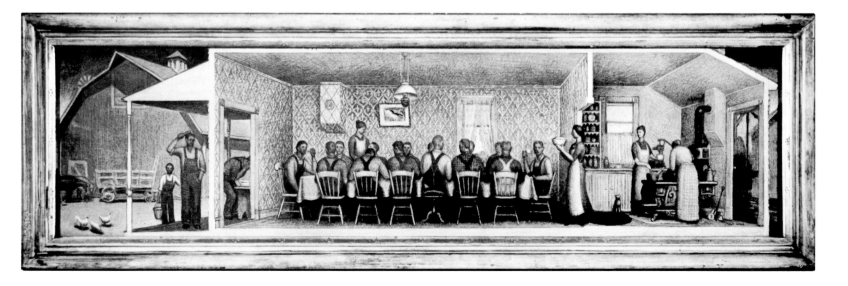

BREAKING THE PRAIRIE 1937

The 1231 square feet of Grant Wood murals in the library at the State University of Iowa in Ames were designed but not painted by the artist. They were created by artists under Wood's supervision in a workshop setting similar to those of Renaissance and Baroque artists in which assistants carried out the designs of the master. Wood's first workshop was an unused swimming pool at the University of Iowa in Iowa City, where he had been appointed to the faculty. The first series of murals to be completed were painted by Iowa artists on relief pay from the short-lived Public Works of Art Project, a state program which Wood directed out of the university from January to June of 1934. The second set of murals—*Breaking the Prairie*— were painted by students at the university in 1936 and 1937, some monies for the project being paid by the Works Progress Administration and National Youth Administration. Wood was paid as a faculty member at the university for teaching a "mural painting" course, while the student assistants received academic credit from the university and relief pay from the government for their work.

The murals were created along set lines of procedure, all of them following academic practice. Wood drew up the initial designs and did a pilot color study for each one. He then assigned Francis McCray, his principal assistant, the task of making full-size cartoons on brown wrapping paper and sent other students off to research the myriad details of the design. Wood prided himself on accuracy, on having the details correct for every farm implement, every piece of modern machinery, every costume, flower, and tree. When the drawings were finished and large pieces of canvas had been sized and primed, the students transferred the designs from the cartoons by running a sprocket wheel around every outline and forcing blue powder through the holes onto the canvas. Going over the powder outline with pencil, they were then ready to paint, each student taking on areas and details he was particularly good at rendering. Besides Wood, thirteen different hands worked on the first se-

ries of murals and seven on the second. Once completed, the canvases were shipped to Ames and glued to the walls.[51]

The program for the murals was inspired by an 1840 quotation by Daniel Webster: "When tillage begins, other arts follow. The farmers, therefore, are the founders of human civilization." Using the first half of the quote as his overall title, Wood intended to show the progress of civilization in Iowa from first tillage to present-day fine arts. He presented this history in three stages for users of the library to pass in sequence in entering the building and climbing the staircase to the reading room.

The first mural, located in an alcove opposite the main staircase, depicts the breaking of Iowan soil in the 1840s and the beginnings of the "art" of farming. The second set of murals in the series (but the first installed), affixed to the walls of the staircase, honors the "practical arts" that follow tillage—agriculture, veterinary medicine, engineering, science, and home economics—representing the five divisions of the university. A third mural group of six panels, showing the arrival and practice of the fine arts, was projected for the second-floor reading room but never executed.

Although Wood spoke of these mural projects as cooperative ventures, it was his philosophy, decorative style, and passion for detail that dominated them.[52] Only Wood would think of treating the stairwell walls as if each were a cross-section of a two-story building, making the pilasters on the library wall integral to his design; or decorating the interior of the home in which the women work with American antiques; or inventing feminine and graceful pigs; or choosing a color scheme emphasizing soft yellows and pinks that brings out the warm tones of the building's travertine. Seen against other government-sponsored murals of the period, Wood's are among the best. His style translated with ease into large-scale paintings. His self-contained, highly simplified figures can be read at a distance and the repeating patterns and abstract geometries he used were visually strong. The decorative abstraction of the streamlined surfaces of the dynamo, for example, is a superb piece of Precisionist painting; and the endlessly repeating

rows of tiny yellow "tubes" in *Breaking the Prairie* are wonderfully effective in conveying a carpet of prairie grass.

Of all the murals, *Breaking the Prairie*, installed in 1937, is the most memorable. A three-sided painting—a triptych form again—the mural celebrates the first pioneers and their labors in clearing and cultivating the land. On either side of the mural young, virile woodsmen clear a wood, trampling wildflowers and destroying flowering trees as they go. Progress, after all, has its price. In the center of the mural a pioneer stops to take water from his wife, who has brought a jug into the fields. His horse-drawn plow is the kind used for plowing sod for the second year; the oxen pulling the heavier plow in the background are breaking the prairie for the first time. Despite the hard labor, neither man nor beast are fatigued. Over the entire scene reign clouds so solid and sculpted that they look like the blessing hands of God. This is the ideal, not the real, world.

Although Wood had referred to pioneers in other work, this mural is the only instance in which he painted Iowa's early history. Here Wood could not draw on personal experience; he had to fabricate the pioneer's history from his imagination, which easily led to the kind of heroics he had eschewed since *American Gothic*. Generally he left it to other artists to paint or sculpt grand and idealized figures of the pioneer mother and rugged settler, but on this one occasion, he created a romantic historic fantasy about the birth of a new civilization. Wood, the great believer in myth who customarily painted folktales in childlike scale, here presented his figures in a grand academic history painting, equating them with those great gods and goddesses of old.

132 STUDY FOR **BREAKING THE PRAIRIE**
c. 1935–37
Colored pencil, chalk, and pencil on paper, 22 3/4 × 80 1/4 in.
The Whitney Museum of American Art, Gift of Mr. and Mrs. George D. Stoddard

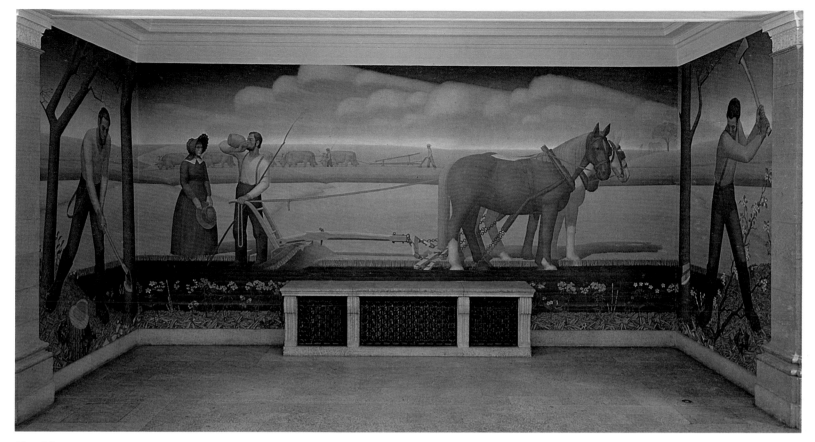

Plate 23
BREAKING THE PRAIRIE 1937
Oil on canvas, center panel 11 × 23 1/4 ft.,
side panels 11 × 7 3/4 ft.
The Iowa State University Library, Ames

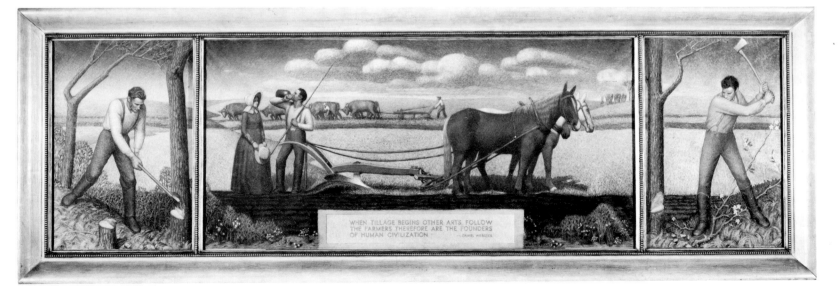

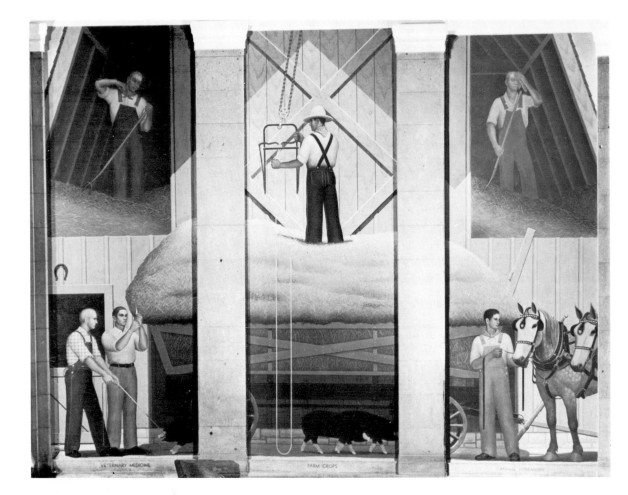

133 AGRICULTURE 1934

Oil on canvas
Veterinary Medicine 16 ft. 9 in. × 6 ft. 1 1/2 in.;
Farm Crops 16 ft. 9 in. × 6 ft. 3 1/2 in.; Animal
Husbandry 16 ft. 9 in. × 6 ft. 4 in.
The Iowa State University Library, Ames

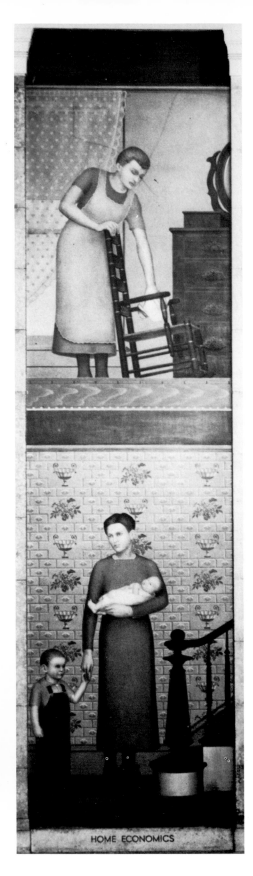

134 HOME ECONOMICS 1934

Oil on canvas, 16 ft. 9 in. × 4 ft. 5 in.
The Iowa State University Library, Ames

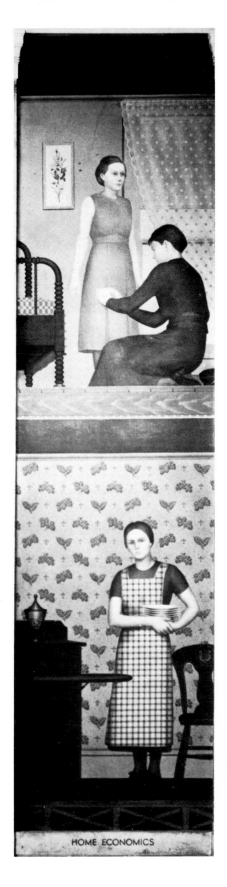

135 **HOME ECONOMICS** **1934**
Oil on canvas, 16 ft. 9 in. × 4 ft. 5 in.
The Iowa State University Library, Ames

136 **ENGINEERING** **1934**
Oil on canvas
Ceramic and Chemical Engineering 16 ft. 9 in.
× 6 ft. 3 1/2 in.; Mechanical Engineering 16 ft. 9 in.
× 6 ft. 3 1/2 in.; Aeronautical and Civil Engineering
16 ft. 9 in. × 6 ft. 2 1/2 in.
The Iowa State University Library, Ames

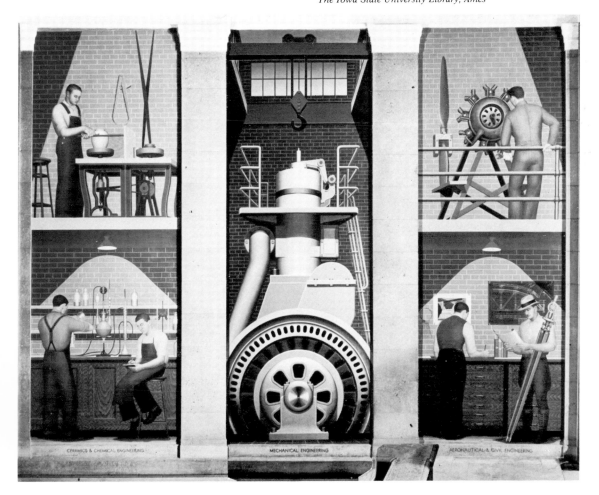

RETURN FROM BOHEMIA 1935

In 1935 Wood signed a contract with a publisher for his biography, which he and Park Rinard, his secretary and friend, were to write. They intended the book to be a full biography, to chronicle the artist's childhood years on the farm, his years as an impressionist artist, and then his swift conversion to regionalism. They called their work "Return from Bohemia" to underline the crucial turning point in the artist's life: his decision to turn away from the bohemian life and modern painting styles of Europe and become an artist of the Midwest.

Although the manuscript was never finished, Wood prepared an illustration for the book's jacket, a large crayon drawing of which he made two nearly identical versions.[53] In both, the artist portrayed himself seated in a barnyard with a palette and brush in his hands painting a stretched canvas on an easel in front of him. Five figures crowd around him: a young boy and girl, a young man, and an older man and woman.

On the most obvious level, the drawing seems easy to understand. It shows the artist "returning" from bohemia, eschewing the private language of modernism to become the people's painter. As the newly acclaimed painter of the Midwest, he is surrounded by the people who are now both his audience and his subject matter. This interpretation would be consonant with the way Wood always characterized his conversion to regionalism, which he saw as a spiritual and psychological homecoming. Even though he had never fled his home town as had other modern artists, Wood thought of his pre-regionalist art as a very specialized and rarified activity that few could practice or truly appreciate. Like most modernists he believed art resided in a separate sphere from his everyday life. But after becoming a regionalist Wood changed his thinking about the nature of art and understood it not as a private search for beauty, but as a public expression built on personal experiences within a community and region. He wanted his art not only to reflect his locale, but also to be intelligible and meaningful to a wide audience.

What is so curious about Wood's drawing, however, is the fact that it does not show the artist and his community reconciled. The people around him register no understanding of what the artist is doing. They are at best perplexed and bewildered, at worst blind and unresponsive to the painting Wood is making. If one looks closely at their faces, one can see that they appear to look less at the canvas in front of them than at the ground; some of them seem, in fact, to have their eyes *shut* to what the artist is painting. To further confuse the issue, Wood drew himself as he appeared in 1935, plump and with a receding hairline, but wearing the round tortoiseshell glasses of his "bohemian" years in the 1920s, glasses he had exchanged by 1932 for wire rims. Furthermore, although he paints in an Iowan barnyard, which would be appropriate for him as a regionalist, he is painting on canvas and using a big, thick brush, implements of his early, not his late, work.

The painting is a conundrum not unlocked by the one statement we have by the artist about a work of this subject. In 1931, four years before he drew *Return from Bohemia*, Wood was reported to have talked about a self-portrait: "The background will be the usual loafing bystanders who find time to watch an artist sketching faces with contempt, scorn and an I-know-I-could-do-it-better look."[54] Although such a statement may be the germ of Wood's later work, it hardly explains the drawing in which the figures do not seem to be looking at the artist's painting whatsoever— nor why the artist would choose to put a drawing on the cover of his biography in which the bystanders register "scorn." Is it possible that the artist intended to summarize his relationship to the community both before and after his "return" in one picture? Although it is unlike him to be metaphysical, the drawing could be read as a compression of time, representing the artist seated at the easel as a *plein air* impressionist painter in whose art people are disinterested and, at the same time, depicting him as a regionalist painter around whom the community crowds as his new constituency. Or it may be that the artist meant his work to be a kind of general treatise about the artist and his public, a relationship fraught with misunderstanding and tension. Wood certainly had known controversy in his lifetime over works like *American Gothic* and *Daughters of Revolution*. But this too would be more philosophical than one would expect of Wood and not particularly in keeping with his constant touting of regionalism as an integrated expression in which the artist is in harmony with his land and people. Whatever his intentions, Wood made a very perplexing drawing in *Return from Bohemia*.

Plate 24
RETURN FROM BOHEMIA 1935
Crayon, gouache, and pencil on paper, 23 1/2 × 20 in.
The Regis Collection

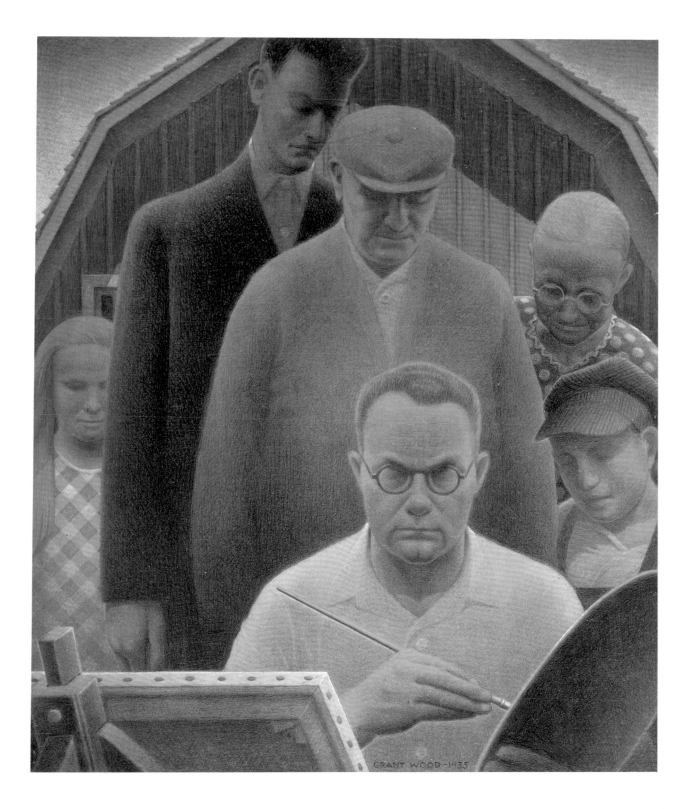

DRAWINGS FOR
MAIN STREET 1936–37

When Wood accepted a New York publisher's offer to illustrate a special edition of Sinclair Lewis's *Main Street*, it seemed a natural pairing; "the novelist and the painter," said one commentator, "have become so well known for their studies of rural America that such a collaboration seems more than just appropriate."[55] No one pointed out, however, that Lewis and Wood had made their reputations portraying very different strata of provincial America. The subjects of Wood's paintings, with the notable exceptions of *Appraisal* and *Daughters of Revolution*, were farmers and rural, nonmodern types living in villages and small towns. Sinclair Lewis, on the other hand, in *Main Street* (1920) and *Babbitt* (1922), wrote about modern small-towners who lived in big houses, traveled in trains and cars, went to the movies, joined clubs, and took vacations in big cities. Although many of Lewis's characters were complacent, conformist, and narrow-minded—the same traits one might attribute to the couple in *American Gothic*—they were not Wood's pitchfork-carrying country types. Furthermore, Lewis was much more critical and despairing of provincial life than Wood could ever be. What Lewis was apt to indict, Wood was likely to enjoy. Lewis belonged to that generation which had revolted against the village, Wood to the one which had returned to it.

But Wood had no trouble rising to the challenge of *Main Street*. He had been a longtime admirer of Lewis and, as early as 1926, credited him with initiating the new "yearning after the arts in the corn-and-beef-belt."[56] Furthermore he warmed to the exclusivity and care being taken with this particular reprint. Commissioned by the Limited Editions Club of New York City, the book was to be printed by the Lakeside Press in Chicago, the same press that had printed a catalogue and hosted an exhibition of Wood's work in 1935. Wood helped choose the book's tan rag paper and the blue-and-yellow linen binding, which complemented the colors he used in his large preparatory drawings done on brown wrapping paper in pencil, charcoal, crayon, and gouache. The edition was limited to a print run of fifteen hundred, each one signed by the artist.

Wood made nine illustrations in all, seven of major figures in the book and two of particular places. In his customary fashion, he assigned each a generic title—the *Booster, General Practitioner, Main Street Mansion*—rather than a specific name, to reflect the sort of small-town types that might exist anywhere in provincial America. "Nine-tenths of American towns," Lewis complained in *Main Street*, "are so alike that it is the completest boredom to wander from one to another."[57] Wood used *Main Street Mansion* as the reprint's frontispiece and *Village Slums* as the final illustration, providing, as it were, both geographic and sociological boundaries for the town. It is in these two sections of Gopher Prairie, the fictional Minnesota grain town in which Lewis set his story, that the major activities of the novel take place. The protagonists, Carol and Will Kennicott, and their friends live along Main Street in commodious homes equipped with modern conveniences. The secondary figures in the story (and, in general, the happier ones)—the town radical, the poor farmers, and the immigrants—live in the village slums, where the houses are huddled together. Lacking modern plumbing in their homes, they share a common water pump and have to trek to outhouses for their facilities.

For his cross-section of *Main Street* characters, Wood asked seven friends to pose for him, inventing for each a telling costume and attribute: a church for the sanctimonious Baptist widow; an American flag for the booster; a carnation for the intellectual; tools (including a hammer and a sickle) for the politically radical handyman; a domestic environment for the pragmatic reformer; lace curtains for the perfectionist trapped in her marriage; and a timepiece for the doctor, whose hand measures a patient's pulse.

Not only do the costumes and props clearly identify each small-town type, but so do their hand gestures and facial expressions, selected by Wood with his usual sensitivity to drama and storytelling. Looking up at each figure from below, Wood exaggerated hands and eyes to reveal the characters' personalities. The pious Mrs. Bogart smirks hypocritically while pulling off her church-going gloves; the booster Jim Blausser exhorts us; Guy Pollock, the defeated lover of poetry and literature, rolls his eyes in aesthetic reverie while sniffing at a carnation; Miles Bjornstrom, the village anarchist, clutches a tool and looks suspiciously at the corrupt world around him; animated Vida Sherwin, the patient agitator for small causes, is caught in midsentence; and Carol Kennicott, the crusader and promoter of culture and beauty, looks askance through a window at the small town that can never measure up to her standards. Though Carol is a sympathetic character in Lewis's eyes, Wood makes her seem intolerant and pokes fun at her drive for perfection by introducing a minor flaw—the middle button of her dress has slipped out of its hole.

Wood spared only Will Kennicott, the general practitioner, from humor and critical commentary. Viewing the doctor from above, the artist did not show his face but only his hands at a quilted bedside, taking a man's pulse. The watch he holds says 2:55, in the early hours of the morning no doubt, given the number of times Kennicott is called to make house calls in the middle of the night. It is a kindly image, offering a much more compassionate view of the country doctor than the rather crude, earthy, and unadventuresome Kennicott that Lewis draws in the book. Involved in a difficult marriage when he created these illustrations, Wood may have over-sympathized with the doctor, who suffers a young, energetic wife constantly urging him and the townsfolk to better themselves. Kennicott hasn't the capacity to dream as his wife does; he is too basic and down-to-earth, a practical, solid citizen who makes his living helping people. In the book he is a complex, only half-likable figure. In Wood's eyes, he becomes heroic, a portrayal that in this case says more about the artist than about the character we meet in *Main Street*.

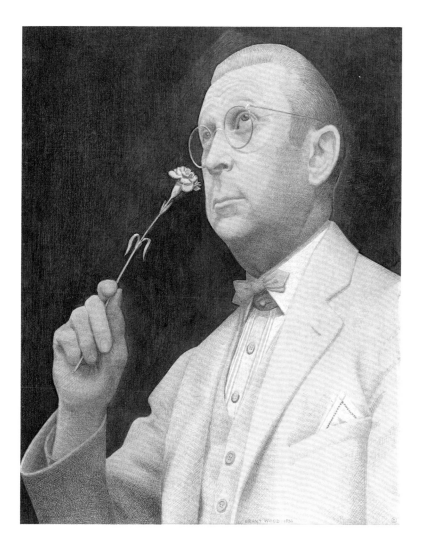

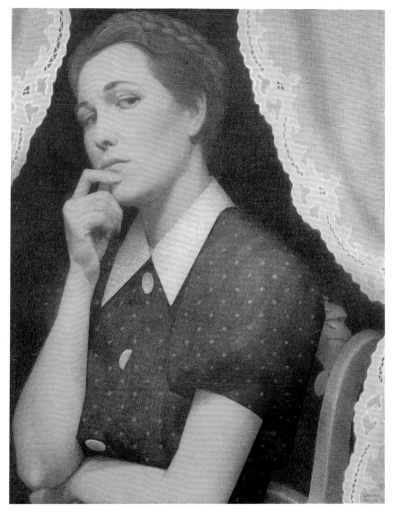

Plate 26
THE PERFECTIONIST 1936–37
Crayon, gouache, charcoal, and ink on paper, 20 1/2 × 16 in.
The Fine Arts Museums of San Francisco, Achenbach Foundation for Graphic Arts, Gift of Mr. and Mrs. John D. Rockefeller 3rd

" 'I believe all of us want the same things—we're all together, the industrial workers and the women and the farmers and the Negro race and the Asiatic colonies, and even a few of the Respectables. It's all the same revolt, in all the classes that have waited and taken advice. I think perhaps we want a more conscious life. We're tired of drudging and sleeping and dying. We're tired of hearing the politicians and priests and cautious reformers (and the husbands) coax us, "Be calm! Be patient! Wait! We have the plans for a Utopia already made; just give us a bit more time and we'll produce it; trust us; we're wiser than you." For ten thousand years they've said that. We want our Utopia *now*—and we're going to try our hands at it. All we want is—everything for all of us! For every housewife and every longshoreman and every Hindu nationalist and every teacher. We want everything. We sha'n't get it. So we sha'n't ever be content—' " [201–02]

Plate 25
SENTIMENTAL YEARNER 1936–37
Crayon, gouache, and pencil on paper, 20 1/2 × 16 in.
The Minneapolis Institute of Arts

" 'When I first came here I swore I'd "keep up my interests." Very lofty! I read Browning, and went to Minneapolis for the theaters. I thought I was "keeping up." But I guess the Village Virus had me already. I was reading four copies of cheap fiction-magazines to one poem. I'd put off the Minneapolis trips till I simply had to go there on a lot of legal matters. . . . That's all of the biography of a living dead man, except the diverting last chapter, the lies about my having been "a tower of strength and legal wisdom" which some day a preacher will spin over my lean dry body.' " [*Main Street*, pp. 156–57]

137 THE GOOD INFLUENCE 1936–37

Pencil, gouache, and ink on paper, 20 1/2 × 16 in.
Pennsylvania Academy of the Fine Arts

"She was a widow, and a Prominent Baptist, and a Good Influence. . . . Mrs. Bogart was not the acid type of Good Influence. She was the soft, damp, fat, sighing, indigestive, clinging, melancholy, depressingly hopeful kind. There are in every large chicken-yard a number of old and indignant hens who resemble Mrs. Bogart, and when they are served at Sunday noon dinner, as fricasseed chicken with thick dumplings, they keep up the resemblance." [69]

138 BOOSTER 1936–37

Charcoal, pencil, and chalk on paper, 20 1/2 × 16 in.
Mrs. Harpo Marx

"In early summer began a 'campaign of boosting.' The Commercial Club decided that Gopher Prairie was not only a wheat-center but also the perfect site for factories, summer cottages, and state institutions. In charge of the campaign was Mr. James Blausser, who had recently come to town to speculate in land. . . . He was a bulky, gauche, noisy, humorous man, with narrow eyes, a rustic complexion, large red hands, and brilliant clothes. He was attentive to all women." [413]

139 THE RADICAL 1936–37

Charcoal, pencil, and chalk on paper, 20 1/2 × 16 in.
Private Collection. Courtesy of Middendorf Gallery

" 'I'm what they call a pariah, I guess. I'm the town badman, Mrs. Kennicott: town atheist, and I suppose I must be an anarchist too. Everybody who doesn't love the bankers and the Grand Old Republican Party is an anarchist. . . . Usually known as "that damn lazy big-mouthed calamity-howler that ain't satisfied with the way we run things." No, I ain't curious—whatever you mean by that! I'm just a bookworm. Probably too much reading for the amount of digestion I've got.' " [115]

140　PRACTICAL IDEALIST　1936–37
Charcoal, pencil, and chalk on paper, 20 1/2 × 16 in.
James Maroney, New York

"She was small and active and sallow; her yellow hair was faded, and looked dry; her blue silk blouses and modest lace collars and high black shoes and sailor hats were as literal and uncharming as a schoolroom desk; but her eyes determined her appearance, revealed her as a personage and a force, indicated her faith in the goodness and purpose of everything. They were blue, and they were never still; they expressed amusement, pity, enthusiasm. If she had been seen in sleep, with the wrinkles beside her eyes stilled and the creased lids hiding the radiant irises, she would have lost her potency." [250]

"A square smug brown house, rather damp. . . . A screened porch with pillars of thin painted pine surmounted by scrolls and brackets and bumps of jig-sawed wood. No shrubbery to shut off the public gaze. A lugubrious bay-window to the right of the porch. Window curtains of starched cheap lace revealing a pink marble table with a conch shell and a Family Bible." [29–30]

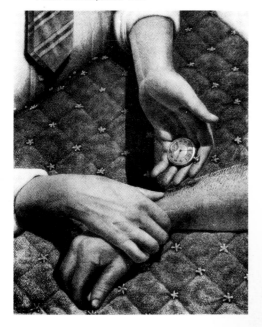

141　GENERAL PRACTITIONER　1936–37
Location of original drawing unknown
Reproduced from Sinclair Lewis, Main Street *(New York, 1937). Courtesy of New York Public Library, Rare Books and Manuscripts Division, Astor, Lenox and Tilden Foundations*

"Familiar to the doctor's wife was the man with an injured leg, driven in from the country on a Sunday afternoon and brought to the house. He sat in a rocker in the back of a lumber-wagon, his face pale from the anguish of the jolting. . . . His drab courageous wife drove the wagon, and she helped Kennicott support him as he hobbled up the steps, into the house. . . . 'I dunno ve can pay you yoost a little w'ile, doctor.' Kennicott lumbered over to her, patted her shoulder, roared, 'Why, Lord love you, sister, I won't worry if I never get it! You pay me next fall when you get your crop.'" [178–79]

"Wherever as many as three houses are gathered there will be a slum of at least one house. In Gopher Prairie, the Sam Clarks boasted, 'you don't get any of this poverty that you find in cities—always plenty of work—no need of charity—man got to be blame shiftless if he don't get ahead.' But now that the summer mask of leaves and grass was gone, Carol discovered misery and dead hope. In a shack of thin boards covered with tar-paper she saw the washerwoman, Mrs. Steinhof, working in gray steam. Outside, her six-year-old boy chopped wood. He had a torn jacket. . . . His hands were covered with red mittens through which protruded his chapped raw knuckles." [113]

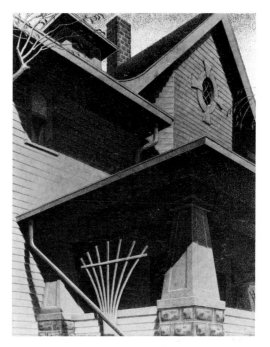

142　MAIN STREET MANSION　1936–37
Charcoal, pencil, and chalk on paper, 20 1/2 × 16 in.
James Maroney, New York, and Hirschl and Adler Galleries, New York

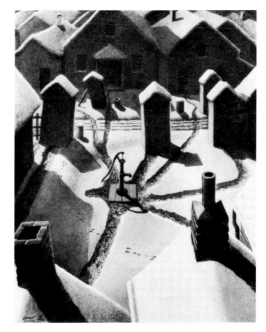

143　VILLAGE SLUMS　1936–37
Charcoal, pencil, and chalk on paper, 20 1/2 × 16 in.
Mr. and Mrs. Park Rinard, Falls Church, Virginia

TAME FLOWERS 1938
FRUITS 1938

Before Wood became a regionalist, his still lifes were very academic, generally of cut flowers in vases on tables, sometimes of bouquets from Turner's mortuary. But in the 1930s Wood paid no more attention to studio still lifes and turned to painting only local produce and flowers in their natural settings. In 1938 he created four black-and-white lithographs for Associated American Artists. These were to be hand-colored, reviving, as he put it in a letter, the "old Currier and Ives process."[58] In the nineteenth century, Currier and Ives hired a large staff to do the time-consuming and fussy work of adding watercolors to prints; Wood's workshop assistants were to be his sister Nan and her husband, Edward Graham, who lived in California and were out of work. He had dreamed up this project to help them out. Nan came to Iowa to learn her new trade, and not surprisingly found her brother's instructions to be meticulous and detailed. He prepared a master set of the four prints as models, specifying the colors for each, all of them subtle—tints, really—many achieved by overlaying two or more layers of watercolor. He made up, for example, four different solutions of green, labeling them A, B, C, and D, and then instructed Nan to paint combination AB in one area, ACD in another, DCBA in yet another, and so on.[59] It was a labor of love and of profit, taking the Grahams three years to complete the one thousand prints, 250 of each design. The prints were sold individually and as sets through Associated American Artists' mail-order catalogues; because of the handiwork, they sold for $10 apiece, rather than the customary $5.

The lithographs were of Iowa's *Wild Flowers* and *Tame Flowers* (the kind of comparison between country and city that the artist always favored) and of native produce, *Fruits* and *Vegetables*. The four prints continue the theme and many of the visual ideas Wood had developed in his *Fruits of Iowa* decorations for the Hotel Montrose. *Fruits*, in fact, is lifted verbatim from one of the Montrose images. In the lithographs, just as in the hotel decorations, each scene takes place on its own jigsawed plot of earth, boasting of Iowa's abundant riches and beauties. They are all booster images—in the lithographs very quaint and charming ones—in the guise of art.

144 **WILD FLOWERS** **1938**
Hand-colored lithograph, 7 × 10 in.
The Fine Arts Museums of San Francisco, Achenbach Foundation for Graphic Arts

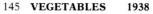

145 **VEGETABLES** **1938**
Hand-colored lithograph, 7 × 10 in.
The Fine Arts Museums of San Francisco, Achenbach Foundation for Graphic Arts

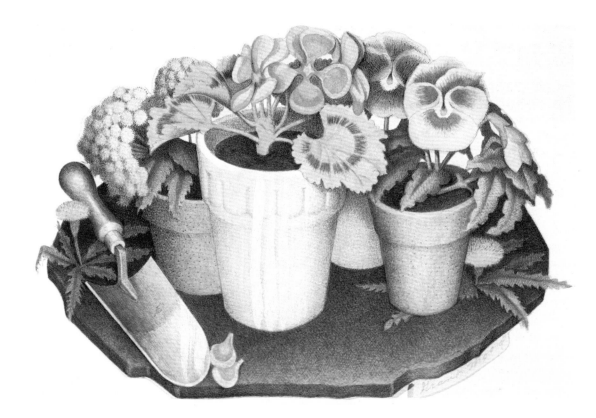

Plate 27
TAME FLOWERS 1938
Hand-colored lithograph, 7 × 10 in.
Davenport Art Gallery, Davenport, Iowa.
Courtesy Associated American Artists, New York

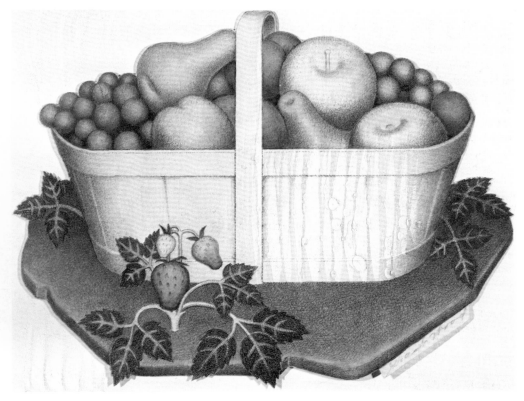

Plate 28
FRUITS 1938
Hand-colored lithograph, 7 × 10 in.
Davenport Art Gallery, Davenport, Iowa.
Courtesy Associated American Artists, New York

PARSON WEEMS' FABLE 1939

Parson Weems' Fable is a play within a play, a fable about the making of fables. Ostensibly about Mason Locke Weems, the late-eighteenth-century Anglican clergyman who fabricated an apocryphal tale about George Washington and the cherry tree, the painting is also for Wood an artistic manifesto. For the parson, who in the painting pulls the curtain back on his American fable, is a thinly disguised surrogate for the artist himself. Parson Weems and Grant Wood are alter egos, both creators of lore, both enriching the national imagination with colorful stories about America's heritage. Fables, the painting makes clear, are inventions; they are based on history but transformed by the artist into colorful tales. What Weems did for George Washington, we realize, is what Wood wanted to do for the midwesterner: to leave behind a body of folklore that would ensure his region and its types a place in the national memory bank. He wanted to fabricate tales that were as long lasting and unforgettable as the one Parson Weems dreamed up about Washington and his hatchet.

Weems published that story in 1806 in the fifth printing of his biography, titled "Life of Washington, the Great," an edition he "Enriched with a Number of Very Curious Anecdotes Beautiful in Character and Equally Honorable to Himself and Exemplary to his Countrymen." One such "curious anecdote" related how the young George received a new hatchet and in his enthusiasm for trying it out was responsible for "barking" one of his father's favorite cherry trees. When asked by his father if it were he who had damaged the tree, the six-year-old George confessed candidly to the deed: "I can't tell a lie—I did cut it with my hatchet." His father, having never beaten the child and always taught him to tell the truth, was ecstatic about the success of his child-rearing: "Glad am I, George, that you killed my tree; for you have paid me for it a thousand fold." The moral of the story was, historians remind us, not about lying, but about the father's liberal attitudes toward bringing up children. Young George can con-

fess to his father "because he is not terrified at the consequences."[60]

Wood no doubt learned his Washington lore at his mother's knee, where he first heard Longfellow's poem about Paul Revere. But he would soon have been disabused of the notion that the story had any basis in fact, for within his lifetime it became intellectually fashionable to debunk Washington, to remove the exemplary anecdotes from his canon and add new, realistic ones—stories about Washington as a teller of dirty jokes and a keeper of mistresses.[61] The all-out effort to humanize and deromanticize the father of the country also affected Parson Weems' standing in the academic community, where he was exposed as a fiction writer with an all too vivid imagina-

tion and stripped of his credentials as George Washington's first biographer.

Parson Weems' Fable, like *Midnight Ride of Paul Revere*, eight years earlier, is a response to the era of debunking; it seeks to reinstate some of the romance once attached to national figures. Wood had been very taken with an article he had read in the *Atlantic Monthly* by Howard Mumford Jones on the consequences of debunking. Jones, a well-known literary critic, felt that the new climate of realism, for all that it contributed, had taken the romance out of American history; as a result anything to do with heritage, democracy, or

146 CARTOON FOR **PARSON WEEMS' FABLE**
1939
Charcoal, pencil, and chalk on paper, 38 3/8 × 50 in.
James Maroney, New York, and Hirschl and Adler Galleries, New York

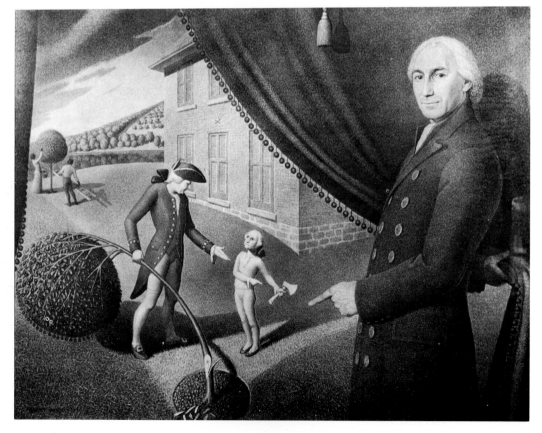

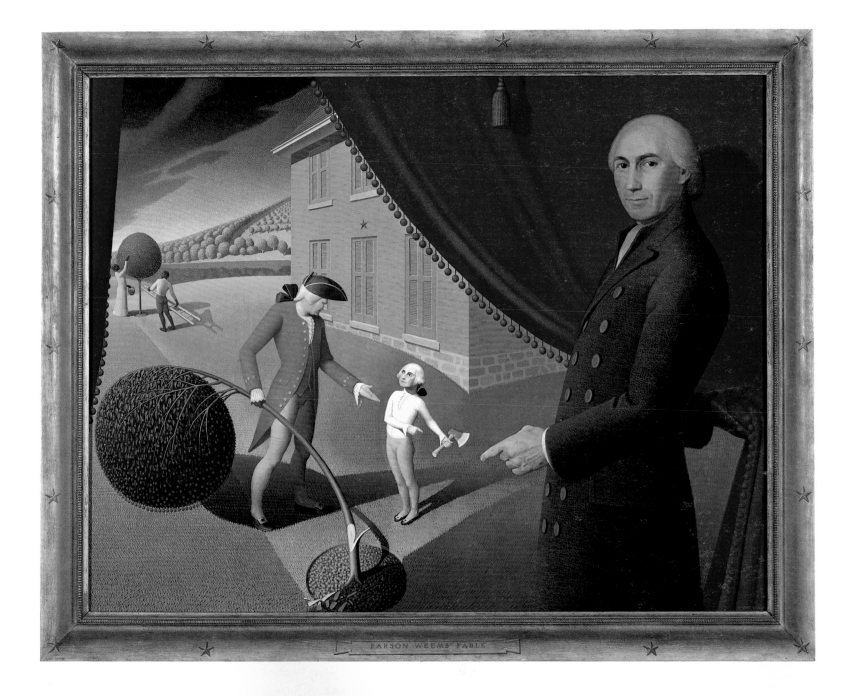

Plate 29
PARSON WEEMS' FABLE　　1939
Oil on canvas, 38 3/8 × 50 1/8 in.
Amon Carter Museum, Fort Worth

147 Charles Willson Peale, *The Artist in His Museum*, 1822, Pennsylvania Academy of the Fine Arts, Joseph and Sarah Harrison Collection.

patriotism had become "the last refuge of a scoundrel." The lack of a "history of liberty," he felt, was particularly dangerous at a time when Italy and Germany were developing sinister national mythologies to pull people together and give them identity. He called upon artists and writers to develop a new kind of patriotism, one "without chauvinism, economic self-interest, or racial snobbery," that would bring back legends, myths, and great historical moments.[62]

"The most effective way to do this," Wood said, as if responding to Jones, "is to frankly accept these historical tales for what they are now known to be—folklore—and treat them in such a fashion that the realistic-minded, sophisticated people of our generation can accept them."[63] By putting Parson Weems in the painting and having him pull back a curtain to reveal his little play, Wood satisfied both himself and the debunkers. He showed the story as Weems' invention while at the same time reinvigorating it as myth and folklore. He based his painting on earlier depictions of the story—perhaps the 1867 engraving reproduced here—using the same setting and cast of characters: the family home, an orchard, black slaves working in the yard, the offended tree, a hatchet, and the son confessing to his father in the foreground. In the Victorian version, the story is presented as a domestic vignette and retains much of its original meaning. The father is compassionate and takes pleasure and comfort in his son's honesty. In Wood's version, however, all sentiment has been replaced by a kind of theater of the absurd in which everything seems all right on the surface, until we look closely and encounter the irrational juxtapositions and startling visual puns.

First we meet the good parson, who manages to not only stand in front of but cast his shadow upon a curtain that seems flush with the painting's surface. We immediately recognize his type from eighteenth-century American portraits and his gesture, that of pulling back a curtain, as a replay of the famous self-portrait of Charles Willson Peale, the great showman-artist of the federal period, displaying the contents of his museum. As we follow the parson's hand past the cherry fringe

of the curtain, we meet other hands in what seems to be a kind of comedy routine, everyone pointing to something else. The principal tree in the drama, we discover, has not been simply "barked," but destroyed, its fruit dangling from its spherical shape like the perfect balls of fringe that appear on the curtain. It is not February as Parson Weems had it and we are not in an eighteenth-century setting, but on the manicured lawn of Wood's own house, and the 1858 structure he had just restored in Iowa City is in the background. Most jolting of all, the six-year-old boy wears the head of the "father of the country" from the famous Athenaeum portrait of Washington by Gilbert Stuart, a painting the Bicentennial Commission a few years back had reproduced and put on the walls of the nation's classrooms. In Wood's painting, instead of looking noble and dignified, however, the famous head appears worried as the young George looks at his father out of the corner of his eyes. Father Washington, in Wood's retelling of the tale, is not compassionate, but angry. This is not a moment of forgiving, as we can tell from the storm clouds in the sky, but of punishment. With the debunker's cry for realism ringing in his ears, Wood shows Dad laying down the law. The boy must give the hatchet back!

Finished in the same way as *Daughters of Revolution*—trompe l'oeil stars on the frame proclaiming the "Americanness" of the subject—*Parson Weems' Fable* sold immediately upon completion to John Marquand, the Boston novelist, and his wife, who would also eventually buy *Spring Turning*. Wood was pleased, for he had always had good rapport with writers, who along with movie people were among his greatest fans. Actors Edward G. Robinson and Katharine Hepburn, movie directors King Vidor and George Cukor, and songwriter Cole Porter all bought his work. Writers and film artists appreciated what many artists and critics disdained in Wood's work—his storytelling and literary qualities. Wood told his tales through the language of theater: the right gestures, appropriate costumes, dramatic lighting, and telling props. And he was, as he tells us through his surrogate in *Parson Weems' Fable*, a master manipulator, a showman engaged in making fictions seem real. For actors and writers, this was their kind of painting, for they too were engaged in the art of make-believe.

148 "Father I Can Not Tell a Lie: I Cut the Tree." Painted by G. G. White and engraved by John C. MacRae, 1867. (Collection of the Library of Congress)

ADOLESCENCE 1940

Wood painted the theme of adolescence on two different occasions: in 1930, the year he developed his mature style, he created *Arnold Comes of Age*; and in 1933 he fashioned a full-sized drawing for *Adolescence*, which, seven years later, he turned into a painting. The first work was a symbolic portrait of a figure passing from childhood into the world of adults; the second a barnyard metaphor for the pain and awkwardness of growing up. Both paintings are, in part, autobiographical. In *Arnold Comes of Age*, the artist conveyed something of his own shyness and struggle to find an identity in the adult world. In *Adolescence*, Wood's memories of his authoritative father and overbearing aunts fuel the tensions between the young, vulnerable chicken and the matronly hens.

Wood painted *Arnold Comes of Age* during the year in which he made the groping transition from impressionist to regionalist. His model, Arnold Pyle, was a young Cedar Rapids artist who had assisted Wood in making frames for paintings and in preparing the drawings for the Memorial Window.[64] Wood was very fond of the young man and, in seeing Pyle turn twenty-one, decided to paint a portrait of a figure approaching manhood. He had just completed *Woman with Plants*, in which he had tried out a new style and pictured his mother as an archetypal midwesterner. His painting of Pyle was yet another exercise in symbolic portraiture, an attempt to paint the passing of Youth in the figure of a friend.

The painting was not very successful. Stylistically, it wavers between the artist's new hard-edged realism and his earlier soft-style impressionism; compositionally, the painting makes a multitude of strained and clichéd references to growing up and the transience of youth. In the background, a river of life flows across the picture separating the young man's youth, represented by the sapling and two young swimmers on the near riverbank, from his adulthood, symbolized by the mature trees and bales of ripened wheat on the shore beyond. At the boy's elbow a butterfly hovers, a creature of beauty that, like adolescence, is short-lived.

Three years later, after he had firmly established himself as a regionalist, Wood tackled the theme again, this time using a much more original metaphor: a pinfeathered chicken rather than a person to express the ungainliness of youth. As a young boy, Wood had raised chickens as pets and had been responsible for feeding them and collecting their eggs. His favorites were the Plymouth Rocks, to whom, he tells us in his biography, he was so sympathetic as they passed through their featherless adolescent state that he rubbed "tallow on their wings to relieve sun-burn."[65] He made childhood drawings of his pet hens and roosters and, quite naturally, used them much later in his regionalist paintings. He painted a fat Plymouth Rock in the arms of the farm woman in *Appraisal* and his first adolescent one in the *Fruits of Iowa* decorations for the Hotel Montrose in which the farmer's wife feeds hens and a goose to one side of her and a gawky fledgling chicken at the other. In *Adolescence* the artist included the same kind of gaunt bird, this time crowded by two very imposing parental figures. All of them are perched on the ridge of a roof. Although stars can still be seen in the darkened sky, the light of dawn appears on the horizon. With the coming of day, the young chicken has stood up, shy and unsure. Standing like a young nubile Venus, trying to shield her pubescent body from our gaze, she is nearly toppled by the two hens on either side, whose matronly plumpness pushes against the young chick's skinny and undeveloped legs. While the parental hens swell with protective authority and overbearing self-satisfaction (looking for all the world like the ladies in *Daughters of Revolution*), the young chicken is vulnerable and ill-at-ease. The juxtaposition is a winning image. With it Wood spun his own Aesopian fable for the trials and tribulations of growing up.

149 Arthur Fitzwilliam Tait, *Quail and Chicks*, 1865, The Congoleum Collection. In the last half of the nineteenth century, Arthur Tait, among others, painted domestic scenes of different baby birds and their parents, many of which were made into Currier and Ives prints with titles like "Bringing Up the Family" or "Happy Little Chicks." Wood was a great fan of Currier and Ives and surely had these kinds of prints in mind when he conceived *Adolescence*.

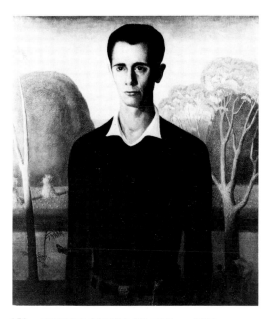

150 **ARNOLD COMES OF AGE** **1931**
Oil on composition board, 26 3/4 × 23 in.
Nebraska Art Association, Courtesy of the Sheldon
Memorial Art Gallery, University of Nebraska—Lincoln

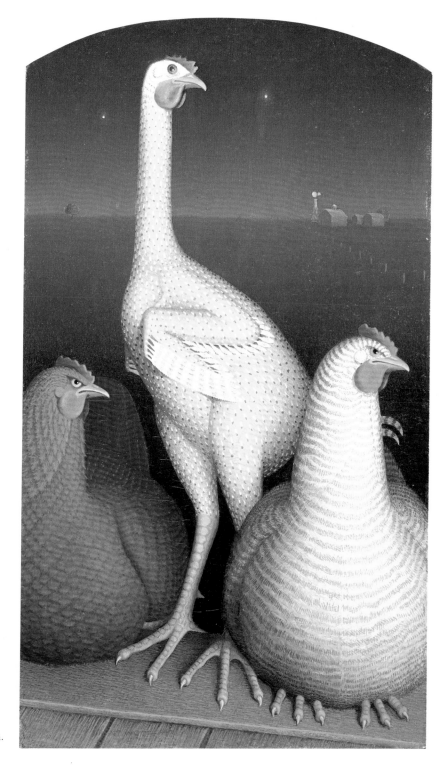

Plate 30
ADOLESCENCE **1940**
Oil on masonite panel, 20 3/8 × 11 3/4 in.
Abbott Laboratories

SELF-PORTRAIT 1932–41

Wood's self-portrait is unabashedly direct, a surprising piece of painting from someone who, in his early years, had been shy and indecisive. As a young man he had trouble looking at people when he spoke to them. But now, at forty-one years of age, the artist confronts the world at close range, staring at us intensely (as he did at himself when he studied his face in a mirror to make the portrait). Without a tinge of humor or reticence, he looks us in the eye and presents his face for inspection—its stout frame, the cleft in his chin, the clean-shaven cheeks, the shine on the nose, the wavy dark blond hair. His candor is almost disquieting.

The assurance of the portrait relays the confidence Wood felt in the post–*American Gothic* years. There is no doubt that he was more at ease in the world than he had been earlier. He now had a national following; he had conquered his fear of the podium and was giving lectures to large audiences. He was enjoying his newfound identity as a midwestern painter, which he spelled out in the portrait. The shocks of grain, rolling hills, and statuesque windmill framing the artist's head were symbolic emblems of the landscape Wood now called his own. The artist had become particularly attached to the windmill, a familiar landmark in the Midwest, which he feared was becoming extinct; he wanted, he told a reporter, his paintings to preserve its "lore."[66] Placed prominently in his *Self-Portrait*, the windmill stands to one side of his head, like a billboard advertising the artist's allegiance to the midwestern rural landscape. In Wood's other paintings of country life (*Young Corn, Fall Plowing, Spring Turning, Dinner for Threshers*) the windmill is less obvious, but it is *always* there. Wood never failed to find a way to work into his compositions its daisy-like spinning vanes peeping over hills, trees, and barns. Like a watchful eye, making sure that all is in order, it was the artist's covert signature.

Wood created his self-portrait in 1932 for a state competition. At his suggestion, the Iowa Federation of Women's Clubs sponsored a contest of artists' self-portraits. Wood submitted an earlier stage of this portrait, in which he wore his regionalist painting uniform—bibbed overalls and white shirt, the dress he wears in his preparatory drawing. Although the painting placed first in the contest, Wood decided the overalls were compositionally awkward and drew attention away from his face. At some point—we do not know when—he painted over them with a dark green paint and signed the painting, "Sketch, Grant Wood 1932." He kept the portrait in his studio until he died and may have worked on it from time to time. Consequently the painting has traditionally been dated 1932–41, the latter date being the year in which Wood became ill and no longer could paint.

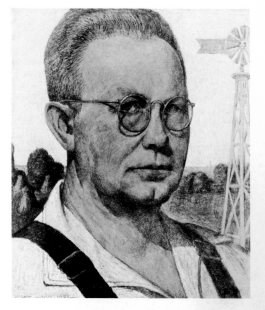

151 SKETCH FOR **SELF-PORTRAIT** **1932**
Chalk and pencil on paper, 15 1/4 × 12 3/4 in.
Private Collection

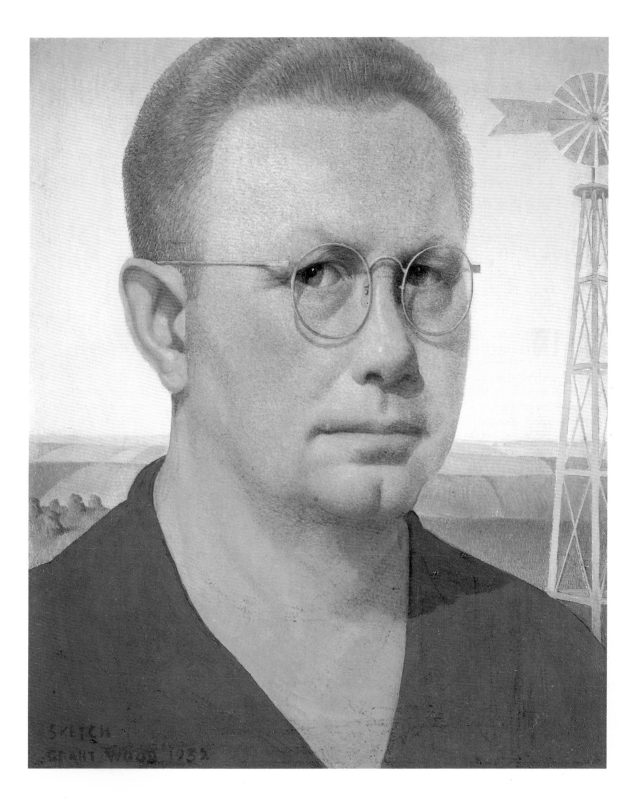

Plate 31
SELF-PORTRAIT **1932−41**
Oil on masonite, 14 3/4 × 12 3/8 in.
Davenport Art Gallery, Davenport, Iowa

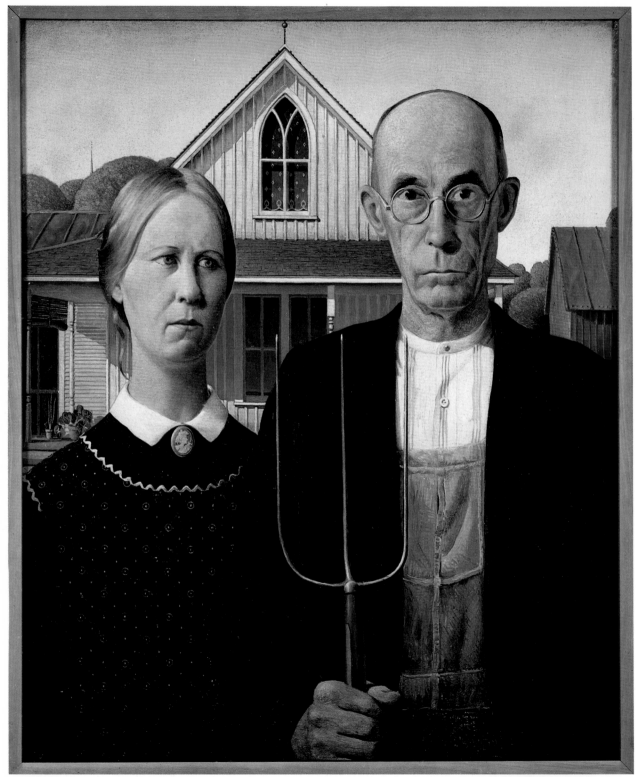

Plate 32
AMERICAN GOTHIC **1930**
Oil on composition board, 29 7/8 × 24 7/8 in.
The Art Institute of Chicago

American Gothic: The Making of a National Icon

In August of 1930 Grant Wood visited Eldon, Iowa, a tiny town of 1,700 in the southern part of the state. Edward Rowan, the director of the Little Gallery in Cedar Rapids, had set up an experimental summer gallery, library, and art school in Eldon and had asked Wood to give the local citizens a demonstration in *plein air* painting. It was on this short trip that Wood came upon the house destined to make him famous. The modest five-room structure, built in the early 1880s by local craftsmen in a style known as Carpenter Gothic, appealed to Wood because of its compactness and its emphatic design—particularly the verticals in the board-and-batten construction and the Gothic window, prominently placed in the gable. With his fondness for repeating geometries, Wood immediately envisioned a long-faced and lean couple, "American Gothic people" he called them, to complement the house and echo its predominantly vertical lines.[1] (He said he would later do a couple in front of a Mission-style bungalow with the emphasis "on the horizontal instead of the vertical.")[2] He made a quick pencil sketch and a loose oil study of the house, asked Mrs.

Rowan to photograph it for him, and returned to Cedar Rapids to work out his idea.[3] This was the genesis of *American Gothic.*

The sketch depicted a dour, oval-faced, tight-lipped man and a similar-appearing woman standing like "tintypes from my old family album" in front of the farmhouse.[4] And, indeed, Wood turned to vintage family photographs, just as he turned to Currier and Ives prints, maps, and atlases in these years, to give his painting an old-fashioned, Victorian cast. The couple was to seem archaic, more in keeping with the period of the house than with modern times. He transformed his sister Nan, the model for the woman in the painting, into a plausible stand-in for one of his ancestors. He asked her to pull her marcelled hair back tightly and put on the same kind of costume Mrs. Wood wore in *Woman with Plants*: an apron trimmed with rickrack over a plain black dress with a white collar and cameo pin at the neck. For Dr. B. H. McKeeby, the Cedar Rapids dentist who agreed to pose as the man, Wood found a collarless shirt among his painting rags and paired it with bibbed overalls and a dark jacket.

Wood adopted not only the figures' dress from late-nine-

152 House in *American Gothic*, attributed to Messrs. Busey and Herald, local carpenters, Eldon, Iowa, 1881–82.

153 STUDY FOR **AMERICAN GOTHIC** **1930**
Oil on composition board, 13 × 15 in.
Mr. and Mrs. Park Rinard, Falls Church, Virginia

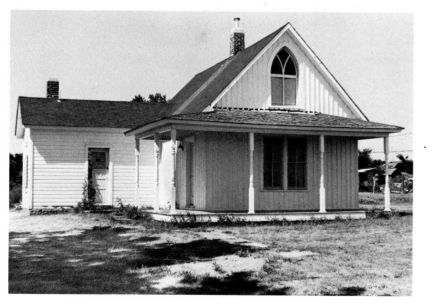

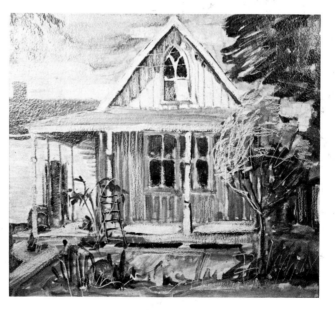

129

154 Maria Littler Wood, carte de visite, 3 1/4 × 2 in. (Family Album, Grant Wood Collection, Davenport Art Gallery)

155 Solomon D. Butcher, "John Curry sod house near West Union in Custer County, Nebraska," c. 1886. (Solomon D. Butcher Collection, Nebraska State Historical Society, Lincoln, Nebraska)

teenth-century photographs, but also their poses and demeanor. The stiff, upright torsos, the unblinking eyes, and the mute, stony faces are characteristic of long-exposure portraits. In placing the man and woman squarely in front of their house, he borrowed another photographic convention, this one from those post–Civil War itinerant photographers who traveled rural America making portraits of couples and families in front of their homes. Such a trade was extremely common in the rural Midwest until World War I and produced untold numbers of

156 Solomon D. Butcher, "Mr. Story, 1 mile N.E. of Miller on Wood River, Buffalo County, Nebraska," 1909. (Solomon D. Butcher Collection, Nebraska State Historical Society, Lincoln, Nebraska)

photographs recording the pride of home and the accumulation of material comforts as much as the likenesses of the inhabitants. Wood might well have known the classic photographs of this type made by Solomon D. Butcher (1856–1927) and published in two books in 1901 and 1904.[5] A photographer and amateur historian, Butcher documented Nebraskans from the pioneer days of sod houses through to the next generation of prim wooden houses and cultivated lawns. But even if Butcher's photographs were unfamiliar to Wood, similar images were common stock in most midwestern family albums, and by the turn of the century these portraits were even made into postcards for families to send to distant relatives and friends.

In such photographs men and women often posed with emblems or attributes appropriate to their status and occupation, a convention borrowed from a much older tradition of portrait painting. Men held shovels, rakes, or pitchforks; women leaned on brooms or chairs or tended plants. Potted plants especially, whether in a window, on a porch, on a lap, or on a crude table in front of a sod house, symbolized a woman's nurturing and horticultural skills. In the Midwest, where winters are long and bitter, keeping plants alive was a recognized female achievement. Wood put two potted plants on the porch of the house in *American Gothic*—the same snake plant and

157 SKETCH FOR **AMERICAN GOTHIC** 1930
Pencil on paper, 4 3/4 × 3 1/2 in.
Richard K. Larcada, New York

begonia he had used in *Woman with Plants*—just over the right shoulder of the woman, to provide her with an appropriate attribute of homemaking and domesticity. The man's attribute was, of course, the pitchfork. Wood's initial sketch had the man hold a rake. A pitchfork was much more appropriate, however, for it resonated with meaning (masculinity, farming, the devil, a weapon), echoed the ovalness of the people's faces, and repeated the lines of the Gothic window. Furthermore, Wood wanted to link his male figure with haying, not gardening, and wanted a tool associated with the nineteenth century. This offended at least one local farmer's wife, who objected to the insinuation that farmers were old-fashioned. "We at least," she complained, "have progressed beyond the three-tined pitchfork stage!"[6] What she meant was that up-to-date farmers now used mechanical haying equipment, horse- or tractor-drawn, rather than working exclusively with hand tools.

Wood worked on *American Gothic* for about two months

and finished it in time to send it, along with *Stone City*, to the jury for the annual exhibition of American paintings and sculpture at the Art Institute of Chicago. The jurors were divided over whether to accept it. Alongside the other entries of modern still lifes, landscapes, and studio nudes, *American Gothic*, with its deliberate archaisms and small size (thirty by twenty-five inches), appeared curiously quaint. But one juror's favorable opinion prevailed, and the painting not only was admitted but was awarded the Norman Wait Harris Bronze Medal and a $300 prize. Pleased with the painting's reception, the Friends of American Art at the Art Institute bought the painting for $300. Among the public it was an overnight success, and the mute and nameless couple attracted critical notice not only in Chicago but in faraway cities such as New York and Boston.

No one could have been more surprised than Grant Wood, who had never won a prize (outside of the Iowa State Fair) and who had never sold a painting to a museum. He was startled not only by his critical acclaim but also by the differing opinions as to who the couple were and what the painting meant. Was Wood mocking these country people, or celebrating them? Was a viewer supposed to laugh at this couple, or despair that such seriousness, even meanness, existed in the world? In the Chicago press, Charles Bulliet delighted in *American Gothic* as "quaint, humorous, and AMERICAN," while a critic in Boston saw the couple as grim religious fanatics. He knew nothing of the artist, he admitted, but guessed Wood must have "suffered tortures from these people who could not understand the joy of art within him and tried to crush his soul with their sheet iron brand of salvation."[7] Even in Iowa, some people were insulted by what they interpreted as the painting's slap at the local citizenry. When the Des Moines *Register* mistakenly entitled its reproduction of the painting "Iowa farmer and his wife," farmers' wives complained to the editor that contemporary farmers never looked that morose or old-fashioned. The painting should be hung in a cheese factory, one woman wrote. "That woman's face would positively sour milk."[8] In return, a Cedar Rapids woman defended the painting as a portrayal of pioneers and said she saw "strength, dignity, fortitude, resoluteness, integrity" in the people's faces, "the same truth and beauty" she found in Jay Sigmund's poems.[9]

Throughout its first decade of life, the painting continued to elicit a variety of interpretations. By and large, the farther a critic lived from the Midwest, the more predisposed he or she was to read the painting as satire or social criticism. Local commentators usually saw the painting in a more benign light.

Thus, for Marquis Childs, a midwesterner, the painting "is Iowa, grim, bleak, angular, with a touch of humor and a heart of gold," whereas for Christopher Morley of the New York *Saturday Review* the faces were "sad and yet fanatical," an indicator of "what is Right and what is Wrong with America."[10] What everyone agreed upon was that the painting said something fundamentally American, that the couple "might come from many parts of this country but no other."[11] The "independent, don't-tread-on-me character" of the painting was so "peculiarly American," *Fortune* magazine declared in 1941, that it would make an ideal anti-German war poster (see fig. 206).[12]

What commentators saw in the image and what the artist had in mind when he made the painting were not exactly the same. From Wood's perspective, the painting was *not* about farmers, *not* about a married couple, and *not* a satire. It was an affectionate, albeit humorous, portrayal of the kind of insular Victorian relations he had grown up with, whose type still populated, in increasingly dwindling numbers, the villages and small towns of Iowa. These were small-town folks, descendants of the pioneers. In 1930 these survivors clung to the values of the past and resisted pressures to modernize, to buy fancy goods, to put in electricity, and to move to the cities. They were, in the words of Ruth Suckow, "narrow, cautious, steady, and thrifty, suspicious of 'culture' but faithful to the churches . . . of varying nationalities, but in the main Anglo-Saxon, Teutonic and Scandinavian, whose womenfolk still apologize if caught spending a good time . . . over a book."[13] Wood had "no intention of holding them up to ridicule," he said on numerous occasions, but, like Sinclair Lewis, he pointed out their foibles as well as their virtues. "These people had bad points," Wood said of his couple, "and I did not paint them under, but to me they were basically good and solid people."[14]

Indeed, *American Gothic* was a logical extension of Wood's earlier efforts to realize an iconic image of the midwestern pioneer in *John B. Turner, Pioneer* and *Woman with Plants*. Only this time he tried two different strategies, both of which were so successful that they became an integral part of his work and his regionalism. First, he worked from memory and personal experience. Instead of pursuing an intellectual and abstract idea of the pioneer, he chose to paint the kind of people he had person-

158 This 1942 photograph makes clear the thirty-two-year age difference between the two models, whom the artist intended to be seen as father and unmarried daughter, not as man and wife. (Cedar Rapids Museum of Art Archives, Gift of John B. Turner II in memory of Happy Young Turner)

132 *AMERICAN GOTHIC*: THE MAKING OF A NATIONAL ICON

ally known in his youth, the kind of house he had grown up in, and the type of faces he could revisit in his family album. Second, he infused the painting with the wit he had long exercised in his personal life—in conversations, costume parties, and gag pieces—but had never allowed into his art. It is, in fact, the gentle humor in *American Gothic* that has caused so much confusion about the picture and led so many to think Wood was ridiculing his subjects. Ironically people laugh at the painting for the wrong reasons, because everyone mistakes the couple for man and wife. Surprising as it may be, Wood conceived of his couple as father and spinster daughter, not as husband and wife. They were to be an "odd" couple, a common literary theme of the period, particularly in the work of Suckow and Sigmund, who wrote of "drab and angular" spinsters whose moral propriety and excessive duty to family kept them from ever leaving home, where they cared for aging or widowed parents and where they withered as social creatures and became excessively unbending in their judgments.[15] Typically, Sigmund and Suckow depicted the spinster as sexually stunted, old-fashioned in dress, tidy and meticulous in housekeeping, and sometimes as a malicious gossip and zealous guardian of community morality. Before Wood asked Nan to pose for the woman, in fact, he had picked out a Cedar Rapids spinster whose face, he felt, was perfect for the role. But he could not gather the courage to ask her, so his thirty-year-old married sister played the prim, dutiful daughter and posed with her aging "father," the artist's sixty-two-year-old dentist.[16]

That Wood's characterization of the woman is so ambiguous betrays his affection for the country couple. He could not bring himself, as Sigmund did in his poem "The Serpent," to characterize his spinster as a "sexless" monster.[17] For Sigmund, the spinster was a "smug and well-kept" woman with a "saintly smile" that betrayed her hypocrisy, an "arch-assassin of reputation" whose fangs were no "less cruel and deadly for being hidden." Yet it is precisely this literary stereotype which lays behind Wood's portrayal. He made the woman look unfashionable and older than her years, for example, not because he meant to make her the man's wife but because this is the way spinsters were popularly perceived. The profile of the young, beautiful goddess on the cameo reminds us of the way she ought, at her age, to look. To point out her repressed sexuality and unfulfilled womanhood, the artist flattened her bosom and decorated her apron with a kind of miniature breast-hieroglyph, a circle-and-dot motif. Then, to underline her insistent tidiness, he allowed a single strand of wayward hair to escape from her bun and snake mischievously down her neck, the only unruly

element in an otherwise immaculate conception (and a far-fetched reference, perhaps, to Sigmund's metaphor of the spinster as serpent). Most telling of all, however, and the artist's most brilliant invention, is the woman's averted gaze. With her eyes cast to one side she appears at once feminine (it would be immodest for her to look us in the eye) and meddlesome (she watches for improprieties in the world around her). She can be read as passive and saintly, the stoic daughter sacrificing her life to keep her father's house—or as the active and malicious town gossip, Sigmund's "arch-assassin of reputation."

If Wood was ambiguous in laying out the daughter's character, he clearly delineated the protective father who stares at us intently, even menacingly. The pitchfork, clutched in his hand, becomes much more than an emblem of rural living and hard work; it is also a symbol of male sexuality and paternal authority. The father interposes the cold, steely tines of his fork between us and his daughter, warning any who might entertain thoughts of trespass—against daughter or homestead. But lest we take the old man's bravura too seriously, the artist parodies his virile show of aggression by mirroring the phallic pitchfork in the seams of his overalls, where the three-tined shape appears limp and worn with age.

There are yet other visual puns and literary references in *American Gothic*, a painting so highly calculated that every formal element interprets the couple's character. The static composition and immaculate forms, for example, express a life of rigid routines and unchanging patterns. The repeated verticals and sharp angles emphasize the figures' hardness, while Wood's blunt palette of white and black, brown and green suggests their simplicity. To entomb the couple as relics from another age, the artist bathed the scene in a dry, white light, crisply embalming every little detail of the pair and their home. To point out the pervasive presence of religion in their lives, he put a dark jacket on the man, suggesting he is a churchgoer, perhaps even a Sunday preacher; heightened the dimensions of the house so that the gothic window hangs like a Christian cross between the two heads; and painted in a church steeple peeping over the treetops and reiterating the vertical thrust of the lightning rod installed on the cottage roof. Finally, although the artist never had his two models pose together, he gave them a familial resemblance and painted them as a monolithic family unit. Their closeness steadfastly blocks our entrance into the painting and into their private domain. Neither they nor their house, with its drawn blinds and closed windows, make us feel welcome.

The couple's austerity, religiosity, and provinciality still,

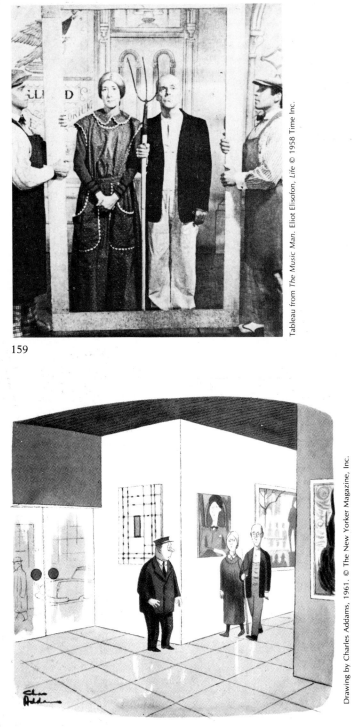

159

160

half a century later, fascinate contemporary critics, who differ just as vehemently over what they see in the painting today as critics did in Grant Wood's day. In 1974 art historian Matthew Baigell characterized the couple as savage, exuding "a generalized, barely repressed animosity that borders on venom." The painting, Baigell argued, satirized "people who would live in a pretentious house with medieval ornamentation, as well as the narrow prejudices associated with life in the Bible Belt."[18] More recently, the writer and literary critic Guy Davenport saw the work in a completely different spirit, calling it a sympathetic evocation of "Protestant diligence on the American frontier." For him the painting's richness lies in its ability to conjure up other mythic images and historical associations. He lets his mind roam freely, seeing the "modest Iowa farm wife" as wearing the "hair-do of a medieval madonna, a Reformation collar, a Greek cameo, a nineteenth-century pinafore."[19]

The conversations between the learned and the painting attest to *American Gothic*'s powerful hold on the American imagination. But even more revealing of the painting's extraordinary capacity for multiple interpretations is its prominent place in contemporary American popular culture. *American Gothic* has been adopted by mass America as a national portrait, the homespun couple coming to stand for the archetypal American family. Thanks to its frequent reproduction, and to cartoonists and admen who mercilessly parody the image, the painting has enjoyed a second life. Its first life has been as a work of art; its second as a popular icon.

The second life doesn't begin until the late 1950s and the early 1960s, when an occasional illustrator or cartoonist would quote the couple in their work. In Meredith Willson's 1957 Broadway musical *The Music Man*, actors briefly took the couple's pose behind an empty frame to set the scene in River City, a small town in Iowa. A few years later, Charles Addams published a cartoon in the *New Yorker* showing the couple startling a museum guard as they walked out of an exhibition in a modern art museum. But then in the late 1960s a virtual torrent of takeoffs of *American Gothic* began to appear. Amateurs and professionals, cartoonists and illustrators, advertisers and partisans of various causes began to use *American Gothic* as an all-purpose "blackboard" on which to write their messages, voice their concerns, or hawk their wares. They have discovered, as the critics have before them, that the image is protean, capable of addressing an infinite number of issues. With a simple change of clothes, faces, tools, or surroundings, parodists have proved that the couple can represent almost any kind of American: rich or poor, urban or rural, young or old, radical or

redneck, and, on rare occasions, black as well as white. In the past two decades, no painting, with the possible exception of the *Mona Lisa*, has been so rapaciously consumed by the American public.

Very often it is the famous whose heads are grafted onto *American Gothic*. The results are intentionally ludicrous, the highly publicized faces of First Families, politicians, and movie stars completely out of character with the apron, overalls, and country setting of Wood's image—most especially when we see Spiro Agnew, wearing the apron, paired with Richard Nixon! Often cartoonists choose the *American Gothic* setting because it gets their point across. Depicting a smiling Jimmy and Rosalynn Carter in 1981 as "Just Plains Folks," the former president holding a pitchfork with a peanut stuck on it, conveyed at a glance their return to small-town living in Plains, Georgia. Another presidential parody, a 1970 image of President Nixon standing between the *American Gothic* couple, his arms lovingly around their shoulders, spoke to his conservative policies and alliance with grass-roots America. In 1972 a most inventive and unlikely "American Gothic" mated two very dissimilar candidates for the Democratic presidential nomination: Shirley Chisholm, then congresswoman from New York, and segregationist George Wallace of Alabama. It comes as a shock to see such an impossible duo, the black civil rights advocate and the deep-South opponent of integration. Placing political opponents together in an image in which we expect to find bedfellows incisively underlines their incompatible points of view.

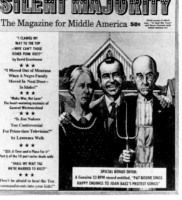

163

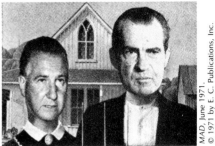

164

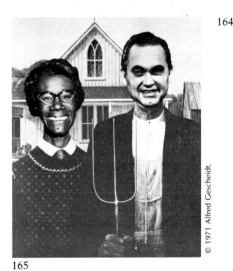

165

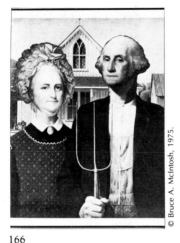

166

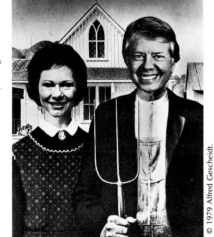

161

162

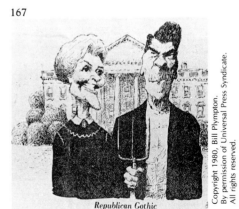

167

168

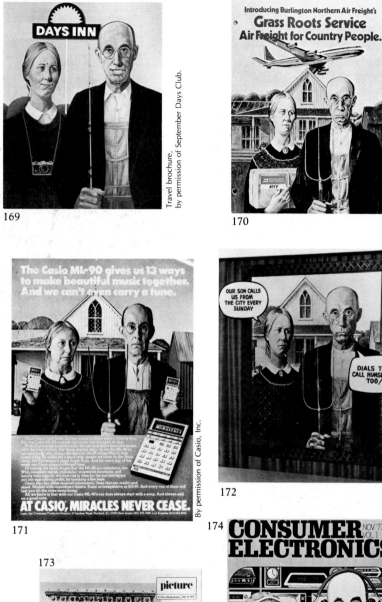

169

Travel brochure, by permission of September Days Club.

170

By permission of Burlington Northern.

171

By permission of Casio, Inc.

172

By permission of Pacific Telephone & Telegraph Co.

173

174

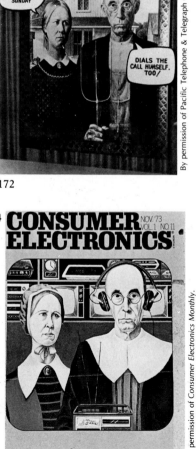

Des Moines Sunday Register, Jan. 9, 1972.

By permission of Consumer Electronics Monthly.

In the "American Gothics" intended to sell us merchandise, the couple usually are depicted with their traditional faces. Because we have adopted them as Mr. and Ms. Average America, they need only don sunglasses and carry cameras to urge us to travel both home and abroad. With pitchfork in hand and speaking as Mr. and Mrs. Midwestern Farmer, they persuade us to listen to a particular country-and-western station, buy a certain breakfast cereal, or purchase our fresh eggs and produce at a local supermarket. And because they look so old-fashioned, we look twice at ads in which they endorse products far beyond their realm of experience—when they sell skis, for instance, or Ford Mustangs, calculators, radios, or computers. To see the pitchfork replaced by skis is amusing; but to find the straight-laced couple promoting sportscars or electronic equipment is so incongruous that we are seduced into reading the advertisement, which is exactly what its designer wants.

Because Wood's couple are so universally recognized and can speak from so many platforms—as rural people, farmers, spouses, clean-living folks, average Americans, and old people— they have been used to address major social and political causes of the past two decades. In their rural guise, holding a pitchfork (or sometimes a marijuana plant), they were easily transformed into long-haired hippies and residents of communes; they also became revolutionaries and raised their pitchforks, or Molotov cocktails, in protest. As farmers, they have served as mouthpieces for those opposing or advocating the sale of surplus wheat to Russia, farm subsidies and mechanization, agricultural corporations, rural health care programs, and community gardens in the city. In statements on contemporary relations between the sexes, the *American Gothic* woman has traded in her apron for a business suit or a judge's robe, spoken out on women's rights, and picketed for the Equal Rights Amendment. Embodying our belief in clean living, the couple have protested pornography and fought for clean air and less congestion and noise in our cities. As average Americans, they have felt the gas shortages, suffered soaring prices in the recession, and seen foreclosure notices posted on their front door.

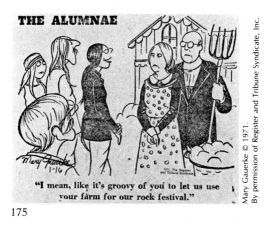

THE ALUMNAE

"I mean, like it's groovy of you to let us use your farm for our rock festival."

175

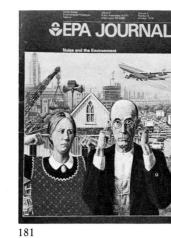

176

AMERICAN GOTHIC ?

177

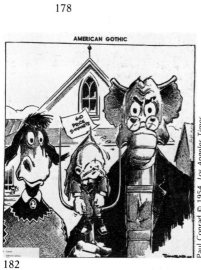

"We believed the President, We believed the Nuclear Energy Commission, We believed, We believed, We believed."

MELTDOWN!

interpretations of present and future possibilities of nuclear power

178

THE BERKELEY LIBERATION

FARM

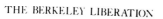

179

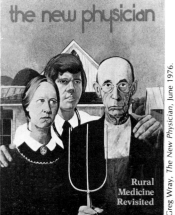

the new physician

Rural Medicine Revisited

180

EPA JOURNAL

Noise and the Environment

181

AMERICAN GOTHIC

182

184

183

THE JERRY FALWELL CHURCH OF THE MORAL PEJORATIVE

A TAX-FREE ORGANIZATION

WOULD THAT BE IN THE KITCHEN SIR? OR BAREFOOT AND PREGNANT, PERHAPS?

"Supreme Court, indeed! Get back in your place, woman!"

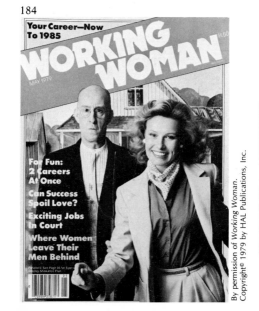

Your Career—Now To 1985

WORKING WOMAN

For Fun: 2 Careers At Once

Can Success Spoil Love?

Exciting Jobs In Court

Where Women Leave Their Men Behind

185

Judicial Confrontation

ERNIE'S PORNOGRAPHY EMPORIUM & SALON

PORNOGRAPHIC BOOKS, TAPES, MOVIES, RECORDS, NOVELTIES, ETC.

YOU MUST BE OVER 21

186

MODERN AMERICAN GOTHIC

FORECLOSURE AUCTION TODAY

By permission of the *Minneapolis Star and Tribune.*

187

The SOCIAL SECURITY SYSTEM: WE BOUGHT IT. WE BUILT IT. WE'RE GONNA KEEP IT!

By permission of the *Minneapolis Star and Tribune.*

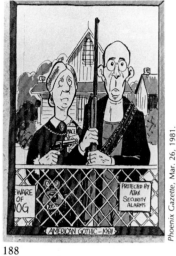

188

AMERICAN GOTHIC - 1981

Phoenix Gazette, Mar. 26, 1981.

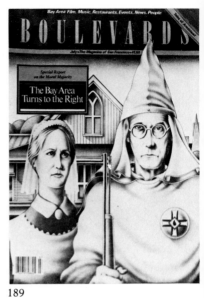

189

BOULEVARDS

Special Report on the Moral Majority
The Bay Area Turns to the Right

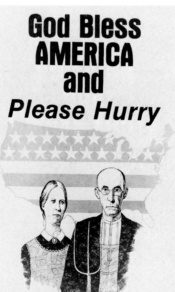

God Bless AMERICA and Please Hurry

190

Image courtesy of Dynamic Graphics, Inc., Peoria, IL.

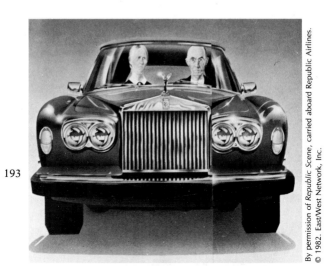

191

"L.A. Gothic" © 1980 Diane Teske Harris.

KIWANIS
A MAGAZINE FOR COMMUNITY LEADERS

The leisure lifestyle comes of age

192

Kiwanis, January 1981.

193

By permission of *Republic Scene,* carried aboard Republic Airlines. © 1982. East/West Network, Inc.

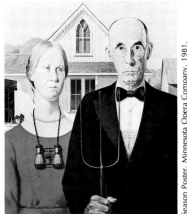

194

Season Poster, Minnesota Opera Company, 1981.

195

Illustration by Dennis Mukai.

196

By permission of The Lodge at Harvard Square.

197

Poster by Stephen Osborn, "American Gothic No. 2 (with apologies to Grant Wood)."

The couple, in fact, are a barometer of our times. They reflect changes in national priorities, values, worries, and aspirations. In the Reagan years they have naturally taken on new guises. While the "American Gothics" of just a decade ago were often commune members and environmentalists, today they are likely to be preppies and aspiring professionals. Although they are still occasionally portrayed as reformers, supporting antinuclear initiatives or worrying about social security benefits and home security systems (survival is definitely on their minds), most telling is their new conservatism and materialism. The couple have often adopted right-wing politics, calling upon God to bless America or even dressing in Ku Klux Klan robes. They have also become elegant. For the first time in their history, the *American Gothic* pair have become materially well-off and chic. That quintessential couple of homespun simplicity have recently been seen driving a Rolls-Royce, wearing leisure suits, carrying tennis rackets and golf clubs, going black-tie to the opera, and advertising preppy coordinates. Their new look mirrors that of Reagan's Washington and, very obviously, the heightened materialist aspirations of our time.

Despite its extraordinary versatility, the image has not served all Americans or all social causes equally. In reviewing several hundred parodies I discovered that *American Gothic* has been used often to discuss farming, marriage, consumerism, or middle-American life-styles, but is seldom adapted for issues that are nationally divisive: the Vietnam war, poverty, the civil rights movement, and racial questions. While the couple stand for white middle-class America with ease, and can sometimes become foreign—"Arab Gothic" to satirize sheiks buying American homes, or "French Gothic" to illustrate the rising numbers of French bakeries in America—they rarely represent blacks, Chicanos, or Asian-Americans. One can only speculate as to why this is the case. It may well be that national prejudices are at work, that minority groups are excluded because they are not seen by illustrators and cartoonists as appropriate symbols for Mr. and Ms. America. Nor perhaps can minority groups see themselves comfortably in an image which speaks so exclusively about white middle America, its myths and traditions—unless that happens to be their history too. The only major image of a black couple that I know of relates to a typical American success story and confirms such a hypothesis. This is a handsome painting by the black Detroit artist Carl Owens portraying the parents of Berry Gordy, the founder of the very successful Motown record company. Commissioned as a family gift for the couple, the portrait speaks to their roots—Berry Gordy, Sr. was a farmer and Bertha Gordy a schoolteacher

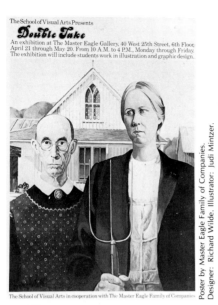

198

Poster by Master Eagle Family of Companies.
Designer: Richard Wilde. Illustrator: Judi Mintzer.

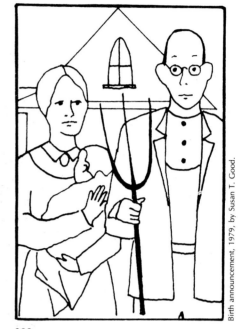

199

American Artists Group Christmas card by Margaret Fleming.

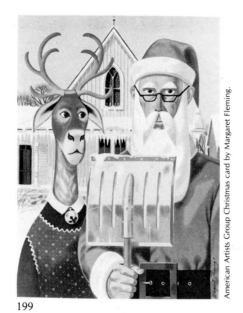

200

Birth announcement, 1979, by Susan T. Good.

201

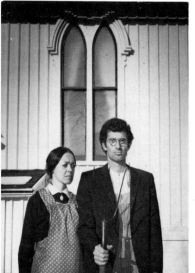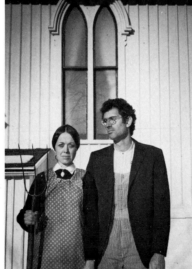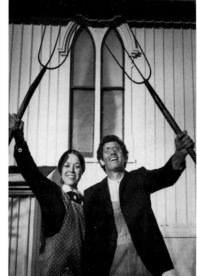

Christmas card, Joe and Wanda Corn, 1975.

202

Nan Wood Graham in her California living room. © 1981 Joan Liffring-Zug.

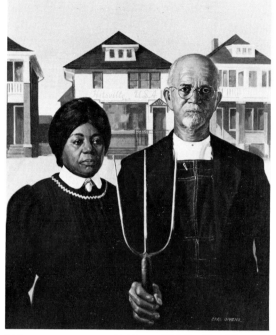

203 Carl Owens, *This Is Your Life*, 1972.
By permission of Esther G. Edwards, Detroit.

204

Howard Kottler, "Look Alikes," 1972.

205

Stamp from Sharjah.

when they first met—and honors the part the Gordys played in their son's success: the single-family, urban house behind the couple labeled "Hitstown, USA" is the house in which Motown began. The couple are sporting spanking clean, crisp *American Gothic* clothes and fashionably cut hairstyles; even the pitchfork looks new. It is clear that they are materially well-off and belong to the American middle class that the painting has come to represent.[20]

The portrait of Mr. and Mrs. Berry Gordy, Sr. belongs to another generic category of takeoffs, the homemade versions done in paint, pencil, photographs, or stitchery that are hung in homes or used as Christmas cards, baby announcements, and invitations for anniversary celebrations. Yet another branch of the *American Gothic* industry consists of lewd and off-color versions, which the artist's sister, the model for the painting, has tried to stop by suing magazines like *Playboy* and *Hustler* for defamation of character, libel, and invasion of privacy. The painting has also been used in unaltered form—as a puzzle, as a decoration for men's ties, jugs, plates, and a liquor bottle, and as a commemorative postage stamp from the emirate of Sharjah, Trucial Oman (now the United Arab Emirates). Recently the figures have been reproduced in a foot-high, free-standing porcelain sculpture, and the whole painting has appeared in relief in a commemorative gold medallion authorized by Congress and issued by the United States mint. On the other side of the one-ounce gold coin there is a portrait bust of the artist.

The couple in *American Gothic* stands today among the most celebrated personages of art: the *Mona Lisa*, Whistler's Mother, *The Blue Boy*, and van Gogh's self-portrait. Unlike the *Mona Lisa*, however, whose modern-day following can be traced back to late-nineteenth- and early-twentieth-century artists and writers, *American Gothic* rose to iconic status in the last fifteen years and almost entirely through its continual use in commercial and popular culture. One contributing factor, to be sure, was the democratization and popularization of high art that began in the 1960s and has continued into our own times. Art museums in this period began to attract a mass public, as middle America became more status-conscious and educated about the history of art. Works of art took on a new currency and highly publicized prominence in our culture. The prices they brought became front-page news; reproductions became a major museum business; and art-book publishing thrived. Artists themselves, particularly the Pop artists, began to "quote" from older artworks. In the broader culture, similar quotations or reproductions flourished. Because the American public recognized the masterpieces of the past, *Guernica* could appear on

antiwar posters; works by Stuart Davis, Thomas Eakins, and John Singleton Copley on American postage stamps; Emanuel Leutze's *Washington Crossing the Delaware* in a ballet by Paul Taylor; and the *Mona Lisa* or *American Gothic* in advertisements.

The explosion of culture in the last fifteen years, however, only partly explains *American Gothic*'s central place in today's popular culture. The painting's content remains the essential reason for its popularity. Like the Statue of Liberty or *Washington Crossing the Delaware*, *American Gothic* embodies many traditional American values and is more important for what it symbolizes than as a work of art. Its symbolic power comes from its capacity to evoke so many mythic strains of our na-

tional experience. A simple pictograph—one house, two people, and a pitchfork—reminds so many Americans of their own ancestral photographs and triggers associations with a wide range of celebrated American experiences: our Puritan beginnings, life on the frontier, free enterprise, self-reliance, the Protestant work ethic, agrarianism, the nuclear family, and the common man. The artist's intentions, of course, were to paint a legendary portrait of *his* roots, not the entire nation's. But he always maintained that a successful regionalist work transcended the local to touch the universal. In *American Gothic* the chord he struck went back at least as far as 1776. Wood's midwestern portrait has transcended time and place to become the national ancestral icon.

206

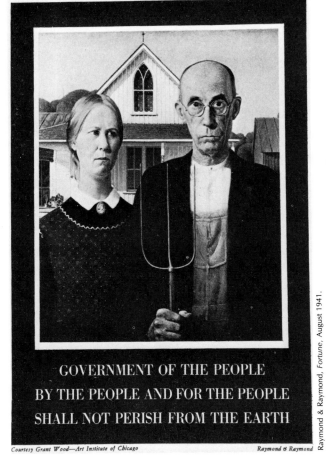

GOVERNMENT OF THE PEOPLE
BY THE PEOPLE AND FOR THE PEOPLE
SHALL NOT PERISH FROM THE EARTH

Courtesy Grant Wood—Art Institute of Chicago Raymond & Raymond

Raymond & Raymond, *Fortune*, August 1941.

207

Drawing by Charles Addams, 1979. © The New Yorker Magazine, Inc.

"I think you know everybody."

Chronology

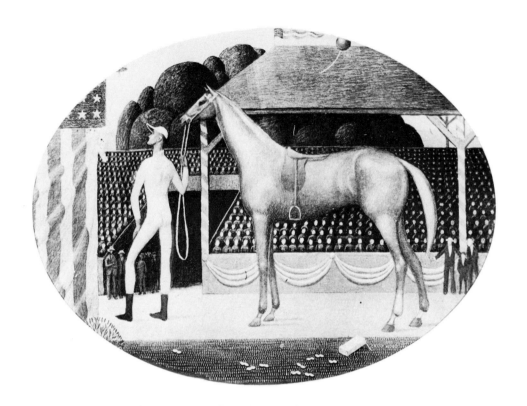

208 RACE HORSE 1933
Charcoal, pencil, and chalk on paper, 16 × 22 1/2 in.
Private Collection

209 DRAFT HORSE 1933
Charcoal, pencil, and chalk on paper, 16 × 22 1/2 in.
Private Collection

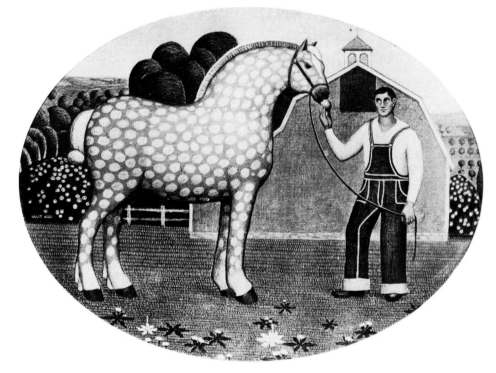

Chronology

1891 Grant DeVolson Wood born 13 February on a farm near Anamosa, Iowa, to Francis Maryville Wood (1855–1901) and Hattie D. Weaver Wood (1858–1935).

1901 Death of Francis Maryville Wood; Hattie Wood moves to Cedar Rapids with her four children.

1910 Graduates from Washington High School, Cedar Rapids. Spends summer term at Minneapolis School of Design and Handicraft and Normal Art studying with Ernest Batchelder.

1911 Attends second summer term at Minneapolis School of Design and Handicraft and Normal Art.

1911–12 Teaches at Rosedale Country School near Cedar Rapids. Sporadically follows a life-drawing class under Charles A. Cummings at the University of Iowa in Iowa City. Makes jewelry and fine metalwork in Cedar Rapids.

1913–15 In Chicago, attends evening classes drawing from the clothed model at the Art Institute. Works as designer at Kalo Silversmith's Shop; in 1914, with Christopher Haga, opens Wolund Shop in Park Ridge to make jewelry and other fine metalwork.

1916 Wolund Shop fails; enrolls at the Art Institute of Chicago in a class drawing from the nude model. Abruptly returns to Cedar Rapids in mid-January, when Mrs. Wood, in financial difficulty, is forced to sell her home. Builds temporary cottage for himself, mother, and sister and, with Paul Hanson, begins two permanent homes in Kenwood Park, Cedar Rapids, one for the Hansons and one for the Woods.

1917 Wood family moves into their new house at 3178 Grove Court, S.E., Cedar Rapids.

1918–19 Serves in army first at Camp Dodge, Iowa, and then in Washington, D.C., designing camouflage for artillery.

1919 In September, begins teaching at Jackson Junior High School under Miss Frances Prescott as principal. Teaches in Cedar Rapids' public schools until 1925. In October, Killian's Department Store sponsors the artist's first exhibition along with the work of his painter friend Marvin Cone.

1920 Makes first trip abroad, spending summer painting in Paris with Marvin Cone. In fall has exhibition with Cone of Paris paintings at the Cedar Rapids Art Association's gallery in public library.

1921 Paints *First Three Degrees of Free Masonry* on a commission from George L. Schoonover.
First Three Degrees of Free Masonry

1922 In September, transfers to McKinley Junior High School with Miss Prescott.
Adoration of the Home

1923–24 On leave from teaching, studies and travels for eleven months abroad. Enrolls in a class at the Académie Julian in Paris in the fall. Spends winter months in Sorrento, Italy, spring and summer in Paris and the French provinces.

1924 Turns top floor of carriage house and stables behind Turner mortuary into a studio and soon thereafter a studio-apartment. Convinces his mother to leave Kenwood Park and live with him at what became known as 5 Turner Alley.

1925 Leaves his teaching job in May to free-lance his artistic skills. Takes on private commissions (e.g., portraits of workers for the J. G. Cherry Company, a dairy equipment plant), and begins to establish himself as home designer and decorator.

1926 In June and July, makes third and last trip to

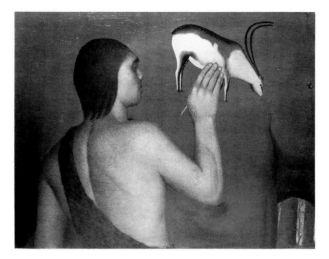

210 STONE AGE PICTURE WRITING 1933
Gesso on composition board, 32 × 42 in.
The Tempel Smith Collection

**211 STYLUS AND WAX TABLET OF THE
ANCIENT GREEKS 1933**
Gesso on composition board, 32 × 42 in.
The Tempel Smith Collection

213 COLONIAL PENMAN 1933
Gesso on composition board, 32 × 42 in.
The Tempel Smith Collection

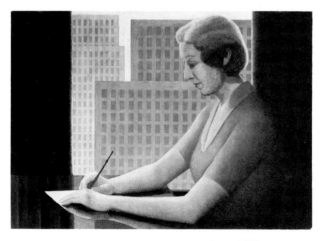

214 MODERN METHOD OF WRITING 1933
Gesso on composition board, 32 × 42 in.
The Tempel Smith Collection

212 BRUSH OF THE MEDIEVAL MONK 1933
Gesso on composition board, 32 × 42 in.
The Tempel Smith Collection

Paris. One-person exhibition of forty-seven paintings at Galerie Carmine, rue de Seine. Begins painting murals for Eugene Eppley's hotels in Sioux City, Waterloo, Cedar Rapids, and Council Bluffs.

1927 In January, receives commission for stained-glass window for new Veterans Memorial Building in Cedar Rapids. In late spring works in Estes Park, Colorado.
 Portrait of Sally Stamats

1928 From September to December, in Munich to supervise the making of the Memorial Window. Ed Rowan arrives in Cedar Rapids under Carnegie Foundation grant to establish the Little Gallery.
 Portrait of John B. Turner, Pioneer

1929 Installs Memorial Window. Has exhibition at Little Gallery. *John B. Turner* wins first prize in portraiture at the Iowa State Fair. *Woman with Plants* shown at Forty-Second Annual Exhibition of Painting and Sculpture at the Art Institute of Chicago.
 Woman with Plants
 Portrait of Gordon Fennell, Jr.
 Portrait of Judge M. D. Porter
 Portrait of Frances Fiske Marshall

1930 *Arnold Comes of Age* (then called *Portrait of Arnold Pyle*) and *Stone City* win first prizes at the Iowa State Fair in the portrait and landscape categories, respectively. Portrait of Pyle also wins the overall sweepstakes prize. *American Gothic* wins Norman Walt Harris medal at Forty-Third Annual Exhibition of Painting and Sculpture at the Art Institute of Chicago. Painting purchased by the Art Institute for $300. Large reception is held for the artist and the painting at the Little Gallery.
 Arnold Comes of Age
 Stone City
 American Gothic
 Portrait of Mary Van Vechten Shaffer
 Portrait of Susan Angevine Shaffer
 Overmantel Decoration

1931 *Appraisal* is shown at the Pennsylvania Academy of Fine Arts and wins sweepstakes prize at the Iowa State Fair. *Midnight Ride of Paul Revere* is exhibited at the annual exhibition at the Art Institute of Chicago.
 Appraisal
 Midnight Ride of Paul Revere
 The Birthplace of Herbert Hoover
 Victorian Survival
 Fall Plowing
 Young Corn
 Plaid Sweater

1932 *Arbor Day* and *Victorian Survival* are invited to an exhibition of modern American art at the Carnegie Institute in Pittsburgh. *Fall Plowing* wins sweepstakes prize at the Iowa State Fair. From 26 June to 6 August, with Ed Rowan and Adrian Dornbush establishes Stone City Colony and Art School. With Bruce McKay begins Robert Armstrong house. Installs *Fruits of Iowa* murals, commissioned previous year, in Hotel Montrose dining room, Cedar Rapids. Exhibits *Daughters of Revolution* in the Whitney Museum of American Art's first Biennial Exhibition of Contemporary American Painting, and *Midnight Ride of Paul Revere* at the Carnegie International exhibition in Pittsburgh.
 Daughters of Revolution
 Arbor Day
 Portrait of Mrs. Donald MacMurray
 Self-Portrait

1933 Stops competing at the Iowa State Fair. From 27 June to 22 August, teaches at Stone City Colony and Art School. Meets John Steuart Curry when Curry visits Stone City as guest teacher. Completes five-panel mural on the History of Penmanship for A. N. Palmer Method Company exhibit at the Century of Progress Exposition in Chicago. Exhibition at Increase Robinson Gallery in Chicago. Makes book jacket for *In Tragic Life* by Vardis Fisher. *Daughters of Revolution*

shown at the Carnegie International exhibition in Pittsburgh.

> *Portrait of Nan*
> *Near Sundown*
> *Trees and Hill*
> *Race Horse*
> *Draft Horse*

1934 Named director of Public Works of Art Project (PWAP) in Iowa. Begins association with University of Iowa in Iowa City (then called the State University of Iowa), where he supervised artists in making the "Practical Arts" murals for the Iowa State University library in Ames (then called the Iowa State College of Agriculture and Mechanic Arts). In September, becomes Associate Professor of Fine Arts at University of Iowa. Helps found the Society for the Prevention of Cruelty to Speakers at the university and decorates its club room. In New York, meets Thomas Hart Benton and Thomas Craven for first time. Exhibits *Dinner for Threshers* at the Carnegie International exhibition in Pittsburgh, where the public voted it the third most popular painting. Featured in 24 December *Time* magazine in story on "U.S. Scene" painting. Provides jacket illustration for Vardis Fisher's *Passions Spin the Plot*.

> *Dinner for Threshers*

1935 Marries Sara Sherman Maxon in March. Elected to the National Academy of Design. His works displayed in one-man exhibition at Lakeside Press Galleries in Chicago and Ferargil Galleries, New York City. Signs contract with Doubleday Doran for his biography and creates drawing, *Return from Bohemia*, for its cover. Moves to 1142 East Court Street, Iowa City. Hattie Weaver Wood dies in October. At first accepts but then declines appointment as regional director for Federal Art Project. In November, signs agreement with Lee Keedick, New York agent, for lecture engagements. Frank Luther Mott helps write and then publish Wood's "Revolt Against the City." Creates jacket illustration for Thomas Duncan's *O' Chautauqua*.

> *Death on the Ridge Road*

1936 Twenty drawings exhibited at Maynard Walker Galleries, New York, and published as illustrations to Madeline Darrough Horn's *Farm on the Hill*, a story for children. Awarded honorary Doctor of Letters degree from the University of Wisconsin, Madison. *Spring Turning* exhibited at the Carnegie International in Pittsburgh.

> *Spring Turning*

1937 Completes illustrations for Limited Editions Club publication of *Main Street*, by Sinclair Lewis. Begins making lithographs for Associated American Artists. Installs mural *Breaking the Prairie* at Iowa State University in Ames.

1938 Receives honorary degree from Lawrence College, Appleton, Wisconsin. Is separated from Sara Maxon Wood. Provides jacket illustration for Sterling North's *Plowing on Sunday*. Completes series of four lithographs for Associated American Artists, for which Nan Wood Graham and husband, Edward Graham, do the hand-coloring.

1939 Divorces Sara Wood.

> *Parson Weems' Fable*
> *Haying*
> *New Road*

1940 Sells *Parson Weems' Fable* to Mr. and Mrs. John Marquand, with Associated American Artists acting as agent, and exhibits the painting in Annual Exhibition of Contemporary American Art, Whitney Museum of American Art. In February makes lecture trip to California, and in May returns to West Coast to paint *Sentimental Ballad* on location at Hollywood studio producing film version of Eugene O'Neill's *The Long Voyage Home*. In fall takes year's leave of absence from the University of Iowa to escape controversy over his position at the school and to paint. His drawing of *Henry Wallace* appears on September 23 cover of *Time* magazine. Does book-jacket illus-

tration for Kenneth Roberts's *Oliver Wiswell* and war-relief poster, *Bundles for Britain*.

Sentimental Ballad
January
Adolescence
The American Golfer, Portrait of Charles Campbell

1941 Awarded honorary degrees from Northwestern University, Evanston, Illinois, and Wesleyan University, Middletown, Connecticut. In the summer paints in an abandoned railroad depot in Clear Lake, Iowa. In fall appointed Full Professor of Fine Arts at the University of Iowa. In December admitted to hospital for surgery.

Spring in the Country
Spring in Town

1942 Dies of liver cancer on 12 February, one day before his fifty-first birthday, in University of Iowa Hospital. Buried at Riverside Cemetery in Anamosa. Memorial exhibition of forty-eight works is held at Fifty-Third Annual Exhibition of American Painting and Sculpture at Art Institute of Chicago.

Notes

INTRODUCTION

1 Hilton Kramer quoted in Jean Kinney, "Grant Wood: He Got His Best Ideas While Milking a Cow," *New York Times,* June 2, 1974, p. 14.
2 See James Dennis, *Grant Wood: A Study in American Art and Culture* (New York, 1975); Matthew Baigell, "Grant Wood Revisited," *Art Journal* 26 (Winter 1966–67): 116–22; and Baigell, *The American Scene* (New York, 1974).
3 Darrell Garwood, *Artist in Iowa: A Life of Grant Wood* (New York, 1944); Hazel E. Brown, *Grant Wood and Marvin Cone: Artists of an Era* (Ames, Iowa, 1972).

THE REGIONALIST VISION

1 The biographical information in this book is culled from a variety of sources, most particularly from discussions with Nan Wood Graham; the Grant Wood holdings at the Archives of American Art, Smithsonian Institution (hereafter AAA); the Grant Wood collection at the Davenport Art Gallery; the manuscript "Return from Bohemia"; Darrell Garwood's *Artist in Iowa: A Life of Grant Wood* (New York, 1944); and Hazel Brown's *Grant Wood and Marvin Cone: Artists of an Era* (Ames, Iowa, 1972).
2 Although this unfinished biography has traditionally been attributed to Grant Wood and can be found under his name on microfilm D24/161–295 at the Archives of American Art, it was written by Park Rinard, who submitted an earlier version of "Return from Bohemia, A Painter's Story," Part I, as his master's thesis to the Department of English, University of Iowa, in 1939. Rinard was an extremely close friend and associate of Wood's, worked as his secretary, and wrote the biography in consultation with the artist. Wood had a contract with Doubleday to publish the manuscript when it was completed. The references given here indicate first the reel and frame numbers of the AAA microfilm and then, in parentheses, the page numbers of Rinard's thesis. In a few instances there are slight differences between the two versions, and in other cases the quoted material in the text appears only in one.
3 Rinard, "Return from Bohemia," AAA D24/199 (pp. 50–51).
4 Ibid., D24/168, 242, 271 (pp. 7, 113, 156).
5 Ibid., D24/209 (p. 65).
6 Ibid., D24/205 (p. 59).
7 Sinclair Lewis, *Main Street* (New York, 1920).
8 Wood's view that the farmer is "central and dominant" in the Midwest is best expressed in his 1935 essay, "Revolt Against the City," reprinted in James Dennis, *Grant Wood: A Study in American Art and Culture* (New York, 1975), pp. 229–35.
9 Rinard, "Return from Bohemia," AAA D24/164 (p. 1).
10 Ibid., D24/165 (pp. 2–3).
11 Ibid., D24/165–66 (pp. 3–4).
12 Ibid., D24/176 (p. 18).
13 Ibid., D24/175 (p. 16).
14 Ibid., D24/276 (p. 162).
15 Ibid., D24/183.
16 Ibid., D24/175 (p. 14).
17 Ibid., D24/173 (pp. 16–17).
18 Ibid., D24/175.
19 Garwood, *Artist in Iowa*, p. 246; Nan Wood Graham, letter to the editor, *Saturday Evening Post*, no. 25 (December 1965): 6.
20 Rinard, "Return from Bohemia," AAA D24/284 (pp. 175).
21 Ibid., D24/292 (p. 187).
22 Ernest A. Batchelder, *The Principles of Design* (Chicago, 1904).
23 Miss Frances Prescott, "A Tribute to Grant Wood," a radio program for WMT, Cedar Rapids, Nov. 16, 1951, preserved on a phonograph record, Grant Wood collection, Davenport Art Gallery.
24 Wood scrapbooks, AAA 1216/246–47 and 406–07.
25 Ibid., 1216/253.
26 Edward Rowan in an undated report to the American Federation of the Arts, Edward B. Rowan Papers, AAA D142/169–70.
27 For the history of Cedar Rapids, see Ralph Clemens, *Tales of the Town, Little-Known Anecdotes of Life in Cedar Rapids* (Cedar Rapids, 1967); Ernie Danek, *Tall Corn and High Technology*, Cedar Rapids (Woodland Hills, Calif., 1980); Janette Stevenson Murray and Frederick Gray Murray, *The Story of Cedar Rapids* (New York, 1950).
28 David Turner, *Cedar Rapids Gazette*, Jan. 12, 1926.
29 Grant Wood to W. J. Brown, letter of Dec. 24, 1926, recorded in the minutes of the Memorial Commission, Cedar Rapids, Jan. 25, 1927.
30 "Grant Wood Is One Artist Of Renown Appreciated In His Own City; Local Tributes," *Cedar Rapids Evening Gazette and Republican*, Feb. 11, 1931, in Wood scrapbooks, AAA 1216/293.
31 "Grant Wood Explains Why He Prefers To Remain In Middle West In Talk At Kansas City," *Cedar Rapids Sunday Gazette and Republican*, Mar. 22, 1931, in Wood scrapbooks, AAA 1216/302.
32 "He Plans For A Native Art," New York *Sun*, Oct. 10, 1934, in Grant Wood scrapbook, New York Public Library.
33 "Mural Painting Is Shown On Streets," in Wood scrapbooks, AAA 1216/267.

Allen E. Philbrick painted four murals in 1911 for the new Peoples Savings Bank of Cedar Rapids. These characterize the city as the home of Agriculture, Industry, Banking, and Commerce and are a prototype for Wood's much more modest *Adoration of the Home*.

34 Paul Engle, taped interview with author, Aug. 9, 1976.

35 See William L. Shirer, *Twentieth Century Journey, A Memoir of a Life and the Times: The Start, 1904–1930* (New York, 1976), pp. 273–79.

36 MacKinlay Kantor, *I Love You, Irene* (Garden City, New York, 1972), pp. 139–43.

37 Rowan Papers, AAA D142/108.

38 Ibid., D142/152, 157–58.

39 Engle interview, Aug. 9, 1976.

40 Rowan Papers, AAA D142/164.

41 Brown, *Grant Wood and Marvin Cone*, pp. 70–72.

42 Rowan Papers, AAA D142/140; and "Folk Jam Little Gallery To Honor Grant Wood, Artist," *Cedar Rapids Evening Gazette and Republican*, Feb. 12, 1931, in Wood scrapbooks, AAA 1216/298–99.

43 *The New Yorker* 1 (Feb. 21, 1925): 2.

44 Ruth Suckow, "Iowa," *American Mercury* 9 (September 1926): 40.

45 Ibid., p. 39.

46 Ibid., p. 40.

47 Shirer, *Twentieth Century Journey*, p. 186.

48 Carl Van Vechten, *The Tattooed Countess* (New York, 1924).

49 Quoted in Garwood, *Artist in Iowa*, p. 88. See also Brown, *Grant Wood and Marvin Cone*, pp. 37–38.

50 Quoted in Brown, *Grant Wood and Marvin Cone*, p. 43.

51 See Wood scrapbooks, AAA 1216/272 for a 1926 catalogue, published by Turner, of Wood's paintings hanging in the Turner mortuary.

52 Photographs of the painted windows and lantern in the James Pickens home, formerly the David and Hilda Turner residence, are reproduced in Barbara Bjornson, "At Home with Collecting,"

The Iowan 24 (Winter 1975): 14–15.

53 Rowan Papers, AAA D142/170.

54 "Many Turn Out For Lecture By Iowa Artist," Dubuque *Telegraph-Herald and Times-Journal*, Mar. 7, 1932, in Wood scrapbooks, AAA 1216/1323. See also "Grant Wood Explains Why He Prefers To Remain In Middlewest In Talk At Kansas City," *Cedar Rapids Sunday Gazette and Republican*, Mar. 22, 1931, in Wood scrapbooks, AAA 1216/302. Hazel Brown, *Grant Wood and Marvin Cone*, p. 66, recalls that in the 1920s Wood and his friends would sit around and discuss Frank Lloyd Wright, Ruth Suckow, and Jay Sigmund.

55 Wood scrapbooks, AAA 1216/257. For an anthology of Sigmund's writings, see Paul Engle, ed., *Jay G. Sigmund* (Muscatine, Iowa, 1939).

56 Engle interview, Aug. 9, 1976.

57 Ruth Suckow, "The Folk Idea in American Life," *Scribner's Magazine* 87 (September 1930): 253.

58 For the history of the magazine, see Milton M. Riegelman, *The Midland, A Venture in Literary Regionalism* (Iowa City, 1975).

59 The mural depicting the entrance to Kanesville is based on an engraving by Frederick Hawkins Piercy, which Piercy did for his 1855 book, *Route from Liverpool to Great Salt Lake Valley* (reprint ed. Fawn M. Brodie [Cambridge, Mass., 1962], pl. XIX). The source for the second mural, the townscape of Kanesville, Wood tells us in a cartouche in the lower left of the painting, is "an old Painting dated 1849." Recently, Judy Wigton of Omaha has identified two paintings in the Joslyn Art Museum that could have served as Wood's model: *Early Council Bluffs, Iowa* and *Mormon Camp Meeting, Council Bluffs* by George Simons (1843–1917), an artist who came to Council Bluffs with a mid-nineteenth-century railroad survey team (Jan. 19, 1983, letter to the author from Holliday T. Day, Joslyn Art Museum). A third mural, from Wood's Hotel Chieftain

series—another self-consciously primitive, bird's-eye view of Council Bluffs—is in storage at the Joslyn Art Museum, Omaha, Nebraska, and is being studied by the museum's curator, Hollister Sturges. All three of the murals were rescued from the Pioneer Room in the Hotel Chieftain in 1970 by Dr. Milton Heifetz of Beverly Hills, just before the interior of the building was gutted for renovation.

60 The construction of the window was handled by the art-glass company of Emil Frei in St. Louis, Missouri.

61 Irma René Koen, "The Art of Grant Wood," *Christian Science Monitor*, Mar. 26, 1932.

62 "Iowan's Art The Vogue," *Kansas City Star*, in Wood scrapbooks, AAA 1216/301.

63 Wood scrapbooks, AAA 1216/278; Rowan Papers, AAA D142/709.

64 Koen, "The Art of Grant Wood."

65 Rowan Papers, AAA D142/169.

66 "U.S. Scene," *Time* 24 (Dec. 24, 1934): 24–27.

67 Adeline Taylor, "Easterners Look Wistfully At Midwest As Nation's Art Crown Brought To It; Grant Wood Lionized On N.Y. Visit," *Cedar Rapids Gazette*, Oct. 21, 1934.

68 For discussion and photographs of the Armstrong house see Martha Darbyshire, "An Early Iowa Stone House," *Arts and Decoration* 44 (March 1939): 12–15; and Joan Liffring, "The Armstrong House," *The Iowan* 11 (Summer 1963): 32–37. I visited the house and interviewed Mrs. Armstrong in August 1976 and September 1982.

69 For material on the Stone City Colony and Art School, see the clippings and documents in the Wood scrapbooks and Rowan Papers at the American Archives of Art and a scrapbook in the Davenport Art Gallery put together by the colony's business manager. Two articles of interest are: Jan Mayskens, "Stone City, Iowa," *Annals of Iowa* 39 (Spring 1968): 261–74; F. A. Whiting, "Stone, Steel, and Fire: Stone City Comes to Life," *Amer-*

ican Magazine of Art 25 (December 1932): 333–42.

70 Engle interview, Aug. 9, 1976.

71 Brochure for the Stone City Colony and Art School, 1932, in Wood scrapbooks, AAA 1216/337.

72 "Many Turn Out For Lecture By Iowa Artist," in Wood scrapbooks, AAA 1216/1323.

73 "Grant Wood Explains Why He Prefers to Remain in Middle West," in Wood scrapbooks, AAA 1216/302.

74 Grant Wood, "Revolt Against the City," reprinted in Dennis, *Grant Wood*, p. 234.

75 Thomas Hart Benton, *An Artist in America* (New York, 1937), p. 258. For Wood's efforts on Curry's behalf, see Susan Kendall, "Rethinking Regionalism: John Steuart Curry and the Kansas Murals Controversy," dissertation in progress at the University of Minnesota.

76 Wood scrapbooks, AAA 1216/337.

77 See Dennis, *Grant Wood*, chap. 8, "Regionalism *vs.* the Industrial City," pp. 150–68, for an argument that focuses on Wood as a pro-agrarian and anti-city advocate.

78 Grant Wood, "A Definition of Regionalism" (1937), reprinted in *Books at Iowa*, no. 3 (November 1965): 3; Wood, "Revolt Against the City," reprinted in Dennis, *Grant Wood*, p. 234.

79 See 1934 letters and reports pertaining to Grant Wood's appointments in the papers of R. H. Fitzgerald, Director of the School of Fine Arts, on file in the Special Collections Department, University of Iowa Libraries, Iowa City, Iowa.

80 "Grant Wood, Clinician—His Patients: Artists; His Operations: On Pictures!" *Daily Iowan*, Oct. 30, 1934.

81 Undated report in R. H. Fitzgerald's papers arguing the reasons that Wood, representing the "liberal movement" of art, should be retained at the university.

82 See R. H. Fitzgerald papers for 1934 discussions of Cummings's conservative allies at the university; and Bess Ferguson, "Charles Atherton Cummings: Pioneer Artist and Educator,"

The Iowan 31 (Spring 1982): 28–33, 50–52.

83 "The Flowering of the Valley, Iowa Trains Creative Artists," *Life* 6 (June 5, 1939): 54–58.

84 Frank Luther Mott, "The S.P.C.S.," *The Palimpsest* 43 (March 1962): 113–32.

85 Mott independently published *Revolt Against the City* as the first in the Whirling World Series of the Clio Press, Iowa City, in 1935. Three more works were published in the series, all by regional writers. In chapter 27 of Nan Wood Graham's unpublished memoirs, "My Brother Grant Wood," she reports the discovery of a copy of *Revolt Against the City* signed by Frank Luther Mott with the inscription, "I 'ghost-wrote' this for Grant." I am inclined to accept the inscription—first, because Wood often let others, particularly Park Rinard, write material for him to look over and sign; and, second, because there are features of the essay that are uncharacteristic of Wood but typical of Mott. Wood repeated himself endlessly in lectures and interviews and it is easy to identify those aspects of the essay, which were a staple of his regionalist creed. (Whoever wrote the essay obviously had access to Wood's clipping file, because some statements in the essay are taken directly from interviews with the artist reported in the press.) What Wood, however, would never do is enliven his arguments with literary references or call himself an antiurbanist, both of which are prominent features of the essay. In the first few pages there are references to writings by Ralph Borsodi, Carl Van Doren, Ralph Waldo Emerson, and Arthur M. Schlesinger and a strong attack against the American city's domination of culture and against urbanism in general. Such sentiments and habits of thought were typical of Mott and other literary regionalists at the university, but not of Wood. When Wood was asked once to comment upon an antiurban, literary definition of

regionalism, he conspicuously removed the phrase "revolting against domination by the city (especially New York), against industrial civilization" from his own definition and emphasized painting from experience and the life one knows best. Even though his paintings are prejudiced in favor of rural life, Wood steadfastly refused to see himself in an adversary position with urban culture and professed high respect for a city artist like Reginald Marsh, whom he thought of as a kindred spirit. See Grant Wood, "A Definition of Regionalism," reprinted in *Books at Iowa*, no. 3 (November 1965): 3–4. For other of Wood's writings at the university see "The Writer and the Painter," *American Prefaces* 1 (October 1935): 3–4; and "Art in the Daily Life of the Child," Child Welfare Pamphlet no. 73 (May 19, 1939), University of Iowa.

86 Wood, "Revolt Against the City," reprinted in Dennis, *Grant Wood*, p. 235.

87 Ibid., p. 232.

88 See, for example, Lincoln Kirstein, "An Iowa Memling," *Art Front* 1 (July 1935): 6, 8; Lewis Mumford, "The Art Galleries," *The New Yorker* (May 4, 1935): 29–31; James Johnson Sweeney, "Grant Wood," *The New Republic* 83 (May 29, 1935): 76–77.

89 Recounted in chapter 25 of Nan Wood Graham's manuscript, "My Brother Grant Wood," and in Lea Rosson DeLong and Gregg R. Narber, *A Catalogue of New Deal Mural Projects in Iowa* (Des Moines, Iowa, 1982), pp. 12–13. The students' protest was stimulated, no doubt, by the announcement that Wood had accepted the invitation to be a regional director of the Federal Art Project, a position he then declined.

90 "Grant Wood, Gentleman—?", *Daily Iowan*, Mar. 19, 1935; "Grant Wood, Esq., Author Lecturer," *Daily Iowan*, Mar. 24, 1935.

91 Madeline Darrough Horn, *Farm on the Hill* (New York, 1936).

92 Sinclair Lewis, *Main Street*, Limited

Editions Club ed. (New York, 1937).

93 In 1937, the year he created *Honorary Degree*, Wood was awarded an honorary Doctor of Letters degree from the University of Wisconsin, Madison. In subsequent years he would receive three more: from Lawrence College, Appleton, Wisconsin; Northwestern University, Evanston, Illinois; and Wesleyan University, Middletown, Connecticut.

94 Letter from Grant Wood to Reeves Lewenthal and Maurice Liederman, Nov. 14, 1939, collection of Mrs. Allan Kline, copies at the Archives of American Art. For insights into Wood's almost paranoid worry about being taken advantage of by dealers, see the artist's correspondence in the Maynard Walker Papers, AAA 2424/682–742.

95 For the announcement of the resale clause, see "Wood to Share Resale Profits on His Painting," New York *Herald Tribune*, Dec. 31, 1939; and "Grant Wood Presents Parson Weems," *Art Digest* 14 (Jan. 15, 1940): 7. In a Jan. 11, 1962, letter to Charles Addams, in the *Parson Weems' Fable* file at the Amon Carter Museum, Mrs. J. P. Marquand explains that Wood "withdrew the whole thing" when she and her husband decided to buy it.

96 Quoted in chapter 42 of Nan Wood Graham, "My Brother Grant Wood."

97 "*The Long Voyage Home* As Seen and Painted By Nine American Artists," *American Artist* 4 (September 1940): 4–14.

98 Nan Wood Graham, "My Brother Grant Wood," chap. 40.

99 Memorandum prepared by University President V. M. Hancher, Apr. 4, 1941, reporting conference with Professor Lester D. Longman, Special Collections Department, University of Iowa.

100 Wood scrapbooks, AAA 1216/337.

101 "Grant Wood Helps Young Artists Develop Technique," *Daily Iowan*, Nov. 3, 1935.

102 Dean George F. Kay to University President V. M. Hancher, "Notes made in relation to conferences in my office with regard to members of the staff of instruction of the Department of Art," Dec. 6, 1940. Special Collections Department, University of Iowa Libraries, Iowa City, Iowa.

103 Elizabeth M. Rochow, interview with author, Aug. 25, 1983.

104 H. W. Janson, interview with author, Aug. 11, 1974.

105 H. W. Janson, "Benton and Wood, Champions of Regionalism," *Magazine of Art* 39 (May 1946): 186.

106 Quoted in "Knocking Wood," *Art Digest* 17 (Dec. 1, 1942): 12.

107 Ibid.

108 In my interviews with Thomas Hart Benton (August 1972), Paul Engle (Aug. 9, 1976), and Reeves Lewenthal (Apr. 27, 1982), all three men spoke of Wood's despair in surmounting the difficulties of his marriage and the controversy surrounding his teaching. See also Thomas Hart Benton, "What's Holding Back American Art?" *Saturday Review of Literature* 34 (Dec. 15, 1951): 38.

109 "Grant Wood Denies Reputation As Glamour Boy Of Painters," *Los Angeles Times*, Feb. 19, 1940, in Wood scrapbooks, AAA 1216 (no frame number; see scrapbook #4, 1939–1947). See also Grant Wood, "John Steuart Curry And The Midwest," *Demcourier* 11 (April 1941): 2–4.

110 "Grant Wood Sees Artists In Significant Role In Defense," *Iowa City Press-Citizen*, May 3, 1941, in Wood scrapbooks, AAA 1216/748. Cécile Whiting, a student at Stanford University, is currently writing a dissertation on the regionalists' and other "American Painters' Response to Fascism, 1933–45."

111 "Americanissimo," *Saturday Evening Post*, Apr. 18, 1942, in Wood scrapbooks, AAA 1216/794.

112 I am indebted here all too obviously to Warren Susman and Karal Ann Marling, whose writings have so clearly identified the mythic, collective, and hopeful dimension of mainstream American culture in the 1930s. See, for example, Warren Susman, *Culture and Commitment, 1929–1945* (New York, 1973), and Karal Ann Marling, *Wall-to-Wall America* (Minneapolis, 1982).

COLORPLATES AND COMMENTARIES

1 Irma René Koen, "The Art of Grant Wood," *Christian Science Monitor*, Mar. 26, 1932.

2 Letter from Secretary of the Memorial Commission to David Turner, Jan. 26, 1928, recorded in the 1928 records of the Memorial Commission.

3 The *Cedar Rapids Sunday Gazette and Republican*, Feb. 10, 1929, announced the opening of Wood's exhibition at the Little Gallery, which included his paintings from Nürnberg and Munich and three portraits, one of them being *John B. Turner, Pioneer*.

4 Wood found glazing a slow process, each layer having to dry before the next was applied. In *Woman with Plants*, he improvised and tried to hasten the drying process with an electric heater, accidentally blistering the paint on the figure's face. Although he tried to repair the damage, the paint adhesion has always been precarious in this area.

5 Edward B. Rowan Papers, Archives of American Art, Smithsonian Institution (hereafter AAA) D141/1387–88. This is an envelope postmarked July 5, 1932, on which Rowan jotted down notes of an interview with Wood.

6 Koen, "The Art of Grant Wood."

7 Ibid. Wood uses the word *decorative* in almost all of his lectures and interviews in the early 1930s.

8 Park Rinard, "Art For Your Sake," an April 27, 1940 broadcast preserved on a phonograph record in the Grant Wood collection at the Davenport Art Gallery, and in Wood scrapbooks, AAA 1216/692. See also "'American Gothic' Is Explained To Grant High Pupils," in Wood scrapbooks, AAA 1216/289.

9 Reported to author by Mrs. Herbert Stamats in a telephone interview, Aug. 19, 1976.

10 Van Vechten Shaffer showed me the extant Grant Wood decorations in his home on August 4, 1976.

11 Koen, "The Art of Grant Wood."

12 Robert S. Lynd and Helen Merrell Lynd, *Middletown: A Study in Contemporary American Culture* (New York, 1929), p. 5.

13 Ibid., p. 6.

14 When *Appraisal* was in exhibition in Chicago in 1931, Wood changed the painting's name to *Clothes*, but then returned the painting to its former name.

15 James Dennis, *Grant Wood: A Study in American Art and Culture* (New York, 1975), p. 78.

16 Anedith Nash, "*Death on the Ridge Road*: Grant Wood and Modernization in the Midwest," forthcoming in *Prospects*, vol. 7.

17 The historical information about the birthplace, its fame, and restoration is taken from Edwin C. Bearss, *The Hoover Houses and Community Structures* (Herbert Hoover National Historic Site, Iowa, 1971).

18 Ibid., p. 28.

19 Ibid., p. 20.

20 Ibid., p. 28.

21 Ibid., pp. 28–29. Allen Philbrick, an instructor at the Chicago Art Institute, had painted the cottage, and Henry Standing had done a drawing of it before Wood made his painting. Some businessmen in Cedar Rapids thought about buying Wood's painting and giving it to the president, but nothing ever came of the idea. It "touches many chords of memory," Herbert Hoover wrote to Christopher Morley, thanking him for a reproduction of Wood's painting (letter of July 16, 1932, collection of the Herbert Hoover Presidential Library, West Branch, Iowa).

22 Park Rinard, "Return from Bohemia, A Painter's Story," Part I, M.A. thesis, University of Iowa, 1939, p. 50.

23 Howard Mumford Jones, "Patriotism—But How?," *Atlantic Monthly* 162 (November 1938): 589.

24 "Artist Denies Intent to 'Debunk' Legend," *New York Times*, Jan. 3, 1940.

25 Ibid.

26 Russell Lynes, *The Tastemakers* (New York, 1955), p. 239.

27 Lewis Mumford, *American Taste* (1929), excerpted in *The Culture of the Twenties*, ed. Loren Baritz (New York, 1970), p. 402.

28 In the 1920s dial phones had just replaced older models, which depended upon a central operator to place calls. See John Brooks, *Telephone, The First Hundred Years* (New York, 1975), p. 168.

29 Rinard, "Return from Bohemia," p. 118. For a description of Aunt Tillie, Wood's mother's so-called maiden aunt, see p. 24; for Aunt Sarah, pp. 98, 118–24.

30 Rinard, "Return from Bohemia," p. 4.

31 Lincoln Kirstein, "An Iowa Memling," *Art Front* 1 (July 1935): 8.

32 Karal Ann Marling, "A Note on New Deal Iconography: Futurology and the Historical Myth," *Prospects* 4 (1979): 438.

33 For a discussion of the government's role in celebrating the Washington Bicentennial and other forms of Washington worship in the 1930s, see Karal Ann Marling, "Of Cherry Trees and Ladies Teas," in *The Colonial Revival in America*, ed. Alan Axelrod (New York, 1983). For bicentennial birthday celebrations in Cedar Rapids, see the *Cedar Rapids Gazette*, Jan. 31, Feb. 7, 14, 21, and 22, 1932.

34 For the DAR's activities, see the *Cedar Rapids Gazette*, Feb. 22, 1931, and Feb. 7, 1932; and *DAR Iowa Society*, vol. 32 (Des Moines, 1931), pp. 94–95, and vol. 33 (1932), pp. 104–05.

35 Although the artist's sister, John Turner, and others have told me about the protests lodged against the Memorial Window, I have failed to turn up any reports about them in the local press, the minutes of the memorial commission, or the records at the Ashley chapter of the Cedar Rapids DAR. Thomas Craven, in an article clearly based on discussions with Wood, describes the controversy and says that the Legion "appealed to the artist to state his case at a public hearing." Thomas Craven, "Grant Wood," *Scribner's* 101 (June 1937): 18.

36 Rowan Papers, AAA D141/806–07, D142/701, 703–04.

37 *Cedar Rapids Gazette*, Feb. 22, 1931.

38 Ann Hawkes Hutton, *Portrait of Patriotism: Washington Crossing the Delaware* (Philadelphia and New York, 1959), pp. 153–58.

39 Darrell Garwood, *Artist in Iowa: A Life of Grant Wood* (New York, 1944), pp. 137–38.

40 Hutton, *Portrait of Patriotism*, pp. 147–48.

41 Ibid., p. 154.

42 Rowan Papers, AAA D142/733.

43 Grant Wood letter reprinted in *Art in America* 53 (August/September 1965):89.

44 *Iowa City Press-Citizen*, Feb. 10, 1940, in Wood scrapbooks, AAA 1216 (no frame number; see scrapbook #4, 1939–1947).

45 Letter to the editor from Mrs. E. E. Graham, printed in "The Sunday *Register*'s Open Forum," *Des Moines Register*, Dec. 21, 1930, in Wood scrapbooks, AAA 1216/286. Biographical information about the making of this portrait comes from Nan Wood Graham's typed report for *Encyclopedia Britannica*, entitled "The Story of My Portrait" and dated July 17, 1944.

46 "Exhibits of Merit at Ferargil's," in Wood scrapbooks, AAA 1216/365.

47 Rinard, "Return from Bohemia," pp. 108–10.

48 Ibid., p. 113.

49 Adeline Taylor, "Grant Wood's Penetrating Eye and Skillful Brush To Deal Next With Some Of America's Pet Institutions," *Cedar Rapids Gazette*, Sept. 25, 1932.

50 Dennis, *Grant Wood*, p. 216.

51 Connie Bailey, "Artists recall the story of the Library's mural," *Iowa State Daily*, Nov. 14, 1980. For other newspaper clippings and university reports about the murals, see the Grant Wood file in the Special Collections Department, Iowa State University, Ames, Iowa.

52 For a discussion of Wood's central role in the 1930s government-sponsored mural movement in Iowa, and his very obvious influence on murals made throughout the state, see Lea Rosson DeLong and Gregg R. Narber, *A Catalogue of New Deal Mural Projects in Iowa* (Des Moines, 1982). Wood's control of the mural projects and workshop methods became controversial. While many artists found working with him an inspiration, others registered objection with the government over Wood's disbursing of relief funds. They wanted "Wood to give out independent assignments rather than just work on his designs" (p. 13).

53 Another version is in the IBM collection in New York and is reproduced in Dennis, *Grant Wood*, p. 156.

54 Adeline Taylor, "First To Spurn All Foreign Influences, Adopt American Viewpoint," *Cedar Rapids Gazette*, Jan. 25, 1931, in Wood scrapbooks, AAA 1216/296.

55 "A Midwest Artist Views 'Main Street,'" *St. Louis Post-Dispatch*, May 23, 1937.

56 "Latin Quarter Notes," in Wood scrapbooks, AAA 1216/271.

57 Sinclair Lewis, *Main Street* (New York, 1920), p. 268.

58 Grant Wood to Mr. Archie B. Winter, Dec. 27, 1938, collection of Mrs. Allan Kline, copies at the Archives of American Art.

59 See Amy Namowitz Worthen, *Benton, Curry, Wood: Selected Lithographs* (Iowa Arts Council, Des Moines, 1978).

60 Gary Wills, "Mason Weems, Bibliopolist," *American Heritage* 33 (February–March 1981): 68.

61 Marling, "Of Cherry Trees and Ladies Teas."

62 Jones, "Patriotism—But How?" pp. 585, 592.

63 From a press release entitled "A Statement From Grant Wood Concerning His Painting 'Parson Weems' Fable,'" Jan. 2, 1940, in the *Parson Weems'* file at the Amon Carter Museum in Fort Worth, Texas.

64 Pyle continued to work closely with Wood. He taught at the Stone City Colony and Art School and was one of the thirteen artists who painted the PWAP murals at the State University of Iowa in Ames. For five years he assisted Edward Rowan in running the Little Gallery in Cedar Rapids.

65 Rinard, "Return from Bohemia," p. 83.

66 Taylor, "First To Spurn All Foreign Influences," in Wood scrapbooks, AAA 1216/296.

AMERICAN GOTHIC: THE MAKING OF A NATIONAL ICON

1 Letter to the editor from Grant Wood, printed in "The Sunday *Register*'s Open Forum," *Des Moines Register*, Dec. 21, 1930, in Wood scrapbooks, Archives of American Art, Smithsonian Institution (hereafter AAA) 1216/286. Calder Loth and Julius Trousdale Sadler, Jr., in *The Only Proper Style; Gothic Architecture in America* (Boston, 1975), p. 104, date the Eldon house at 1881–82 and attribute the building of it to Messrs. Busey and Herald, local carpenters.

2 Letter to the editor from Grant Wood, Dec. 21, 1930.

3 August 19, 1941, letter from Edward B. Rowan to Marion Mayer, in the papers of Marion Mayer, Archives of American Art.

4 "Grant Wood Denies Reputation As Glamour Boy Of Painters," *Los Angeles Times*, Feb. 19, 1940, in Wood scrapbooks, AAA 1216 (no frame number; see scrapbook #4, 1939–1947).

5 Solomon D. Butcher, *Pioneer History of Custer County, and Short Sketches of Early Days in Nebraska* (Broken Bow, Neb., 1901); and *Sod Houses, or the Development of the Great American Plains* (Kearney, Neb., 1904).

6 Letter from Mrs. Ray R. Marsh of Washta, printed in "The Sunday *Register*'s Open Forum," *Des Moines Register*, Dec. 14, 1930, in Wood scrapbooks, AAA 1216/283.

7 C. J. Bulliet, "American Normalcy Displayed in Annual Show," *Chicago Evening Post*, Oct. 29, 1930, in Wood scrapbooks, AAA 1216/279; Walter Prichard Eaton, "American Gothic," *Boston Herald*, Nov. 14, 1930, in Wood scrapbooks, AAA 1216/282.

8 Letter from Mrs. Earl Robinson of Collins, Iowa, printed in "The Sunday *Register*'s Open Forum," *Des Moines Register*, Nov. 30, 1930, in Wood scrapbooks, AAA 1216/283.

9 Letter from Grace M. Shields of Cedar Rapids, printed in "The Sunday *Register*'s Open Forum," *Des Moines Register*, Dec. 21, 1930, in Wood scrapbooks, AAA 1216/286.

10 Marquis W. Childs, "The Artist in Iowa," *Creative Art* 10 (June 1932): 461–69; Christopher Morley, "The Bowling Green," *Saturday Review of Literature* 7 (Jan. 17, 1931): 533.

11 Eaton, "American Gothic."

12 *Fortune* 24 (August 1941): 79.

13 Ruth Suckow, "Iowa," *American Mercury* 9 (September 1926): 45.

14 Dorothy Dougherty, "The Right and Wrong of America," *Cedar Rapids Gazette*, Sept. 5, 1942.

15 The phrase "drab and angular" is used by Sigmund to describe a spinster in his short story, "First Premium," in *Wapsipinicon Tales* (Cedar Rapids, 1927). See also Sigmund's poems, "The Serpent," *Frescoes* (Boston, 1922), pp. 40–42, and "Hill Spinster's Sunday," in *Jay G. Sigmund*, ed. Paul Engle (Muscatine, Iowa, 1939), p. 19. Ruth Suckow's spinsters are far more sympathetic and appealing characters than Sigmund's. In "Best of the Lot," *Smart Set* 69 (November 1922): 5–36, she describes how a promising young girl, who ends her life as a lonely spinster, is never able to realize her potential because the family always needed her. See also Suckow's "Midwestern Primitive," *Harper's Monthly Magazine* 156 (March 1928): 432–42, and "Spinster and Cat," *Harper's Monthly Magazine* 157 (June 1928): 59–68.

16 Wood rarely went to the trouble of ex-

plaining the painting's original cast of characters and left that task for friends to do. The first public statement that Wood's couple were father and daughter appeared in a letter to the editor by Nan Wood Graham in "The Sunday *Register*'s Open Forum," *Des Moines Register*, Dec. 21, 1930. Mrs. Graham gave a fuller account of Wood's original ideas for the painting in "American Gothic," *Canadian Review of Music and Art* 3 (February–March 1941): 11–14. Arnold Pyle and Park Rinard, two of Wood's closest friends, also explained the couple's relationship as father and daughter in *Catalogue of a Loan Exhibition of Drawings and Paintings by Grant Wood* (Chicago, 1935), p. 6.

17 Jay Sigmund, "The Serpent," in *Frescoes* (Boston, 1922), pp. 40–42.

18 Matthew Baigell, *The American Scene* (New York, 1974), p. 110.

19 Guy Davenport, *The Geography of the Imagination* (San Francisco, 1981), pp. 12–15. I am indebted to Josephine Withers for referring me to Davenport's essay.

20 I owe a special thank you to Allen and Dorian Hyshka-Stross for having alerted me to this takeoff and to Mrs. Esther Gordy Edwards for talking with me about the painting.

Bibliography

Readers who seek an authoritative bibliography on Grant Wood will find it in Mary Schulz Guedon's handy compendium, *Regionalist Art, Thomas Hart Benton, John Steuart Curry, and Grant Wood: A Guide to the Literature* (Metuchen, N.J.: Scarecrow Press, 1982). Scholars will also want to consult the rich Grant Wood holdings at the Archives of American Art, Smithsonian Institution, Washington, D.C., most particularly the microfilms of the many scrapbooks assembled by the artist's sister, Nan Wood Graham. Upon Mrs. Graham's death, these scrapbooks will go to the Davenport Municipal Art Gallery, which houses an important Grant Wood collection of family memorabilia, photographs, newspaper clippings, as well as works of art.

Listed here are a few references to the major books, museum catalogues, and art historical writings on Grant Wood. Other bibliographical references may be found in the endnotes.

BOOKS

Brown, Hazel E. *Grant Wood and Marvin Cone; Artists of an Era*. Ames, Iowa: Iowa State University Press, 1972.

Czestochowski, Joseph S. *John Steuart Curry and Grant Wood, A Portrait of Rural America*. Columbia, Mo.: University of Missouri Press, 1981.

Dennis, James M. *Grant Wood: A Study in American Art and Culture*. New York: Viking, 1975.

Garwood, Darrell. *Artist in Iowa: A Life of Grant Wood*. New York: Norton, 1944. Reprint. Westport, Conn.: Greenwood, 1971.

Liffring-Zug, Joan, ed. *This Is Grant Wood Country*. Davenport, Iowa: Davenport Municipal Art Gallery, 1977.

EXHIBITION CATALOGUES

Art Institute of Chicago. *The Fifty-Third Annual Exhibition of American Paintings and Sculpture*. Chicago: Art Institute, 1942.

Cedar Rapids Art Center. *The Grant Wood Collection; Cedar Rapids Art Center*. Cedar Rapids, Iowa: Cedar Rapids Art Center, 1973.

———. *Grant Wood, The Graphic Work*. Cedar Rapids, Iowa: Cedar Rapids Art Center, 1972.

Davenport Municipal Art Gallery. *Grant Wood and the American Scene*. Davenport, Iowa: Municipal Art Gallery, 1957.

Hathorn Gallery. *Grant Wood*. Saratoga Springs, N.Y.: Skidmore College, 1974.

Lakeside Press Galleries. *Catalogue of a Loan Exhibition of Drawings and Paintings by Grant Wood*. Chicago: Lakeside Press Galleries, 1935.

University of Kansas Museum of Art. *Grant Wood, 1891–1942*. Lawrence, Kans.: University of Kansas Museum of Art, 1959.

ARTICLES

Baigell, Matthew. "Grant Wood Revisited." *Art Journal* 26, no. 2 (Winter 1966–67): 116–22.

Corn, Wanda M. "The Painting That Became a Symbol of a Nation's Spirit." *Smithsonian* 11, no. 8 (November 1980): 84–97.

———. "The Birth of a National Icon: Grant Wood's *American Gothic*." In *Art: The Ape of Nature*, edited by Moshe Barasch and Lucy Freeman Sandler, pp. 749–69. New York: Harry N. Abrams, 1981.

Dennis, James M. "An Essay into Landscapes; The Art of Grant Wood." *Kansas Quarterly* 4, no. 4 (Fall 1972): 12–122.

Janson, H. W. "Benton and Wood; Champions of Regionalism." *Magazine of Art* 39 (May 1946): 184–86, 198–99.

———. "The Case of the Naked Chicken." *College Art Journal* 15 (Winter 1955): 124–27.

———. "The International Aspects of Regionalism." *College Art Journal* 2 (May 1943): 110–15.

———. "Review of *Artist in Iowa—A Life of Grant Wood*, by Darrell Garwood." *Magazine of Art* 38 (November 1945): 280–82.

Index

Numbers in **boldface** indicate figures and plates. Titles in **boldface** indicate works by Grant Wood.

PHOTO CREDITS

Lenders to the Exhibition

Abbott Laboratories
Amon Carter Museum
The Art Institute of Chicago
Associated American Artists
Mr. and Mrs. Peter F. Bezanson
Melvin R. Blumberg
Eugenie Mayer Bolz
The Cedar Rapids Museum of Art
The Cincinnati Art Museum
Coe College
Davenport Art Gallery
Deere & Company
Des Moines Art Center
Mrs. Ernest J. Dieterich
Ms. Esther Gordy Edwards
The Fine Arts Museums of San Francisco,
 M. H. De Young Memorial Museum
The Fine Arts Museums of San Francisco,
 Achenbach Foundation for Graphic Arts
Gulf States Paper Corporation, The Warner Collection
Hirschl and Adler Galleries
Joslyn Art Museum

Richard K. Larcada
Family of Maurice J. Liederman
James Maroney
Mrs. Harpo Marx
The Metropolitan Museum of Art
The Minneapolis Institute of Arts
The New Britain Museum of American Art
Mrs. I. Stuart Outerbridge, Jr.
The Pennsylvania Academy of the. Fine Arts
The Regis Collection
Mr. and Mrs. Park Rinard
The Sheldon Swope Art Gallery
King W. Vidor Trust
Suzanne Vidor
Whitney Museum of American Art
Williams College Museum of Art
Private collection on extended loan to the University of
 Wisconsin, Elvehjem Art Museum
Private collection, courtesy of Middendorf Gallery
Private collection on loan to the University of Iowa
Other private collections and anonymous loans

Exhibition Checklist

PAINTINGS AND DRAWINGS

1. **QUIVERING ASPEN 1917**
 Oil on composition board, 14 × 11 in.
 Davenport Art Gallery, Davenport, Iowa

2. **OLD SEXTON'S PLACE c. 1919**
 Oil on composition board, 15 × 18 1/8 in.
 Cedar Rapids Museum of Art, Gift of Happy Young and John B. Turner II

3. **FOUNTAIN OF VOLTAIRE, CHATENAY 1920**
 Oil on composition board, 13 × 15 in.
 Cedar Rapids Museum of Art, Gift of Happy Young and John B. Turner II

4. **CEDAR RAPIDS,** or **ADORATION OF THE HOME 1921–22**
 Oil on canvas, 22 3/4 × 81 3/8 in.
 Cedar Rapids Museum of Art, Mr. and Mrs. Peter F. Bezanson Collection

5. Lunette of **SUMMER c. 1922–25**
 Oil on canvas, 16 × 39 in.
 Cedar Rapids Museum of Art, Cedar Rapids Community School District Collection

6. Lunette of **AUTUMN c. 1922–25**
 Oil on canvas, 16 × 45 1/4 in.
 Cedar Rapids Museum of Art, Cedar Rapids Community School District Collection

7. **THE RUNNERS, LUXEMBOURG GARDENS, PARIS 1924**
 Oil on composition board, 15 5/8 × 12 1/2 in.
 Cedar Rapids Museum of Art, Bequest of Miss Nell Cherry

8. **TRUCK GARDEN, MORET 1924**
 Oil on composition board, 12 3/4 × 15 3/4 in.
 Davenport Art Gallery, Davenport, Iowa

9. **YELLOW DOORWAY, ST. EMILION 1924**
 Oil on composition board, 16 1/2 × 13 in.
 Cedar Rapids Museum of Art, Gift of Happy Young and John B. Turner II

10. **LILIES OF THE ALLEY c. 1925**
 Earthenware flowerpot and found objects, 11 × 11 1/4 × 7 in.
 Cedar Rapids Museum of Art, Gift of Happy Young and John B. Turner II

11. **THE OLD J. G. CHERRY PLANT 1925**
 Oil on composition board, 13 1/4 × 40 3/4 in.
 Cedar Rapids Museum of Art, Cherry-Burrell Charitable Foundation Collection

12. **GRANDMA WOOD'S HOUSE 1926**
 Oil on composition board, 8 3/8 × 10 3/8 in.
 Davenport Art Gallery, Davenport, Iowa

13. **OLD SHOES 1926**
 Oil on composition board, 9 3/4 × 10 in.
 Cedar Rapids Museum of Art, Gift of Happy Young and John B. Turner II

14. STUDY FOR **MEMORIAL WINDOW 1927**
 Watercolor, 24 × 18 1/2 in.
 Private Collection

15. **HOUSE IN THE WOODS 1928**
 Oil on masonite panel, 12 3/4 × 15 in.
 Davenport Art Gallery, Davenport, Iowa

16. **CORNSHOCKS 1928**
 Oil on composition board, 15 × 13 in.
 Eugenie Mayer Bolz

17. **CALENDULAS c. 1928–29**
 Oil on composition board, 17 1/2 × 20 1/4 in.
 Private Collection

18. **PORTRAIT OF JOHN B. TURNER, PIONEER 1928–30**
 Oil on canvas, 30 1/4 × 25 1/2 in.
 Cedar Rapids Museum of Art, Gift of Happy Young and John B. Turner II

19. ***WOMAN WITH PLANTS 1929**
 Oil on upsom board, 20 1/2 × 17 7/8 in.
 Cedar Rapids Museum of Art, Cedar Rapids Art Association Purchase

20. **PORTRAIT OF MARY VAN VECHTEN SHAFFER 1930**
 Oil on composition board, 15 1/4 × 13 in.
 Private Collection

21. **PORTRAIT OF SUSAN ANGEVINE SHAFFER 1930**
 Oil on composition board, 15 1/4 × 13 in.
 Mrs. I. Stuart Outerbridge, Jr.

22. **STONE CITY 1930**
 Oil on composition board, 30 1/4 × 40 in.
 Joslyn Art Museum, Omaha, Nebraska

23. SKETCH FOR **AMERICAN GOTHIC 1930**
 Pencil on paper, 4 3/4 × 3 1/2 in.
 Richard K. Larcada, New York

24. STUDY FOR **AMERICAN GOTHIC 1930**
 Oil on composition board, 13 × 15 in.
 Mr. and Mrs. Park Rinard, Falls Church, Virginia

**Works not able to travel for entire itinerary*

25. **AMERICAN GOTHIC 1930**
Oil on composition board, 29 7/8 × 24 7/8 in.
The Art Institute of Chicago

26. **OVERMANTEL DECORATION 1930**
Oil on upsom board, 41 × 63 1/2 in.
Cedar Rapids Museum of Art, Gift of Isabel R. Stamats in memory of Herbert S. Stamats

27. **APPRAISAL 1931**
Oil on composition board, 29 1/2 × 35 1/4 in.
Anonymous Collection

28. **VICTORIAN SURVIVAL 1931**
Oil on composition board, 32 1/2 × 26 1/4 in.
Anonymous Collection

29. ***MIDNIGHT RIDE OF PAUL REVERE 1931**
Oil on composition board, 30 × 40 in.
The Metropolitan Museum of Art, Arthur Hoppock Hearn Fund

30. DRAWING FOR **THE BIRTHPLACE OF HERBERT HOOVER 1931**
Chalk and pencil on paper, 39 3/8 × 29 3/8 in.
Private Collection. On loan to The University of Iowa Museum of Art

31. **THE BIRTHPLACE OF HERBERT HOOVER 1931**
Oil on composition board, 29 5/8 × 39 3/4 in.
The Minneapolis Institute of Arts and the Des Moines Art Center

32. **PLAID SWEATER 1931**
Oil on composition board, 30 × 25 in.
Melvin R. Blumberg

33. **FALL PLOWING 1931**
Oil on canvas, 30 × 40 3/4 in.
The John Deere Collection, Moline, Illinois

34. ***YOUNG CORN 1931**
Oil on masonite panel, 24 × 29 7/8 in.
Cedar Rapids Museum of Art, Cedar Rapids Community School District Collection

35. **ARBOR DAY 1932**
Oil on masonite panel, 24 × 30 in.
Suzanne Vidor

36. **DAUGHTERS OF REVOLUTION 1932**
Oil on masonite panel, 20 × 40 in.
The Cincinnati Art Museum, The Edwin and Virginia Irwin Memorial

FRUITS OF IOWA SERIES

37. **FARMER WITH PIGS 1932**
Oil on canvas, 46 1/4 × 28 1/2 in. (image),
71 1/4 × 49 1/4 in. (canvas)

38. **BOY MILKING COW 1932**
Oil on canvas, 45 1/2 × 39 1/2 in. (image),
71 1/4 × 63 1/4 in. (canvas)

39. **FARMER'S WIFE WITH CHICKENS 1932**
Oil on canvas, 45 × 27 1/4 in. (image),
71 1/4 × 49 in. (canvas)

40. **FARM LANDSCAPE 1932**
Oil on canvas, 23 1/4 × 45 1/2 in. (image),
43 3/8 × 64 1/2 in. (canvas)

Nos. 37–40: Coe College, Cedar Rapids, Iowa, Gift from the Eugene C. Eppley Foundation

41. **PORTRAIT OF NAN 1933**
Oil on masonite panel, 40 × 30 in.
On loan to the Elvehjem Art Museum, University of Wisconsin, Madison

42. DRAWING FOR **DINNER FOR THRESHERS 1934**
Pencil on paper, 18 × 72 in.
Private Collection

43. **DINNER FOR THRESHERS 1934**
Tempera on masonite panel, 20 × 81 1/16 in.
The Fine Arts Museums of San Francisco, Gift of Mr. and Mrs. John D. Rockefeller 3rd

44. DRAWING FOR **DEATH ON THE RIDGE ROAD 1934**
Pencil and chalk on paper, 31 1/4 × 39 in.
James Maroney, New York

45. ***DEATH ON THE RIDGE ROAD 1935**
Oil on masonite panel, 32 × 39 in.
Williams College Museum of Art, Gift of Cole Porter

46. **RETURN FROM BOHEMIA 1935**
Crayon, gouache, and pencil on paper, 23 1/2 × 20 in.
The Regis Collection

DRAWINGS FOR *FARM ON THE HILL*

47. **GRANDPA EATING POPCORN 1935**
Crayon, gouache, and colored pencil on paper, 26 1/4 × 19 1/2 in.
The Warner Collection of Gulf States Paper Corporation, Tuscaloosa, Alabama

48. **GRANDMA MENDING 1935**
Crayon, gouache, and colored pencil on paper, 26 1/4 × 19 1/2 in.
The Warner Collection of Gulf States Paper Corporation, Tuscaloosa, Alabama

49. STUDY FOR **BREAKING THE PRAIRIE c. 1935–39**
Colored pencil, chalk, and pencil on paper, 22 3/4 × 80 1/4 in.
The Whitney Museum of American Art, Gift of Mr. and Mrs. George D. Stoddard

50. **SPRING TURNING 1936**
Oil on masonite panel, 18 1/8 × 40 in.
Private Collection

ILLUSTRATIONS FOR *MAIN STREET*

51. ***THE GOOD INFLUENCE 1936–37**
Pencil, gouache, and india ink on paper,
20 1/2 × 16 in.
The Pennsylvania Academy of the Fine Arts

52. **BOOSTER 1936–37**
Charcoal, pencil, and chalk on paper, 20 1/2 × 16 in.
Mrs. Harpo Marx

53. **SENTIMENTAL YEARNER 1936–37**
Crayon, gouache, and pencil on paper, 20 1/2 × 16 in.
The Minneapolis Institute of Arts

54. **THE RADICAL 1936–37**
Charcoal, pencil, and chalk on paper, 20 1/2 × 16 in.
Private Collection. Courtesy of Middendorf Gallery

55. **VILLAGE SLUMS 1936–37**
Charcoal, pencil, and chalk on paper, 20 1/2 × 16 in.
Mr. and Mrs. Park Rinard, Falls Church, Virginia

56. **THE PERFECTIONIST 1936–37**
Crayon, gouache, charcoal, and ink on paper,
20 1/2 × 16 in.
The Fine Arts Museums of San Francisco, Achenbach Foundation for Graphic Arts, Gift of Mr. and Mrs. John D. Rockefeller 3rd

57. **MAIN STREET MANSION 1936–37**
Charcoal, pencil, and chalk on paper, 20 1/2 × 16 in.
James Maroney, New York, and Hirschl and Adler Galleries, New York

58. **SPRING PLOWING** (drawing for textile design) **c. 1939**
Tempera on paper, 16 × 38 in.
Mr. and Mrs. Ernest Johnston Dieterich

59. CARTOON FOR **PARSON WEEMS' FABLE 1939**
Charcoal, pencil, and chalk on paper, 38 3/8 × 50 in.
James Maroney, New York, and Hirschl and Adler Galleries, New York

60. **PARSON WEEMS' FABLE 1939**
Oil on canvas, 38 3/8 × 50 1/8 in.
Amon Carter Museum, Fort Worth

61. **ADOLESCENCE 1940**
Oil on masonite panel, 20 3/8 × 11 3/4 in.
Abbott Laboratories

62. **JANUARY 1940**
Oil on masonite panel, 18 × 24 in.
The King W. Vidor Trust

63. ***SENTIMENTAL BALLAD 1940**
Oil on masonite panel, 24 × 50 in.
The New Britain Museum of American Art (Charles F. Smith Fund)

64. **SELF-PORTRAIT 1932–41**
Oil on masonite, 14 3/4 × 12 3/8 in.
Davenport Art Gallery, Davenport, Iowa

65. **SPRING IN TOWN 1941**
Oil on masonite panel, 26 × 24 1/2 in.
The Sheldon Swope Art Gallery, Terre Haute, Indiana

PRINTS

Note: Numbers in parentheses refer to the catalogue of graphics of Grant Wood listed by Joseph S. Czestochowski in *John Steuart Curry and Grant Wood, A Portrait of Rural America* (Columbia and London: University of Missouri Press, 1981).

66. **TREE PLANTING GROUP 1937 (W–3)**
Lithograph, 8 1/2 × 11 in.

67. **SEED TIME AND HARVEST 1937 (W–4)**
Lithograph, 7 1/2 × 12 1/4 in.

68. **JANUARY 1937, (W–5)**
Lithograph, 8 7/8 × 11 7/8 in.

69. **SULTRY NIGHT 1937 (W–6)**
Lithograph, 9 × 11 3/4 in.

70. **HONORARY DEGREE 1937 (W–7)**
Lithograph, 11 3/4 × 7 in.

Nos. 66–70: The Fine Arts Museums of San Francisco, Achenbach Foundation for Graphic Arts

71. **FRUITS 1938 (W–8)**
Hand-colored lithograph, 7 × 10 in.

72. **TAME FLOWERS 1938 (W–9)**
Hand-colored lithograph, 7 × 10 in.

73. **VEGETABLES 1938 (W–10)**
Hand-colored lithograph, 7 × 10 in.

74. **WILD FLOWERS 1938 (W–11)**
Hand-colored lithograph, 7 × 10 in.

Nos. 71–74: Associated American Artists

75. **FERTILITY 1939 (W–12)**
Lithograph, 9 × 12 in.

76. **IN THE SPRING 1939 (W–13)**
Lithograph, 9 x 12 in.

77. **JULY FIFTEENTH 1939 (W–14)**
Lithograph, 9 × 12 in.

78. **MIDNIGHT ALARM 1939 (W–15)**
Lithograph, 12 × 7 1/2 in.

79. **SHRINE QUARTET 1939 (W–16)**
Lithograph, 7 1/4 × 12 in.

80. **APPROACHING STORM 1940 (W–17)**
Lithograph, 12 × 9 in.

81. **MARCH 1941 (W–18)**
Lithograph, 9 × 12 in.

82. **FEBRUARY 1941 (W–19)**
Lithograph, 9 × 12 in.

83. **DECEMBER AFTERNOON 1941 (W–20)**
Lithograph, 9 × 12 in.

Nos. 75–83: The Fine Arts Museums of San Francisco, Achenbach Foundation for Graphic Arts

84. **FAMILY DOCTOR 1941 (W–21)**
Lithograph, 10 × 12 in.
Family of Maurice J. Liederman

WORKS BY OTHER ARTISTS

85. MARVIN CONE (1891–1964)
STONE CITY c. 1936
Oil on canvas, 19 1/2 × 36 in.
Private Collection

86. CARL OWENS (1929–)
PORTRAIT OF MR. AND MRS. BERRY GORDY, SR. 1972
Oil on canvas, 37 × 31 in.
Ms. Esther Gordy Edwards, Detroit, Michigan

87. JOHN STEUART CURRY (1897–1946)
PORTRAIT OF GRANT WOOD 1933
Charcoal and pencil, 24 × 18 in.
The Joslyn Art Museum, Omaha, Nebraska, Given in memory of Maurie Evans